# BROOKLYN BRIDGE

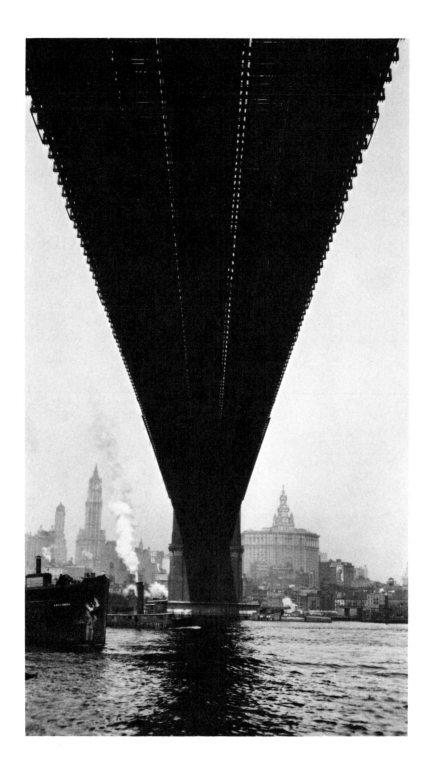

# BROOKLYN
# BRIDGE FACT AND SYMBOL

ALAN TRACHTENBERG

THE UNIVERSITY OF
CHICAGO PRESS
*Chicago and London*

FOR BETTY

The University of Chicago Press, Chicago 60637
The University of Chicago Press, Ltd., London

Paperback edition 1979
Printed in the United States of America
96 95 94                7
LCN 78-68548
ISBN 0-226-81115-8 (paper)

# Contents

# Preface to the Phoenix Edition

The "Afterword" on Walker Evans, and the inclusion of a portfolio of his Brooklyn Bridge photographs of 1929, many never before seen, owe everything to the generosities of Arnold Crane and of the Walker Evans Estate. My thanks go to John Hill and Amos Chan for their assistance. Joel Snyder has earned my special gratitude, not only for his help in providing prints for reproduction from original negatives in the remarkable Arnold Crane collection, but for his sympathetic grasp of the significance of this addition to a book I had long thought completed and final. He provided important information as well as invaluable aid, and the present version of the book owes much to his cooperation.

*Hamden, Connecticut*          Alan Trachtenberg
*August 1978*

# Preface

One purpose of this study is to establish the importance of Brooklyn Bridge as a cultural symbol in America. Another is to examine the process whereby the bridge, an artifact, became a symbol. By distinguishing between "fact" and "symbol" I mean to designate two separate modes of existence: one has a specific location in time and space; the other, its place in the mind, or in the collective imagination of Americans. Coming into existence in a time of change—change from a predominantly rural to an overwhelmingly urban and industrial society—Brooklyn Bridge seemed to represent that change. As a major construction in America's leading city, it became the vehicle for ideas and feelings associated with the new conditions. Americans have tended to invest the fact with feelings about the great alteration in their common lives, and thus it became for them a symbol.

A symbol serves a culture by articulating in objective form the important ideas and feelings of that culture. It serves, Alfred North Whitehead writes, to enhance what is being symbolized. Brooklyn Bridge symbolized and enhanced modern America. But symbols, Whitehead continues, frequently become fixed and hard, arousing automatic responses. The health of a people depends largely on their ability to question their inherited symbols in light of contemporary actualities, to keep them fluid, vibrant, and responsive. The process of interrogation will not destroy valuable symbols, but may replenish their cohesive meanings.

In the course of this study I have received generous assistance from many sources. To Bernard Bowron and Leo Marx I owe my chief intellectual debts. Mr. Bowron shared with me his abundant insights and advice. Without his encouragement and stimulation

the work might never have materialized. Any one familiar with Leo Marx's studies in American literature and culture will recognize how indebted I am to his formulations. From Dmitri Tselos I learned much that I needed to know regarding architectural history and scholarly method. Philip Young tried to save me from the usual mistakes of pedantry. His standards are strenuous, and he is not to blame if I have not met them.

To give the names of all who have contributed to my work, perhaps unwittingly, would result in an endless list. My obligations, and gratitude, extend to numerous colleagues, librarians, administrators, and friends. I would like to single out the staffs of the Rensselaer Polytechnic Institute library and the Rutgers University library, who tend valuable Roebling collections. Their assistance quite literally made this study possible.

A grant from the American Council of Learned Societies enabled me to reach certain materials otherwise unavailable. Time released from teaching from the Department of English, The Pennsylvania State University, allowed me to prepare the final manuscript.

Betty Trachtenberg was throughout a gracious partner; many of her responses are woven into the text.

For permissions granted, I thank the Estate of David B. Steinman for "The Harp"; the Estate of Hart Crane (David Mann and Samuel Loveman, executors) for unpublished lines; Liveright Publishing Corporation for lines from *The Collected Poems of Hart Crane*, copyright © R, 1961. For permission to reclaim my own work, I thank the editors of *The Massachusetts Review* for an earlier version of Chapter one, "Brooklyn Bridge and the Mastery of Nature" (Autumn 1963), and the editors of *The American Quarterly* for "The Rainbow and the Grid" (Winter 1963), now Chapter two.

Finally, I would like to thank the Arnold Crane Collection for its kind permission to reprint the Walker Evans photographs appearing on pages ii, 172–78, and 182–83; and the Walker Evans Estate for the photographs appearing on pages 179–81 and on the cover.

A. T.

BROOKLYN BRIDGE

*The idea of each epoch always finds its appropriate and adequate form.*

―――――――――――――――――――

G. W. F. HEGEL

# Prologue

Brooklyn Bridge belongs first to the eye. Viewed from Brooklyn Heights, it seems to frame the irregular lines of Manhattan. But across the river perspective changes: through the narrow streets of lower Manhattan and Chinatown, on Water Street or South Street, the structure looms above drab buildings. Fragments of tower or cable compel the eye. The view changes once again as one mounts the wooden walk of the bridge itself. It is a relief, an open space after dim, crowded streets.

On most traffic bridges the only foot passage is a pavement alongside rushing vehicles. Here the walk is a promenade raised above the traffic; one can lean over the railing and watch cars speeding below. The promenade is wide enough for benches — for walkers and for cyclists. Old-fashioned lamp posts remind the walker that it is, after all, a thoroughfare. But the walk is narrow enough for the promenader to reach over and touch the large, round cables, wrapped in wire casing, or the rough wire rope of the vertical suspenders. Crossing the verticals is a rigging of diagonal wire ropes — stays, attached somewhere below to the floor of the roadway.

One has the illusion of an enclosure. The web formed by the diagonals and the verticals captures the walker's attention; it is a diagram of the physical forces of the bridge. Each diagonal is lashed to the verticals it crosses in a series of iron knots. These knots are points for the eye as one strolls along; with each succes-

3

sive step, one is tempted to raise one's head to follow the sequence of knots. The movement is upward, until one reaches the stairs leading to the balcony which widens around the massive piers of the towers. Before one climbs the steps, the eye climbs the tower itself, swept there by the rising knots of the diagonals. Meanwhile the roadway itself has been rising, slowly, in a slight bow.

It is tempting to linger on the balcony, to walk around the center pier, to gaze up at the underside of the arches, to feel the coarseness of the Maine granite, or to read the plaques attached to it. But another experience lies ahead, and one soon descends the few steps back onto the promenade. The diagonals and their knots now swoop down toward the center of the bridge. But at the same time the roadway slopes upward: its bow has become more pronounced, an upward counterpoint to the descending knots. At the very center of the bridge, the main cables and their smaller ropes drop out of sight altogether, somewhere below the railing. The walker has a clear plateau to himself at the highest point of the promenade. He has a view of the harbor on one side, the Navy Yard on the other. He has the New York skyline, the Bay, the Statue of Liberty. Sea gulls wheel and dip into view; one may fly across the bridge and pivot out of sight below.

As the walker continues the upward-downward motion begins again; the cables rise into view and mount the sky, up to the next tower. The walker is once more carried along, up to a balcony, and down, down into the dark opening of a subway concourse.

# I

# SOURCES

Thomas Pope's Rainbow Bridge, 1811

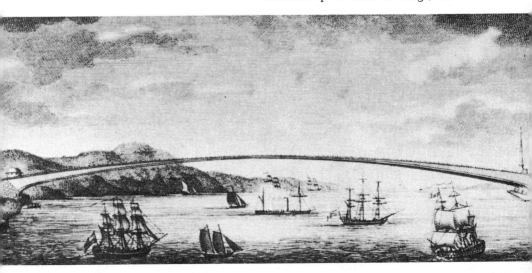

# 1

The whole earth is the lords Garden & he hath given
it to the sonnes of men with a generall Condicion,
Ge: 1.28. Increase & multiply, replenish the earth
& subdue it . . . why then should we stand hear striveing
for places of habitation . . . and in ye mean tyme suffer
a whole Continent, as fruitful & convenient for the use
of man to lie waste without any improvement.

JOHN WINTHROP, "Conclusions for the Plantation in New England" (1629)

The Americans entered the wilderness as masters,
determined to subdue it; and not as children of nature,
nursed and brought up in its bosom. They could not at
first love what was not theirs; and when it became
theirs, they had already changed its face.

FRANCIS GRUND, The Americans (1837)

# Wilderness Transformed

At the Opening Ceremonies of Brooklyn Bridge on May 24, 1883, the Honorable Abram S. Hewitt began his oration with an image of primitive Manhattan.

> Nature wore a hardy countenance, as wild and as untamed as the savage landholders. . . . The trees were lofty; and old, decayed and withered limbs contrasted with the younger growth of branches; and wild flowers wasted their sweetness among the dead leaves and uncut herbage at their roots. The wanton grape vine swung carelessly from the topmost boughs of the oak and the sycamore.

Here was the primal wilderness: the "fresh green breast of the new world" witnessed by Dutch sailors two hundred and seventy years before. Savage, rich, and going to waste — unrestrained nature had sole possession of the island.

The picture was affecting indeed, particularly side by side with "the panoramic view" that now "presents itself to the spectator standing upon the crowning arch of the Bridge":

> In the place of stillness and solitude, the footsteps of these millions of human beings; instead of the smooth waters "unvexed by any keel," highways of commerce ablaze with the flags of all nations; and where once was the green monotony of forested hills, the piled and towering splendors of a vast metropolis, the countless homes of industry, the echoing marts of trade, the gorgeous palaces of luxury, the silent and steadfast spires of worship!

The first scene had been "the product of natural forces working through uncounted periods of time"; "patiently through ages," glaciers had carved a river between the two islands of "Manahatta" and "Seawanhaka" (Long Island). But the hand of man had "reversed" the "work of separation wrought so surely, yet so slowly, by the hand of Time"; the islands were "joined again, as once they were before the dawn of life in the far azoic ages." True, the wilderness was no more: the "green monotony" and "wanton grape vine" had given way before "piled and towered splendours." But was not this itself a fulfillment of man's "never-ending struggle . . . to subdue the forces of nature to his control and use?" The bridge was "not merely a creation," but a "growth": "It stands before us today as the sum and epitome of human knowledge; as the very heir of the ages." [1]

Mr. Hewitt, a prominent Congressman, industrialist, and philanthropist, provided the fitting note for the occasion. Hailed as the Eighth Wonder of the world, the Great East River Bridge was tangible proof of America's achievement. Manhattan and Brooklyn were now major cities. And the country was united: more than a decade ago the railroad had reached the west coast. Now, wrote one observer, "with the completion of this bridge, the continent is entirely spanned, and one may visit, dry and shod and without the use of ferry boats, every city from the Atlantic to the Golden Gate." [2] For many Americans in 1883, Brooklyn Bridge proved the nation to be healed of its wounds of civil war and again on its true course: the peaceful mastery of nature. The bridge seemed to

1. *Opening Ceremonies of the New York and Brooklyn Bridge*, May 24, 1883 (Brooklyn, 1883), 43–7. The description of primitive Manhattan was taken by Hewitt from Martha Joanna Reade Nashe Lamb, *History of the City of New York: Its Origins, Rise and Progress* (New York, 1877–81).
2. Willard Glazier, *Peculiarities of American Cities* (Philadelphia, 1886), 315. Manhattan had been connected to the mainland as early as 1842 by the "High Bridge," an aqueduct to bring the Croton water supply into the city.

embody those forces which had pruned the wild forest and set a city upon a hill.

I

Economic necessity had led to the vast transportation develop-ments in pre–Civil War America. Roads and canals, the paths of commerce, had followed the axe into the wilderness. But the eco-nomic motives of this exciting movement frequently lay obscured beneath a rhetoric of myth. To many, roads fulfilled fervent dreams of the West as a new Garden of Eden, as the long-sought passage to the Orient. "Geographical predestination" was an argument as persuasive as the needs of commerce.[3]

"Providence designed us to be a great and united nation," an orator had proclaimed in 1794, and geography was his proof: "Our lines are marked by the very hand of nature."[4] It became clear, however, that the "hand of nature" created barriers as well as gate-ways to western expansion. The eastern mountain ranges and the many north-south rivers posed serious obstacles to communication. Moreover, the promising landscape raised a political doubt: could the republican principle, hitherto most successful in small nations, survive on so large a scale? Perhaps the very size of the continent would be the nation's undoing.[5]

3. See Henry Nash Smith, *Virgin Land: The West as Myth and Symbol* (Cambridge, 1950), chs. 1–4, for a discussion of the role of the "passage to India" argument in the rhetoric of agrarians; Albert K. Weinberg, *Manifest Destiny* (Baltimore, 1935), ch. 2, for the idea of "geographical predestination"; and George Rogers Taylor, *The Transportation Revolution, 1815–1860* (New York, 1951), for an account of the role of transportation in the rapidly changing economic life of the early republic.
4. John B. Johnson, *An Oration on Union* (New York, 1794); quoted in Merle Curti, *The Roots of American Loyalty* (New York, 1946), 43.
5. This idea stemmed from the political theory of Plato, Aristotle, Rousseau, and Montesquieu. It insisted that a democracy had "natural limits," determined by the distance between the central government and the most remote citizens. The entire body of citizens should be able to convene as often as public functions require. In

Transportation became the country's most urgent need. If geography bestowed a favor upon the young society, it also presented a challenge. In the early republic, the idea of "opening up" the West and binding it to the East became the focus of national unity. The high theme of "manifest destiny" required at first adequate roads. The verb used over and over again to express the idea of unity, "to cement the Union," was more than a figure of speech. Facing a landscape covered with barriers to its own promises, American society had to become technological in order to survive. It had to develop an industrial force in order to exploit the promise of the land.

Many Americans, however, had interpreted the promise of the land to be a great agrarian republic, spreading westward from the tide-lands. Jefferson envisioned such a republic, rooted in the soil, as America's best defense against the corruption of the Old World. Europe represented intrigue, superstition, crowded, fuming cities — evils America might avoid. The virgin land seemed to promise a new chance for man. As a republic of small, independent farms, America might escape the ravages of history. As long as the class of self-sufficient husbandmen predominated, Jefferson argued, the opportunity for liberation would remain. And separated from "the exterminating havoc of one quarter of the globe," the land itself encouraged optimism: "a chosen country, with room enough for our descendants to the hundredth and thousandth generation." [6]

No. XIV of The Federalist Papers, Madison tried to allay the fear that the vast extent of the American continent was an argument against federalism. Madison claimed that "improvements" will shortly eliminate distances. Moreover, he argued, the geography would assist rather than hinder union. "The communication between the western and Atlantic districts, and between different parts of each, will be rendered more and more easy, by those numerous canals with which the beneficence of nature has intersected our country, and which art finds it so little difficult to connect and complete."

6. The Writings of Thomas Jefferson, ed., Paul Leicester Ford, Vol. VIII (New York, 1897), "Inaugural Address, March 4, 1801," 4. Also, A. Whitney Griswold, Farming and Democracy (New York, 1948), "The Jeffersonian Ideal," 18–46.

But to benefit from the land required an efficient system of communications. Thus, the building of roads and canals was to President Jefferson's mind one of the functions of the central government. Anticipating the liquidation of the public debt in 1806, Jefferson announced an ambitious program for the "progress of improvement." This program was to be, Henry Adams has pointed out, Jefferson's last bequest to mankind; it contained the crown of his hopes for republican government in America. The proposal was twofold, a national system of public higher education, and a national system of roads "commensurate with the majesty of the country." The roads would guarantee the Union: "New channels of communication will be opened between the States, the lines of separation will disappear, their interests will be identified, and their union cemented by new and indestructible ties." Jefferson's message of 1806 led to Secretary of the Treasury Albert Gallatin's *Report on Public Roads and Canals* (1808). Gallatin followed Jefferson in arguing that internal improvements should be federally controlled because their benefits were national:

> Good roads and canals will shorten distances; facilitate commercial and personal intercourse; and unite, by a still more intimate community of interests, the most remote quarters of the United States. No other single operation within the power of government can more effectively tend to strengthen and perpetuate that union, which secures external independence, domestic peace, and internal liberty.

The main benefit was unity. In the Jeffersonian plan roads would protect the agrarian republic.[7]

7. Henry Adams, *The Life of Albert Gallatin* (New York, 1879), 349; *The Writings of Thomas Jefferson*, "Sixth Annual Message, December 2, 1806," 494; *Report of the Secretary of the Treasury on the Subject of Public Roads and Canals*, March 2nd, 1807 (Washington, 1816), 73. For the setting of the Gallatin report, see Carter Goodrich, "National Planning of Internal Improvements," *Pol. Sci. Q.*, Vol. LXIII (1948), 22–30, and, "Public Spirit and American Improvement," *Am. Philos. Soc. Proc.*, Vol. XCII (1948), 305–9.

But improvements had ambiguous consequences. The first function of roads was to bring the farmer to market; hence they facilitated the commercial entanglements Jefferson hoped to avoid. In this alone, not to speak of the industrial plant necessary to construct them, roads threatened rather than protected agrarian self-sufficiency.

Alexander Hamilton, Jefferson's rival, recognized that internal improvements spelled the end of agrarianism; and as an advocate of manufacturing, he applauded this development. Roads and canals, he wrote in 1791, "put the remote parts of a country more nearly upon a level with those in the neighborhood of the town." For this reason, they are "the greatest of all improvements." The "cultivation of the remote" would equalize the level of civilization between town and country; it would produce a uniform society, devoted to industry rather than farming, to the town rather than the country. Productivity through the "application of ingenious machinery" to nature, not closeness to nature, would be the cardinal value.[8]

In retrospect Hamilton appears to have been wiser than Jefferson; he stood on the side of historical inevitability. Jefferson had used the image of the "noble husbandman" to affirm the value of an organic way of life; but Hamilton foresaw that economic necessity would defeat this hope. What Jefferson affirmed lay beyond logic: it was a dream of timeless harmony with nature. Such a dream could hardly prevail against the dynamics of an expanding society.

Take, for example, the arguments of agrarians themselves. They supported Gallatin's program with considerable force. In 1810, a congressman from western New York, Peter B. Porter, spoke on the

8. *Industrial and Commercial Correspondence of Alexander Hamilton*, ed. Arthur Harrison Cole (Chicago, 1928), "Report on Manufactures," 247–323. Hamilton argues that the idea that agriculture is "natural" in that "nature cooperates with man," is "both quaint and superficial." Rather, he argues, the husbandman is at the mercy of nature, while the "artificer," with the "application of ingenious machinery," makes nature his "auxiliary."

issue. In that year, he pointed out, more than a million farmers were scattered throughout the remote sections of New York, Pennsylvania, and Virginia. They were out of touch with the seaboard markets. Such isolation naturally caused hardships:

> There is no place where the great staple articles for the use of civilized life can be produced in greater abundance with greater ease, and yet as respects most of the luxuries and many of the conveniences of life the people are poor.

The people are poor in luxuries and conveniences because "they have no vent for their produce at home." The lack of a market mocks the great fertility of the land.

> Such is the fertility of their land that one-half of their time spent in labor is sufficient to produce every article which their farms are capable of yielding, in sufficient quantities for their own consumption, and there is nothing to incite them to produce more.[9]

These farmers, it is clear, wanted no part of self-sufficiency; they apparently preferred agrarian business to agrarian independence. They judged the value of the land by how quickly they could convert its products into cash.[10]

And roads were to lead away from the land more often than to it. An effective argument for persuading farmers to support local improvement projects was that construction would inflate the cash value of nearby lands. Land values rather than the land itself seemed to keep Americans on the go in this pre–Civil War period. A new land bubble further west might make one's fortune. Roads were a good investment; they offered a double opportunity, a fast killing and a fast get-away. Not the old homestead but modern capitalism lay at the end of the line.

9. Quoted in Goodrich, "National Planning . . . ," 24.
10. For the farmer's greater attachment to land values than to the land itself — for the failure, in short, of a true peasant class to emerge in America — see Richard Hofstadter, *The Age of Reform* (New York, 1960), "The Agrarian Myth and Commercial Realities," 23–60.

## II

It is well known that American society followed Hamilton's course toward manufacturing and capitalism. But Jefferson's dream did not die; in fact, the rapid movement toward cities and bigness contributed as much as any intrinsic force in the dream itself to keep it alive. As Leo Marx has so forcefully shown, the pastoral ideal persisted as a reaction — unconscious as well as calculated — to what Carlyle in 1831 called "industrialism." [11] In particular, while industrialism was transforming America into a land of cities and railroads, some Americans continued to celebrate the road in the language of the Jeffersonian utopia.

The utopian vision of the road has its fullest, most affecting expression in Walt Whitman's "Song of the Open Road" (1856). Translating "the long brown path before me" — an obviously rural image — into an idea of light-hearted freedom, the poet invites his readers to take his hand. "Allons," he cries: "the road is before us!" An adventure in freewheeling democracy, the fluid pathway leads to the earth, "expanding right hand and left hand," to the "open air," where all "heroic deeds" are conceived, and to an "interchange" with strangers. "I think I could stop here myself and do miracles," Whitman writes. The road expresses his — and his culture's — yearnings for individual power and self-possession:

> From this hour I ordain myself loos'd of limits and imaginary lines,
> Going where I list, my own master total and absolute,
> Listening to others, considering well what they say,
> Pausing, searching, receiving, contemplating,
> Gently, but with undeniable will, divesting myself of the holds that
>     would hold me.

Whitman infuses the poem with credibility: ". . . it is safe — I have tried it — my own feet have tried it well — be not detain'd."

11. *The Machine in the Garden* (New York, 1964), esp. "Two Kingdoms of Force," 227–354.

*Jefferson    road to utopia*
*Hamilton  vs road to city-center industrialization*

It is likely that the tone derives in part from the real road-building accomplishments of American society. The mastery of space and time implicit in the poem seemed to have an analogue in daily triumphs over nature, triumphs which ironically resulted in mechanizing American life: brown pathways more and more gave way to shining steel rails. Nonetheless, the theme of "wilderness transformed" still aroused emotions of rapture and hopes of liberation from history. "A new dispensation" still seemed the destiny of Americans.[12]

Whitman's road changed accordingly to accommodate the old vision to the new technology. In "Passage to India" (1868), a poem less light-hearted but more utopian, the road is frankly technological. And its dimensions are now cosmic. The drama is no longer personal and individualistic, no longer full of the gaiety of a country jaunt. Now all of history is somberly implicated. To enlarge his conception, Whitman exploited what Henry Nash Smith has called "the oldest of all ideas associated with America — that of a passage to India." This idea had obsessed the imagination of Jefferson's followers, most notably the Missourian statesman, Thomas Hart Benton. In the 1840's, discussion of a transcontinental railroad had revived the old dream of Columbus; Benton, a leading proponent of the railroad and western expansion, cited the riches of Asian trade as his chief argument. But the argument was not exclusively — or mainly — commercial; it was a quasi-religious

12. See Charles L. Sanford, *The Quest for Paradise: Europe and the American Moral Imagination* (Urbana, 1961), esp. "The American Cult of Newness: A Rebirth Out of Hell," 94–114. Mr. Sanford explores the provocative hypothesis that "the Edenic Myth . . . has been the most powerful and comprehensive organizing force in American culture" (vi). The term "new dispensation," was used by Edward H. Knight in "Mechanical Progress," *The First Century of the Republic* (New York, 1876) — a collection of essays. The first century of American history, he wrote, "was no common century"; "it may be said to have leaped into existence." And machinery was the cause of newness: "It was as if by a mysterious impulse all started at once, the utilization of buried stores of coal by means of the Watt engine being the great fact of the new dispensation."

vision of national destiny and fulfillment. Cathay and its riches, Benton wrote, would free America from Europe and place her "at the highest pinnacle of wealth and power." The passage to India thus became, Mr. Smith comments, "a symbol of freedom and of national greatness." [13]

*roadas*

Whitman's poem, "Passage to India," projects a theory of history which joins the theme of an Asian route to the technological thrusts of the new nation. In this theory, the engineers who had built the Pacific Railroad, the Atlantic Cable, and the Suez Canal, had thereby linked the separate parts of the world. They had completed Columbus's voyage. Columbus himself was but the "chief histrion" in the main drama of history — a drama until now "inscrutable." But now the hidden purpose was clear:

> Lo, soul, seest thou not God's purpose from the first?
> The earth to be spann'd, connected by network . . .
> The lands to be welded together.

Thus the "strong light works of engineers" fulfilled the strivings of the past.[14]

The spatial connections, however, were not ends in themselves. They introduced a new phase of history, and inaugurated "a worship new." They opened the way, in short, for the poet.

Whitman placed all his hopes upon the prophetic role of poetry; only the poet could perceive and proclaim the true import of modern technology. All of history thus far had amounted to suffering and alienation: "What is this separate Nature so unnatural?" History was the career of man's frustrated quest for a restored wholeness. The geographical gaps were now closed, but the quest would not be fulfilled until a poet-messiah, "the true son of God," appeared. Then: "All these separations and gaps shall be taken up and hook'd and link'd together. . . . Nature and Man shall be disjoin'd and diffused no more." "India" was more than a place;

13. *Virgin Land*, chap. 2, *passim*.
14. *Leaves of Grass and Selected Prose*, ed., Sculley Bradley (New York, 1951), 339–47.

it was a form of consciousness, a synonym for Edenic harmony. In the drama of restoration America would play a central role. Columbus's discovery was the first act:

> thou born America
> For purpose vast, man's long probation fill'd,
> Thou rondure of the world at last accomplish'd.

America is the appropriate emblem for the new worship, the new brotherhood, the new Eden. On its shores East and West shall meet in peace, the cultures of the world shall mingle freely, and man shall regain his ancient harmony with nature.

The most striking feature of Whitman's poem is its circular definition of progress. Progress is a "return" to the past. By linking the modern West with the traditional East, the engineers have brought forward "the dark unfathom'd retrospect." Roads return to nature, to "reason's early paradise" and "innocent intuitions." They lead away from history. This view of progress is striking if only because in the American world outside the poem, roads traveled in the opposite direction — not toward nature, but toward the city. More than any other factor before the Civil War, transportation represented change; it struck down geographical barriers and tied all regions to their major market cities. Roads brought commerce and capitalism, factories and warehouses. They brought history to the New World.

### III

What Whitman failed to consider was that the engineer could not open a path to nature without first taking an attitude toward the land and toward society that would very likely postpone appreciably the metaphysical passage to India. Elsewhere, especially in *Democratic Vistas* (1871), Whitman expressed reservations about the course of development of American society, but in "Passage to India," he seemed not to concede that a basic conflict between two ways of life was at stake in the massive transformation of nature.

The poet was not alone in his confidence. Ralph Waldo Emerson, for example, in a lecture "The Young American" (1844), saw internal improvements as "beneficent for America"; they eliminate "local peculiarities and hostilities," and reveal a "sublime and friendly Destiny." Most of all, he found, the railroad carries city people into the country and introduces them to the land. The railroad might even plant a garden in the West; he calls it a "magician's rod, in its power to evoke the sleeping energies of land and water." Emerson, like most of his contemporaries, expected the machine to serve what was still basically an agrarian society.[15]

Thomas Ewbank had no such illusions. At one time a manufacturer, Ewbank was Commissioner of Patents in the 1840's. In his Report of 1849 he spread before Congress the prospect of "an infinity of work" for Americans. Man's original sin, he wrote, was indolence, not disobedience. But shirk it as he will, man's work will not be finished until "the planet is wholly changed from its natural wilderness . . . into a fit theatre for cultivated intelligences." Until then, all other activities were pointless; technology provided all the poetry and morality man needed. A steamer, he wrote, was a mightier epic than the *Iliad*, and "a lever, hammer, pulley, wedge, and screw, are actual representations of great natural truth." Ewbank foresaw endless progress through machinery. Engineers and inventors held "the future destinies of the planet in their hands." [16]

Ewbank's ideas were an outgrowth of eighteenth-century empiricism and deism. He saw the world as an immense mechanism. In *The World a Workshop* (1855), Ewbank claimed that the inventor is the true man; to be human is to be a "Manipulator of Matter." In regard to agrarianism, Ewbank echoed Hamilton: "the

15. *The Complete Works of Ralph Waldo Emerson,* Centenary Edition (Boston, 1904), Vol. I, 361–95.
16. 31st Cong., 1 Sess., "Report of the Commissioner of Patents," Part I, *House of Representatives, Executive Documents,* no. 20 (Washington, 1849), 486.

hypothesis that the chief employment of man was to till the soil and raise cattle, is an unworthy one." Food, he argued, is a mere adjunct to life; agrarians are "surface dreamers." He did not want a reconciliation between agarianism and industrialism, but a total surrender to the machine. This, he saw, would establish a new way of life, a way of rapid transportation, cities, and capitalism. The following passage admirably describes the conflict.

For what classes then chiefly was the world of inorganic matter provided? Observe that dwelling; it belongs to a family neither rich nor poor; neat, commodious, and attractive in itself; it has a garden in front, an orchard and corn-field behind. Mark the social enjoyments, intelligence, and contentment of its inmates; the abundance of necessaries, of comforts and conveniences; the ornaments and elegances in dress and furniture, with contributions from almost every productive and decorative art.

But, hark! a train of cars is approaching. It stops one moment and starts the next with a shriek for the city, whirling us along level and undulating lands, through tunnelled mountains, over rivers on bridges of granite, and others of iron. In the quick-moving panorama arise before us, and in a moment pass by, brick and lime kilns; potteries; tanneries; machine shops, chair, cloth, and carpet factories. We come in sight of a bay, on which ships laden with foreign merchandise are floating in with the tide, and others with home manufactures passing out. Crossing over in a steamer we find an extensive border of leafless forest resolved into masts of vessels crowded into continuous docks, and on landing, feel the air rent and agitated, like rippled water, with the noise of stevedores and draymen. We have business to transact for a friend, and pick our way along the sidewalks, among packing cases of dry-goods, casks of hardware, bundles of sheet and hoop iron, and loads of other goods. Next we stop at a telegraph office, and in five minutes our friend, though five hundred miles distant, receives and answers our note. On leaving the street of the merchants for others occupied by watchmakers, jewellers, opticians, philosophical

and musical instrument makers, engravers and printers, we call at a newspaper office to insert an advertisement and order the daily sheet for a neighbor. Need we proceed? It was for men who bring such things out of inert matter that this world of matter was made.[17]

Ewbank describes the rural life quite fairly, even fetchingly. Peaceful and self-sufficient, it is an orderly relation to nature. But the moment the train invades the scene, we are meant to realize that the rural life is based on the wrong mode of nature, that which is fertile, growing, but subject to decay. The civilization represented by the railroad and the city is based on inorganic matter, the true riches of nature. This civilization, Ewbank was sure, Americans would recognize as their own; the other was an ancient dream.

The dream of a tenderly cultivated plot has consistently appealed to Americans, perhaps never more so than now, in an age of automation. But strong as that appeal has been, American behavior toward the land has been something else again. Americans have always subscribed to Eden, and proceeded to transform it in the name of progress. This was true even before modern mechanical devices. It was true from the very beginning, when the sight of untamed wilderness going to waste converted transplanted Europeans

17. *The World a Workshop* (New York, 1855), 22–3. This passage expresses an interesting variant of what Leo Marx has discovered to be a basic episode in American literature — the intrusion of a machine (usually a railroad) upon a pastoral setting. In literature, the event usually causes dislocation, generates a conflict — and leads to a reaffirmation of the pastoral ideal as a reconciliation. In this passage, however, the invasion of the railroad upon a scene described in conventional pastoral terms (the modest dwelling, the corn-field, the abundance, the homely arts — in other words, the garden) is meant to leave us reeling with pity for the inadequacy of the ideal. Rather than a conflict, this invasion results in total victory for the railroad — and the emotion of power, fulfillment, and mastery. It is clear, moreover, that Ewbank sees the railroad not only as an agent of "industrialism," but a servant of capitalism: the pastoral scene is not shown as wrong or bad in itself, but simply swept under by a new social order. For this reason, it can be said to possess a power of its own in Ewbank's language — as a dream. *Machine in the Garden*, 15–16.

into Americans. Francis Grund, an Austrian traveler, observed in 1837 that Americans had always

> treated nature as a conquered subject: not as a mother who gave them birth. They were the children of another world, who came to burn, ransack and destroy, and not to preserve what they had found. They burned the forests, dug up the bowels of the earth, diverted rivers from their course, or united them at their pleasure; and annihilated the distances which separated the North from the South, and the East from the West.[18]

Americans were such excellent transformers of nature, Grund wrote, that no single change seemed permanent; they "live in the future, and *make* their country as they go on." To many Americans, the going itself was the main business of man on a wild continent beyond the reach of history. Jefferson's hopes for local attachments to the soil were defeated by the very means necessary to open the continent, the means of transportation. Not the land, not the garden, but the road, from Jefferson's own national turnpike to the latest superhighway, has expressed the essential way of American life.[19]

18. Francis Grund, *The Americans* (Boston, 1837), 317.
19. I mean, of course, not only the literal road — but all that is implied by it: cities, automobiles and the power of the automobile industry, construction companies — and boondoggles. In other words, an entire social order which values "quick turnover" above planning and harmony. For vivid illustrations of the consequences of the transvaluation of Jefferson's ideal, see Peter Blake, *God's Own Junkyard: The Planned Deterioration of America's Landscape* (New York, 1964).

# 2

Then asked Ganglere: *What is the path from earth to heaven?* Har
answered, laughing: *Foolishly do you now ask. Have you
not been told that the gods made a bridge from earth
to heaven, which is called Bifrost? You must have seen it.
It may be that you call it the rainbow. It has three colors, is very
strong, and is made with more craft and skill than other structures.
Still, however strong it is, it will break when the sons of Muspel
come to ride over it, and then they will have to swim their
horses over great rivers in order to get on.* Then said Ganglere:
*The gods did not, it seems to me, build that bridge
honestly, if it shall be able to break to pieces, since they
could have done so, had they desired.* Then made answer
Har: *The gods are worthy of no blame for the structure. Bifrost is
indeed a good bridge, but there is no thing in the world that
is able to stand when the sons of Muspel come to the fight.*

*The Younger Edda,* v:13

# The Rainbow and the Grid

In a scrap-book referred to as "the first written history of Brooklyn," Jeremiah Johnson entered in 1800 the following note:

> It has been suggested that a bridge should be constructed from this village across the East River to New York. This idea has been treated as chimerical, from the magnitude of the design; but whosoever takes it into their serious consideration, will find more weight in the practicability of the scheme than at first view is imagined.

The weight of the scheme lay in the fact that the bridge "would be the means of raising the value of the lands on the east side of the river." Johnson, then a supervisor of the town but later to become, as a general in the War of 1812 and a mayor, "Brooklyn's first and foremost citizen," seemed to approve of the idea. "Every objection to the building of the bridge could be refuted," he observed, and only "a combination of opinion to favor the attempt" was wanting. Plans were already "laid down on paper" by a "gentleman of acknowledged abilities and good sense." The gentleman would "engage to erect it in two years' time." [1]

1. Henry R. Stiles, A History of the City of Brooklyn, 3 vols. (Brooklyn, 1867), Vol. 1, 383–4. Also, Harold Coffin Syrett, The City of Brooklyn, 1865–1898, Columbia University Studies in History, Economics and Public Law, No. 512 (New York, 1944), 146. Although a major general, Johnson never actually commanded a division. Born in 1766, he became a wealthy farmer and landholder; from 1837 to 1840 he served as mayor of Brooklyn. He died in 1852.

This note, scribbled among newspaper clippings and miscellaneous data in an old scrap-book, contains the germ of all future talk about Brooklyn Bridge. It would be a plan of great "magnitude"; it would require a devoted builder and a sympathetic public. And a chief argument on its behalf would be the increase in real estate values on Long Island. At the outset of its career as an idea, in other words, the bridge was already thought of as a practical fusion of two sets of values: the visionary ("chimerical") and the pecuniary.

## I

It is possible that General Johnson's gentleman was the same man who proposed in 1811 to raise a "rainbow bridge" across the East River. He was Thomas Pope, a craftsman then living in New York. Described by his friend, the architect Benjamin Latrobe, as a "perfect master of the practice of building and surveying," Pope had devised a method of constructing a cantilever arch out of wooden parts. He explained his method, and proposed to demonstrate it across either the Hudson or the East River, in A *Treatise on Bridge Architecture* — the first study of its kind to appear in America.[2]

Like the more famous Pope, the American builder declaimed frequently in rhyme. His epigraph blazed on the title page:

> Exulting Science now disdains
> The ties of custom's proud controul,
> And breaks the rude and barbarous chains
> That fetter'd down the free-born soul.

And like Jefferson, Pope gave "the ancients" their due, but respected "experience" most of all. In a study of the past, he pointed out in his Preface, we discover "those fundamental rules which

2. Very little is known of Thomas Pope beyond the few comments made by Latrobe. See Talbot Hamlin, *Benjamin Henry Latrobe* (New York, 1955), 419. The full title of Pope's book was, in proper eighteenth-century style: A *Treatise on Bridge Architecture, in which the Superior Advantages of the Flying Pendant Lever Bridge are Fully Proved* (New York, A. Niven, 1811). All page references are to this edition.

have, in later times, governed the improvement of every age." But
the past cannot answer the questions of the present. There is no
true standard except "experience." The practical men, the crafts-
men, are the genuine scientists; the academicians are "unskilled
pretenders."

There is nothing distinctly American about Pope's ideas. They
were prevalent throughout western Europe in the last half of the
eighteenth century. The work of engineers like Perronet in France,
and Rennie and Telford in England, had demonstrated that the
age of steam required a new marriage between theory and practice.
But in advocating that such a marriage take place in America, Pope
argued for America's unique historical and geographical advantages.

Like Horatio Greenough in the next generation, Pope con-
demned the Georgian style of public architecture on behalf of sim-
pler vernacular forms. About façades he writes, "we have the pain-
ful mortification to witness the whole of an extended front, though
built with marble, crowded with glaring absurdities from one end
to the other." This situation ill bespeaks "the wisdom, grandeur
and correct taste of a great nation." (p. xxi) Pope blamed the
academic imitators, the "gentlemen of the gown," those flimsy
pretenders to Science, and enemies to the useful Arts, who now
strut about like so many crows dressed in a few borrowed plumes,
which only serve to make their deformity more conspicuous." (p.
xxii) His solution was "a combination formed of ingenious me-
chanics and learned mathematicians." The list of subscribers to his
*Treatise* consists largely of craftsmen: masons, carpenters, stone
cutters, shipwrights, and merchants. Professional and educated
classes are also represented by Governor Daniel D. Tomkins, Lieu-
tenant Governor Dewitt Clinton, James Renwick, Robert R.
Livingston, the president of the New York American Academy of
Arts, and several faculty members of Columbia College.[3]

3. Horatio Greenough, *Form and Function*, ed. Harold A. Small (Berkeley, 1958),
64–5. For the impact of engineering upon the theory of design, see Nikolaus Pevsner,
*Pioneers of Modern Design: From William Morris to Walter Gropius* (Penguin

Pope's main concern, however, was bridges. The study consists of four parts; a historical account of the development of bridges, a description of Pope's own patented invention, a cantilever "Flying Pendant Lever Bridge," an appraisal of the structural uses of native timber, stone, brick, and iron, and an extraordinary conclusion, a verse essay of 105 heroic couplets proposing a model bridge at New York. On the eve of the nation's first period of modern technological change, Pope enlists history and invention, science and poetry in America's campaign to master the continent.

Pope's historical account of "sundry bridges," still a major source of information, serves in the *Treatise* as a prologue to the yet unwritten chapter on American bridges. In the New World, geography had prepared a new phase in bridge building:

> It is a notorious fact that there is no country in the world which is more in need of good and permanent Bridges than the United States of America. Extended along an immense line of coast on which abound rivers, creeks, and swamps, it is impossible that any physical union of the country can really take place until the labours of the architect and mechanic shall have perfectly done away with the inconvenience arising from the intervention of the waters.

If nature created the problem, it also provided for the solution: "Our forests teem with the choicest timber; and our floods can bear it on their capacious bosoms to the requisite points." In short, "Public spirit alone is wanting to make us the greatest nation on earth; and there is nothing more essential to the establishment of that greatness than the building of bridges, the digging of canals, and the making of sound turnpike roads." (p. 127)

From this argument Pope proceeds directly to a "mathematical description" of his invention, a prefabricated timber bridge which can be mass-produced and assembled on the building site. Using

Books, 1960), rev. ed., 118–48, and, Walter Curt Behrendt, *Modern Building: Its Nature, Problems and Forms* (New York, 1937), 71–6.

the method of his masters, Archimedes, Galileo, and Newton, Pope demonstrates through axioms and deductions the practicality of his vision. Furthermore, the mathematical nature of the plan, together with the reliance upon native timber, meant that the Flying Pendant Lever Bridge was universally applicable in America: potentially, it was a national form.

The bridge itself was a very flat arch, consisting of twin cantilevers joined at the center, and stiffened with diagonal bracing. The two cantilever arms were made of longitudinal ribs formed into a solid sheathed girder. Pope claimed that such a structure could reach 3000 feet across the Hudson River; if the principles were mathematically sound, he felt, only the strength of the material would limit the size of the span. But, as a start, Pope told of a 94-foot model of a Flying Pendant Lever Bridge, or, as it came to be known, the "rainbow bridge," which he had exhibited in New York as a proposed East River Bridge. He included testimony by a group of New York shipwrights about the soundness of the plans. The "rainbow bridge" was to soar 1800 feet from shore to shore, 223 feet above high water — dimensions which exceed John Roebling's East River Bridge.

It is significant that Pope did not design his bridge to fit any specific place; it was an invention in the broadest sense, a contrivance to be used wherever a bridge was needed. In this sense it can be spoken of as a "pure" bridge, making its national significance all the more forceful. Pope's invention represented the "free-born soul" which "breaks the rude and barbarous chains" of academic tradition; it represented America itself.

In the long poem which serves as his conclusion, Pope writes:

> Let the broad arc the spacious HUDSON stride,
> And span COLUMBIA's rivers far more wide;
> Convince the world AMERICA begins
> To foster arts, the ancient work of kings.

The poem is a plea for the chance to build one model bridge (in this case, over the Hudson River, which has the double virtue of being wider than the East River, and of fitting the metrical pattern of the line). The very boldness of the plan was, Pope thought, its most attractive feature:

> Stupendous plan! which none before e'er found,
> That half an arc should stand upon the ground . . .
> Like half a rainbow rising on the shore,
> While its twin partner spans the semi o'er,
> And makes a perfect whole, that need not part,
> Till time has furnished us a nobler art.

About half of the poem describes the technical aspects of the bridge, the "simple rules" upon which this self-evident structure is based. The rest of the poem is taken up with a dialogue between the author and a skeptic, who wonders "how to reconcile those novel truths/With what the *Doctors* teach their college youths." The poet argues for experiment and freedom against those "fools" who teach "That nothing strange or new can e'er be brought,/But what in ancient times were known or wrought." Pope casts himself and his bridge — a "perfect whole" — as defenders of truth and science against ignorance and superstition.

Thomas Pope was not given the opportunity to build his bridge; three years later he was in Pittsburgh, without work. Latrobe tried his best to procure a position for the unemployed architect, who "has with a large & expensive family shared the fate of others in our seaport towns and is now out of business." But his effort failed: "I feel most exceedingly sorry for Pope. . . . He is besides crazy about his patent lever bridge." In any case, his bridge would not have arched either the Hudson or the East river; wood is too light a material to support a single span of such measurements. But the span was more than anything else a vision. Pope seemed obsessed, in fact, with the visual form rather than the function of his bridge;

he failed to describe a roadway, or the kind of traffic it might carry. Illustrated in the *Treatise*, the "rainbow bridge" is a flat, graceful arch, flanked on the New York side with two spires. The slender, tapered arms of the arch foreshadow the stark lines of Robert Maillart's reinforced concrete arches in Switzerland. For Pope, the rainbow arch was an ideal for America. To "cultivate its growth" would bespeak nobility of heart and mind. Poor as he was, Thomas Pope remained convinced that to raise his bridge would be a tribute to science, to art, and to America for fostering both.

## II

A more accurate sign of what was being fostered is the report in 1811 of a New York commission appointed four years earlier to propose "Improvements touching the layout of streets and roads in the City of New York." This report established the gridiron street plan for Manhattan, a plan which, according to one historian, "marks the division between old and modern New York." [4] If Pope's vision belonged to the eighteenth century, the commissioners' report, whose sole concern was efficiency and exploitation of the land, belonged to the nineteenth. They make a nice contrast in values.

The gridiron plan of 1811 has been blamed for many of the unpleasant features of modern Manhattan: the narrow east-west streets, the congestion, the unimproved condition of riverside areas. The grid became a vise. Strictly speaking, it was not a city plan at all; compared to L'Enfant's plan for Washington, it was simply a street map. One modern study has called it a drainage system. [5]

Compared to Pope's "rainbow bridge," the gridiron was totally

4. I. N. Phelps Stokes, *The Iconography of Manhattan Island, 1498–1909* (New York, 1918), III, 478.
5. Thomas Adams, Harold M. Lewis, Lawrence M. Orton, *The Building of the City: Regional Plan of New York and Its Environs*, II (New York, 1931), 51.

devoid of art or beauty; it was a strict application of plane geometry. Its only intention was to lay out streets and divide the land into salable packages. The commissioners were unmoved by thoughts of national grandeur. Explaining their choice of the grid-iron pattern, they wrote that they had considered "whether they should confine themselves to rectilinear and rectangular streets, or whether they should adopt some of those supposed improvements, by circles, ovals and stars, which certainly embellish a plan, whatever may be their effects as to convenience and utility." Embellishment was so far from their purpose that they used the term with disdain.

The commissioners did not hide their assumptions: utility meant nothing more or less than a straight line between any two points. Speaking of themselves in the third person, they wrote:

> In considering that subject, they could not but bear in mind that a city is to be composed of the habitations of men, and that strait sided and right angled houses are the most cheap to build, and the most convenient to live in. The effect of these plain and simple reflections was decisive.[6]

Moreover, economy was a matter of the *cash* value of land, rather than any other salutary values — the *disposal* rather than the use of land.

> Those large arms of the sea which embrace Manhattan Island, render its situation, in regard to health and pleasure, as well as to convenience of commerce, peculiarly felicitous; when therefore, from the same causes, the price of land is so uncommonly great, it seemed proper to admit the principles of economy to greater influence, than might under circumstances of a different kind, have consisted with the dictates of prudence and the sense of duty.

The same geography which moved Thomas Pope to dream of a

6. Quoted in Christopher Tunnard and Henry Hope Reed, *American Skyline* (New York, 1956), 57.

rainbow, here is an excuse to surrender "prudence" and a "sense of duty."

The peculiar style of the 1811 plan is, then, its unrelenting adherence to the single motive of exploitation. In this it was unambiguous; the landscape *had to be* subdued, not for the sake of achieving a harmonious life between man and nature, but for the sake of quick sale of private building lots. A modern city was to be imposed upon the island; nature was granted no part in determining how that city should grow and organize itself. As an exasperated critic of the plan wrote in a pamphlet in 1818, the gridiron ignored the changing levels of land, which was expected to surrender its character to the platte. The city seems, this irate citizen wrote:

> resolved to spare nothing that bears the semblance of a rising ground. . . . These are men, as has been well observed, who would have cut down the seven hills of Rome, on which are erected her triumphant monuments of beauty and magnificence and have thrown them into the Tyber or the Pomptine marshes.[7]

The land was a hindrance in the minds of the commissioners; it had to be transformed into geometry.

How did the gridiron serve the city? At first it was a means of earning public revenue. Late in the seventeenth century, the city corporation had been the leading land-owner on Manhattan Island. The land tax was the corporation's major source of revenue. The easiest way to raise large sums of money for public projects such as swamp reclamation, was either to lease or sell packages of the land. In the eighteenth century, the city used both methods; long-term leases were issued with the expectation that improvements upon the land would increase values and thus rents and taxes. The city continued this practice throughout the eighteenth century. At the beginning of the nineteenth century, there were improved lots

7. Quoted in Stokes, III, 478.

scattered across the island, most of which was still wilderness. "New streets were needed," writes one historian, "to serve the land already sold and to open up the common land still in city ownership." [8] In 1807, the legislature authorized a commission to design an efficient method to expedite the further sale of land for revenue, as well as to encourage private building that would raise tax values.

The grid of 1811 was a major step toward the transfer of ownership of the island from public to private hands. After 1811, municipal ownership and the leasehold system slowly disappeared in favor of outright sale; the real-estate speculator, like John Jacob Astor in the 1820's, assumed control of the city's land. In 1844, to settle an enormous public debt, the city finally auctioned off what remained of its original heritage of common land.

Thus the city surrendered control over its own destiny. As the *Regional Plan* of 1931 put it, the division of the land into salable packages made individual profit rather than "architectural control in the interests of the community" the decisive factor in the city's growth and appearance. [9] The residential square, development of waterfront lands, and the planning of civic centers were the most obvious casualties.

Another consequence of the 1811 plan affected the architecture of the city. Buildings necessarily were shaped by the limited space of individual lots. Narrow spaces, together with the danger of costly fires in crowded sections, made the rural New England methods of wood frame construction risky, and led to the more appropriate iron-frame structures of James Bogardus in the 1830's. These in turn led to the steel-skeleton skyscraper. This line of architectural development, based primarily on the internal structure of single narrow buildings rather than the treatment of spaces wider than the individual lot, became America's unique contribution to modern architecture. One interesting result of the emphasis

8. Cleveland Rodgers, *New York Plans for the Future* (New York, 1943), 34–53.
9. Adams, *et al.*, 50.

upon a uniform internal structure is that monumentalism in building was restricted to façades rather than the arrangement of buildings in relation to each other. The gridiron eliminated the chance to create a zone of buildings in relation to nature; instead, Frederick Law Olmsted's Central Park is set aside from the essential life of the city, in its own rectangular space, and Bogardus's iron front developed into a standard pseudo-Renaissance form that lined the crowded streets of lower Manhattan.[10]

The 1811 plan determined the character of Manhattan. It prepared the way for real-estate speculation: every street was a potential investment, a potential business street. And every street might become, by the same utilitarian logic, a highway. "The city," writes Lewis Mumford, "from the beginning of the ninteenth century on, was treated not as a public institution, but a private commercial venture to be carved up in any fashion that might increase the turnover and further the rise in land values." This was the attitude toward the land and the city fostered by the grid.[11]

III

In their mood of expansion Americans rarely paused to consider that the rainbow and the grid denoted alternative ways of creating the future. Thomas Pope's was a lofty vision based on native materials and vernacular crafts: it implied an organic culture ruled by nature and experience. The grid implied mechanization of the land — a culture devoted to accumulation, profit, and narrow utilitarianism. Needless to say each image implied a set of emotions: one was aesthetic, the other acquisitive. There would seem to be no common ground between them.

But in the inflationary feelings of pre–Civil War America,

10. See Carl Condit, *American Building Art: The Nineteenth Century* (New York, 1960), 30–50.
11. Lewis Mumford, *The City in History* (New York, 1961), 426.

economic growth did seem to have a visionary aspect. Miracles were wrought overnight, and left their trace in statistics. In the 1820's New York merchants had won control of both inland and overseas trade — a control consolidated by the opening of the Erie Canal in 1825. Thereafter, population, capital, and real-estate values climbed enormously. The population of Manhattan grew from 95,000 in 1810 to 205,000 in 1830. A conservative prediction at that time was one million by 1900; by 1860 it had already reached over 800,000. In 1825, 500 new businesses opened, and 3000 new buildings went up. Twelve banks had a combined capital of 13 million dollars, and ten insurance companies together held 10 million. By 1860, 57 banks had attained control of over 67 million dollars. Real estate was valued at about 400 million dollars; personal property was worth close to 180 million dollars. The prospects of wealth and population for the fish-shaped island seemed unlimited. And this unmistakably meant progress.[12]

Transportation became a crucial matter to the daily life of the city, particularly since the municipal government, hampered by its subordination to the state government at Albany, was unable to mobilize public resources to meet the needs. Transportation was left in the hands of private developers, and the result was confusion. The first street railroad appeared in 1831, New Yorkers already demanding "rapid" transit; by 1860 there were twenty competing lines, each operating its own self-determined route. Not until the 1890's did the city itself enter the tangled field of public transportation.[13]

12. See Robert Greenhalgh Albion, "New York Port and Its Disappointed Rivals, 1815–1860," *Journal of Economic and Business History*, Vol. III (1930–31), 602–29. Albion observes that the success of New York commerce was based on four factors: 1) an attractive auction system for disposing of imports; 2) a regular transatlantic packet; 3) the development of trade along the coast, especially with southern cotton interests, and 4) the Erie Canal. See also Blake McKelvey, *The Urbanization of America, 1860–1915* (New Brunswick, 1963), 4–35.
13. Rodgers, 47. Also, Arthur Meier Schlesinger, *The Rise of the City, 1878–1898* (New York, 1933), 78–121.

One of the most trying transportation problems concerned the masses of people — something like one-tenth of the population of Brooklyn — who crossed the East River twice daily. The experience of Walt Whitman in the 1840's and the 1850's, of living in Brooklyn and working in Manhattan, was common. The passage was, of course, by ferry.

Brooklyn in this period was called Manhattan's dormitory. But actually, it was a large city in its own right. Its growth had been even more rapid than New York's. In 1810, as a village on Long Island, Brooklyn had about 3000 people; at the end of the century, just before its consolidation with the other boroughs to form Greater New York, it had a million — the third largest city in the country. Much of its growth came from its absorption of twenty-five other suburban villages during the century, but commerce and industry were also factors. Chartered as a city in 1834, it rose to third in the nation in manufacturing by 1880, fourth in total capital invested in industry, fourth in total value of manufactured products, and second in wages. In 1880 it had over 5000 factories; twenty years earlier, it had had less than 500.[14]

In spite of its industrial and commercial growth a vigorous village pride persisted in Brooklyn throughout the century. Early in its years of growth the spirit of localism was defensive; members of the older generation set their teeth to resist the encroaching metropolitanism represented by Manhattan. New York and Brooklyn have nothing in common, neither in "object, interest, or feeling," argued General Jeremiah Johnson in 1833. Four years before his election as mayor of the city, Johnson spoke of Brooklyn as though it were a distinct region, set apart from the commercial center across the river. Geography would, he felt, preserve the uniqueness of the region. The waters that flow between the two cities "form a barrier between them which, however frequently passed, still form and must forever continue to form an unsurmountable obstacle to

14. Syrett, 140.

their union." This was surely an anachronistic point of view in 1833, at the height of the period when nature's obstacles seemed invitations to surmount them, and when the continent's waterways seemed to guarantee national unity rather than the preservation of regional peculiarities.

General Johnson's localism soon gave way to civic boosting; the charms of Brooklyn were put on the market, so to speak, in competition with the lures of Manhattan. Brooklyn businessmen wanted closer ties with the market of Manhattan; they wanted more New Yorkers to cross the river, to live on Long Island and buy their goods there. Most of all, they anticipated the rise in property values which would accompany such a move. The growth and prosperity represented by the grid was a more attractive vision than General Johnson's provincialism. And eventually the commercial classes of Brooklyn would demand a bridge, as Johnson himself foresaw in 1800, to realize that vision.

But were there no second thoughts about Brooklyn's rise to modern urbanism? One apparently optimistic citizen was Walt Whitman. The poet had divided his youth between city and country, and his poems between 1855 and 1860 show in their images an intimacy with both ways of life. In *Specimen Days* (1882), Whitman cites as one of the "leading sources" of his character the "combination of my Long Island birth-spot, sea-shores, childhood scenes, absorptions, with teeming Brooklyn and New York." There is no apparent conflict in Whitman's poetry between the two ways of life, between Long Island and the cities, except, perhaps, for the poem, "Give Me the Splendid Silent Sun" (1865). There, the poet rejected the peace of the country for the excitement of the city. But in "Crossing Brooklyn Ferry" (1856) he identified himself with both "Brooklyn of ample hills" and "the streets of Manhattan island."

In a group of articles written for the Brooklyn *Standard* in 1861–62, just before he left for the Civil War battlefront, Whitman went so far as to call for political union between the two cities, to

make them one in name. Collected as "Brooklyniana," [15] the articles were easy rambling accounts of local Brooklyn traditions, old houses, old families, obscure incidents. He referred to stories he had heard as a boy from old-timers like General Johnson, and described his own favorite excursions on Long Island. The entire series is itself a relaxed and whimsical excursion. But the tone is deceptive. Beneath the surface we sense a conflict. The earliest Dutch settlers, he pointed out, had chosen to live in Brooklyn while Manhattan served only as their outpost. Manhattan was "sterile and sandy, on a foundation of rock," while the "aboriginal Island of Paumanock" was a "beautifully rich country, sufficiently diversified with slopes and hills, well wooded, yet with open ground enough." The farmers settled in Brooklyn, the traders in Manhattan. Nothing at all recommended Manhattan as a place to live.

The apparent point of this contrast is simply that Brooklyn and Manhattan complement each other. Whitman foresaw "a great million inhabitants" in Brooklyn alone; he was happy to report that already the smaller city was "steadily drawing hither the best portion of the business population of the great adjacent metropolis." Cheaper gas rates, "the best water in the world," light taxes, honest government — these were the virtues of Brooklyn, and these would attract the masses of New York: pay taxes and drink water east of the East River!

Despite Whitman's apparently cheerful outlook, the substance itself of "Brooklyniana" betrays a certain uneasiness. The War is never mentioned. Most of the space is given over to stories out of the rural past, a past which Whitman admitted was in danger of disappearing. "The whole spirit of a floating and changing population like ours," he observed, "is antagonistic to the recording and preserving of what traditions we have of the American Past." It is deplorable to forget the past; but this was happening " in the huge

15. *The Uncollected Poetry and Prose of Walt Whitman,* ed. Emory Holloway (New York, 1932), Vol. II, 222–325. All page references are to this edition.

cities of our Atlantic seaboard." Brooklyn and New York in particular, he wrote, are "filled with a comparatively fresh population, not descendants of the old residenters, and without hereditary interest in the locations and their surroundings." Still, he was sure, "there will come a time, here in Brooklyn, and all over America, when nothing will be of more interest than authentic reminiscences of the past." We may properly wonder what the poet expected of the sense of the past as those huge cities of the seaboard got even more gigantic. Here Whitman wants to preserve what General Johnson had tried to defend. Yet the chief enemy of tradition was precisely that language of boosting Whitman himself used.

Fortunately, Whitman had at least two languages; "Brooklyniana" is forgotten, and "Crossing Brooklyn Ferry" still lives, still moves readers. The poem addresses the unborn millions, and welcomes them to the ferry as it makes its orderly passage from one shore to another. The imagery evokes eternal objects: water, land, hills, birds. They are "dumb ministers"; they assure the continuity of life and the immortality of the poet. The ferry is a way to reinstate oneself in the "float" of existence. The language of the booster, however, would lead one to conclude that the ferry was, after all, a highly inefficient way for millions to cross a river.

## IV

In 1829 the New York *Gazette* reported a proposal for a chain suspension bridge, 2100 feet from toll station to toll station, arching 160 feet above the East River. The promoter had two arguments: such a bridge would supply a monument to rank New York and Brooklyn with London and Westminster, and "the rise of property in Brooklyn alone would defray the expense of the project." He suggested that "pure" water from Brooklyn could be carried to Manhattan in pipes under the bridge floor.[16]

16. Reported in *Engineering News*, Vol. X (May 26, 1883), 241.

A more feasible proposal came in 1835 from a civil engineer and architect, W. Lake, in a letter to the *American Railroad Journal*. He referred to the common inconvenience suffered by ferry users, especially those in a hurry. A solution to the daily interruptions of business, he wrote, would be a suspension bridge which would not interfere with river traffic (although his plan was for a five-span bridge, which would have rather crowded the river with supporting piers). Such a bridge, he pointed out, was not only practical from the engineering point of view, but also commercially profitable: it would be a good speculation for an ambitious company. Also, it would add beauty to the city.

> The rapidly increasing intercourse between New York and Long Island will, probably, soon require the formation of a wide street leading from Broadway. What a beautiful connection would such a bridge, as it is here described, form between this supposed new street and Fulton Street, Brooklyn! It would altogether be one of the most magnificent suspension bridges in the world.[17]

In a subsequent issue of the journal, Mr. Lake reinforced his proposal by describing the theory and history of suspension bridges, referring to Thomas Pope's *Treatise*.

There were other plans and projects. In 1836, someone suggested a dike across the river; in the 1840's, there was talk of a "stupendous" bridge one hundred feet wide.[18] One projector blandly proposed to fill in the East River, giving the city more land, more profit, and settling for all the time the matter of bridges.[19] In these years a street in Brooklyn running down to the river was hopefully named Bridge Street.

17. *American Railroad Journal*, Vol. IX (January 10, 1835), 4–5.
18. Syrett, 146.
19. Rodgers, 56n.

# 3

Why is this splendid domain entrusted to our care? Is it that we should enslave our brother of a darker color, or that we should employ nature's forces and make them our slaves? When the miserable competition, strife and jealousy that now exist between the different nations will cease and give way to more rational pursuits which will make plenty for all, then we shall go to work with those stupendous forces at our command, and change the face of the desert of Sahara in Africa. This waste once cultivated, and we will have materially changed the climate of our two continents. No scourging sirocco will then anymore sweep over Africa and the south of Europe. After we on this continent have ceased to fight mosquitoes and alligators, Indians and grisly bears, we will then go to work on a large scale and sink artesian wells of 1000 feet deep to water the extensive forests which we are bound to plant in the great basin. This will influence our climate and seasons. Nature invites us to do all this and plenty more.

JOHN AUGUSTUS ROEBLING, "The Harmonies of Creation"

# An American Dream

I

John Augustus Roebling, the creator of Brooklyn Bridge, was born in Germany in 1806, in the midst of revolution and change. The Napoleonic Wars had penetrated the thousand-year-old walls of his birthplace, Mühlhausen, a small trading city in Thuringia. The Battle of Jena, seventy miles away, had been fought the year of his birth, and in 1815 Mühlhausen had sent 500 men to Waterloo. John Roebling was the first of his family to break free of provincial life. The Roeblings were an old and respectable family, tracing their ancestry to the sixteenth century. By and large they had been tradespeople; John's father was a tobacconist. In 1823 the young man left Mühlhausen, enrolled in the Royal Polytechnic Institute of Berlin, and began the process of intellectual liberation which culminated nine years later in his emigration to America. In Berlin, Roebling found himself in the stream of liberal ideas which had been circulating in Europe since the French Revolution. The intellectual life of his student days provided the young and brilliant engineer with his basic stock of ideas — ideas which soon led to a deep dissatisfaction with German life, and an equally deep belief in America as a new hope for mankind.[1]

1. The standard sources for Roebling's biography are Hamilton Schuyler, *The Roeblings: A Cenutry of Progress* (Princeton, 1931), and D. B. Steinman, *The Builders of the Bridge* (New York, 1945). One of the leading suspension bridge builders of the twentieth century, Steinman claims to have been directly inspired by Roebling

Among his early influences none was profounder nor more lasting than his association with the philosopher Hegel, who had recently assumed a position at the University of Berlin. There he delivered his famous lectures on the Philosophy of Religion, the Philosophy of Fine Art, the Philosophy of History, and the History of Philosophy. Roebling attended these lectures, and he became, according to family legend, a close friend and favorite student of the philosopher. The relationship was instrumental in his decision a few years later to leave Germany for America.

To its youthful adherents in the 1820's, Hegelianism was far from the schematic and arbitrary system of concepts it often seems today. The older philosopher inspired his students with radical dreams of self-realization, of personal potency over the apparently erratic course of history. To realize one's potential — this was the aspect of Hegel's system which struck Roebling most forcefully.

According to Hegel self-realization, for individuals and nations, was possible only within the conditions set by history. The theme

and Brooklyn Bridge. In the preface he writes: "In partial discharge of that debt of inspiration, the writing of this book has been undertaken" (vii). Designer of more than 400 bridges on five continents, including the world's longest suspension bridge over the Mackinac Straits in Michigan, Steinman was also a poet — a member of the Poetry Society of America, and author of *Songs of a Bridgebuilder* (Grand Rapids, 1960). The following is typical:

THE HARP

Five stories high above a city street
He dwelt, a child with wonder in his eyes.
For him, through winter cold and summer heat,
The sunbeams danced and stars sang lullabies.

How did the stranger guess the secret dream
That, day and night, within the child's heart burned?
Outside the window, in the sunset gleam,
Glittered the instrument for which he yearned:

One day, as if on wings, a stranger came
And stood within the room, unheralded.
Gently he spoke, calling the boy by name:
"David, play on your harp!" he softly said.

A bridge! The cables swung across the bay,
The strands that hummed like harp-strings murmuring,
They whispered to the child, "Some day . . . Some day . . ."
"There is my harp, sir. I can hear it sing!"

In 1948 Steinman was in charge of the renovation of Brooklyn Bridge; he is responsible for the addition of braces over the traffic lanes, which have considerably strengthened the structure without altering its appearance. The modernized bridge was opened to traffic in 1954. He died in 1960.

of world history had been the struggle for freedom, for the suprem-
acy of Reason. But in order to shape reality, Reason required some
common conditions. It needed, for example, the recognition that
man *as such* is free — not only one man but all men. Orientals had
allowed that only their despot was free; Greeks and Romans had a
consciousness of freedom, but also kept slaves. Not until the emer-
gence of Christianity in the German nations did the world achieve
the necessary intellectual conditions for universal freedom; for
Christianity had made each individual a true spiritual being,
equally capable with all others to reach truth. The French Revolu-
tion, in turn, had supplied the necessary material conditions by
instituting a society of law and private property. The final step
toward the realization of freedom was the modern state, a universal
form which established the rule of law and reconciled the antag-
onisms of private property-holding individuals.

Thus, Hegel felt, by the 1820's history had at last achieved the
necessary conditions, and Germany's constitutional monarchy
seemed to him to represent Reason on earth. The state — and
middle-class society — represented the fulfillment and embodiment
of freedom.

Hegel's forceful defense of the monarchy restored to Germany
after the Napoleonic Wars has led to his reputation as a reaction-
ary. And it seems to cast some doubt upon the depth of his in-
fluence upon Roebling, who later fled the restrictions of monarchy.
But by defending the state Hegel meant to defend Reason, not
tyranny: reform might weaken the hold of law, which represented
Reason. At the same time Hegel seemed to recognize that Europe
held in uneasy balance forces likely to overwhelm the shaky order
achieved after Napoleon. He recognized that "the cunning of
reason" might require sacrifice of many individuals to maintain
order, sacrifices of individuals for the sake of the universal. Thus a
streak of pessimism regarding the future of Europe implicitly
underlay his philosophy of history.

In the unity of opposites which formed the heart of Hegel's dialectic, however, pessimism co-exists with optimism, and despair contains the germ of hope. By the same dialectic, America which had emerged from Europe was destined to transcend her. Herein lay a new hope.

It was not unusual for Europeans to conceive of America in religious or philosophical terms. John Locke had written: "In the beginning all the world was America." And Europeans in the eighteenth century tended to believe, as Jefferson did, that the tablets of the mind could be indeed wiped clean and a new beginning made in the New World. Hegel's conception of America was equally elevated. In his lectures on the philosophy of history, he cited two main facts which gave America its special character: its republican constitution, and its still vacant "immeasurable space." By protecting property, the constitution promoted "the endeavor of the individual after acquisition, commercial profit, and gain" — necessary for the pursuit of freedom. The role of spatial vastness was more significant: it freed America from the necessity of developing a strong central government, a European-style state. Hence, "still in the condition of having land to begin to cultivate," America was "the land of the future, where, in the ages that lie before us, the burden of the World's History shall reveal itself." It was America's destiny, wrote Hegel, to "abandon the ground on which the History of the World has developed itself." It was "the land of desire for all those who are weary of the historical lumber-room of old Europe." [2]

In short, Hegel imparted to Roebling a belief that America's role was to fulfill the future — to become the true home of Reason, of freedom actualized in social forms. Freedom lay, the philosopher taught, with the recognition of Reason's sovereignty, of that which was truly "necessary" to self-realization. A quest for freedom, for

2. *Lectures on the Philosophy of History*, tr. J. Sibree (London, 1890), 88–90.

the necessary and the possible, became the cardinal motive of Roebling's life.

Other factors entered into Roebling's decision to emigrate. German society revealed itself inhospitable to his ambitions. Although the Restoration had imposed unity on the multitude of political divisions in the country, industry was still backward and the middle class still disorganized. For an engineer these conditions created impassable barriers. After his graduation in 1826, Roebling took the only position open to him, as an assistant engineer in Westphalia. His chief hope was to carry forward his studies of a new kind of bridge he had seen over the Regnitz at Bamburg. It was a suspension bridge, and Roebling had described the structure and the suspension principle in his graduation thesis. In Berlin, this new type of construction had been discussed enthusiastically by the lecturer J. F. W. Dietleyn. Dietleyn had described several English examples in which the roadway was suspended from chains of iron bars; he also described pioneer suspension bridges in America, including one in Philadelphia with wire cables instead of chain links from which to hang the roadway. Roebling was greatly attracted to the challenges of this new form.

But his hopes were defeated by the excessive bureaucracy and inadequate technological development of German society. In his position in Westphalia he felt himself restricted to a narrow routine and a rigid procedure; innovations were simply not permitted. Nothing could be accomplished, he wrote in his diary, without "an army of councilors, ministers, and other officials discussing the matter for ten years, making long journeys, and writing long reports, while the money spent in all these preliminaries comes to more than the actual accomplishment of the enterprise." [3] More-

3. Quoted in Steinman, 15–16.

over, in reaction to the July Revolution of 1830, which failed
to ignite an upheaval in Germany, the monarchy had tightened its
restrictions on personal freedom, on the universities, and on the
right to travel. Reason, Roebling felt, was stifled at every turn. In
1830, at the end of his three-year apprenticeship, he was ready to
depart the "historical lumber-room of old Europe" for the "im-
measurable space" of new America.

If Hegel had provided the philosophic frame of expectation, and
German society the particular irritation toward change, John A.
Etzler offered Roebling the concrete inducement to shed the past.
Etzler, a childhood friend and also an engineer, had returned from
America to Mühlhausen in 1829, full of enthusiasm for the New
World. He had returned to promote colonization, and Roebling
became his most eager follower. The relationship between the
youthful engineers is significant, for Etzler was a complete Utopian.
His imagination fed on lavish images of the future society Hegel
had referred to — a society of man's self-realization through mas-
tery of nature. And the future, he felt, lay but a few years ahead, in
the land across the sea.

Together the two men prepared and published secretly (Etzler
had already been imprisoned for his activities in 1829, shortly after
his return) a pamphlet urging resettlement in America. *The Gen-
eral View of the United States of North America, together with a
Community Plan for Settlement* has not survived, but we can judge
its contents and its tone by Etzler's utopian tract, *The Paradise
within Reach of All Men, without Labor, by Powers of Nature and
Machinery* (Pittsburgh, 1833). This later book proposed a way of
achieving within ten years just what the title announced. "There
are powers in nature," Etzler wrote, "sufficient to effect in one year
more than hitherto all men on earth could do in many thousands
of years." The "requisite powers" for the world's transformation
were the wind, the tides, the waves, and the sun. They are there for
the taking, without cost, and they consume no materials. All that

was needed were machines — "human contrivances" — to provide "a medium between the powers and their final application, in order to convert them into uniform operations." They would be perpetual motion machines, and their product would be a "paradise" — "where everything desirable for human life may be had for every man in superabundance, without labor, without pay." Etzler promised "the most magnificent palaces," "the most delightful gardens," and floating islands bearing gardens and palaces to cover the ocean. He promised, in short, Atlantis resurrected: "a regeneration of mankind to a far superior kind of beings with superior enjoyments, knowledges and powers."

Etzler made his proposals without a single illustration or diagram of his machines. Rather than a blueprint, the book was an argument about the possible: it aimed to persuade its readers that such could be done. One reader among the multitudes who remained unconvinced was Henry David Thoreau, who ten years later wrote "Paradise (To Be) Regained," a review of Etzler's book. Paradise indeed had not been regained, and Thoreau not only ridiculed the miscalculation but attacked the vision itself as materialistic. Moreover, Etzler had hoped to dazzle nature with his rhetoric, wishing away all physical resistances. In an ironic tone, Thoreau scoffed, "It will be seen that we contemplate a time when man's will shall be law to the physical world, and he shall no longer be deterred by such abstractions as time and space, height and depth, weight and hardness, but indeed shall be a lord of the creation." [4]

John Roebling was soon disenchanted with such disregard of reality. "Mr. Etzler's profit calculations are taken out of thin air," he wrote to a friend after the voyage to America. They had left Mühlhausen together with a group of emigrants in 1831, the year of Hegel's death. In America, however, they shortly took separate

4. "Paradise (To Be) Regained," *The United States Magazine and Democratic Review*, Vol. XIII (1843), 451–63.

paths. Etzler and his followers went toward the West, to found a communistic society. Roebling's group purchased a tract of land near Pittsburgh, and established a farming community which they named Saxonburg. After several months of hardships — clearing the land and building houses — he wrote to a friend in Germany: "The booklet published by Etzler and me was in many respects persuasive and for that reason I wish it had never been printed. . . . I blame Etzler's carelessness and bold, unfounded assertions." [5]

Roebling's task was to master his new environment, and Etzler's fanciful notions did not help; he rejected them — but only as errors of calculation. The vision itself Roebling never repudiated. In regard to Etzler, wrote Washington Roebling: "My father considered him the greatest genius he ever met." [6] Probably an exaggeration, but nonetheless the two men shared a common ideal, derived largely from Hegel, of a new world where man would at last master nature and free himself from the irrationalities of history.

## II

"It is not contempt for our Fatherland that causes us to leave it," the young immigrant recorded in the diary of his voyage to America in 1831; it was instead "an inclination and an ardent desire that our circumstances may be bettered." He had no "exaggerated views or extravagant hopes"; success would depend only on the "personal energy and power of will of each individual." And this act of will, breaking his ties with Europe, was not a tentative venture: "As we see the last of the shores of Europe vanish from our sight, we separate ourselves at a single stroke from the Old World." [7]

The theme of Roebling's diary and of letters sent back to Ger-

5. Roebling's letters to friends in Germany have been collected as "Opportunities for Immigrants in Western Pennsylvania in 1831," *The Western Pennsylvania Historical Magazine*, Vol. XVIII (June 1935), 73–108.
6. Roebling Collection, Rutgers University Library.
7. *Diary of my journey from Mühlhausen in Thuringia via Bremen to the United States of North America in the year* 1831 (Trenton, 1831).

many was that America stood for "personal freedom and natural independence" — the conditions necessary for Reason. In America a man may choose his own fate without "unnatural" restraints. A "reasonable and humane Constitution" protected man's "natural rights" and left him free to pursue his own ends. "I have found all that I sought," Roebling wrote after a few months: "a free, reasonable, democratic government and reasonable, natural relationships of the people toward each other; freedom and equality; a peaceful, generous, beautiful country the blessings of which are not forcefully and deceitfully taken away from the land toiler by tyrants. No unbearable taxes — no executor — no arrogant burgomaster, or chief magistrate." He had found indeed what he had sought: the antithesis of Europe.

Trained by Hegel to recognize the potentialities of the moment, Roebling was originally drawn to farming. In discussing his decision he revealed his grasp of historical reality. "The American farmer lives a very happy life indeed," he observed. To him rural families seemed self-sufficient: they made their own clothing and had "a surplus of the necessities of life." But their happiness depended heavily upon geography. In Pennsylvania "we are in one of the most advantageous sections of America, in the vicinity of a good market . . . where we can dispose of all products for *cash*." Cash was the key to happiness, and proximity to a market the source of cash:

> Now, consider this: the farmer of the western states must compete in one market with the Pennsylvania farmer. . . . Think of the transportation! For the western farmer there is very little profit; he must barter his products for a mere trifle, and the merchants with whom he deals in turn use this method to enrich themselves through the farmer's hard toil. . . . Many people go out there, lured by the reputation of the West. . . . Many have returned from these moorlands of the West, sick and weak, and have then stayed in Pennsylvania.

With profit, "contented people can in truth lead a happy, free, and unconstrained life here"; without it, people are "sick and weak."

What Roebling observed was nothing less than America's historical need for roads, for a system of mechanical links between ideals and realities. This need provided Roebling with his major roles in American society, as a manufacturer and an engineer.

The transition from farmer to manufacturer-engineer was a swift one. In 1837, the year he became a naturalized citizen, Roebling heard of an opening for an assistant engineer on the Sandy and Beaver branch of the Pennsylvania Canal. His farming enterprise was neither thriving nor failing; it provided a living, but was tiring — and a far cry indeed from the self-realization he had dreamed of. He took the position without hesitation. But the job lasted no more than a few months; his post was eliminated as a consequence of the serious depression of that year.

The set-back did not last very long, and by the end of 1837, Roebling had regained his position. He never again tilled the soil. But the lay-off had given him a taste of the insecurity common among professional engineers. It was the first of a number of lessons by which Roebling came to understand the realities — the necessities and possibilities — of American society.

By 1837 the civil engineer had become a clearly defined vocational type in American society. The transportation revolution had begun a decade or two earlier with the limited skills of gentlemen builders and craftsmen — both types without formal training in modern theory and techniques. At the beginning of the internal improvements movement in the late eighteenth century, the gentleman-proprietor-engineer, the man with a "stake in society," was the acknowledged leader of construction projects. From 1816 to 1837 the construction company or corporation had taken over; it provided the more complex organization of skills and materials necessary for projects larger than eighteenth-century canals. And

the construction company became the training ground for a corps of civil engineers. The engineer became the creature and property of the company.[8]

This situation did not suit Roebling's desire for independence, for a free hand to carry out his projects. From a letter he wrote to the chief engineer of the Sandy and Beaver Canal after the unexpected lay-off in 1837, we can sense his frustration: "I cannot reconcile myself to be altogether destitute of practical occupation." He described several plans he had worked out for improvements in the dams and locks of the canal system, a new contrivance for railroad switches, and large improvements of the channel at the mouth of the Mississippi below New Orleans.[9] In making these proposals to his former superior, Roebling demonstrated his naïveté; though technically feasible, the projects were meaningless without political and commercial backing. He had yet to learn that the independent engineer needed the talents of the promoter in order to earn commissions.

His days of independence were still several years ahead. Later in 1837 the immigrant engineer secured a position on another branch of the Pennsylvania Canal. He was raised, after a few years, to Principal Assistant and given charge of a survey for a railroad between Harrisburg and Pittsburgh. It was on this assignment that his manufacturing career began.

One of Roebling's responsibilities was a survey for portage railroads. This was a mode of transportation used to connect waterways when the canal route was blocked by mountains. The boats were loaded onto railway trucks and hauled over the mountain on inclined planes; the source of power was a stationary engine at the top of the slope. The rope connecting the truck to the engine — a heavy hemp cable, about six inches thick — was the key feature of

8. My account of civil engineering in this period is based largely on David Hovey Calhoun, *The American Civil Engineer* (Cambridge, 1960).
9. See Steinman, 49–50.

the portage device; if it failed, the operation faced disaster. The ropes, which frayed easily, were a constant hazard and, because of their short durability, a large expense.

Contemplating this situation, Roebling characteristically searched for an improvement; and in 1841 he found one. He developed a technique of spinning wires together to form wire rope — a cable lighter, smaller, and stronger than hemp. At first the higher officers of the canal system were reluctant to replace the traditional hemp hawsers, because it would have required a revision of existing cost structures. Eventually the innovation was accepted; and Roebling was given the contract to produce the wire rope. In a work shed on his farm in Saxonburg his manufacturing career was launched.

"My father always held it as a necessity," wrote Washington Roebling, "that a Civil Engineer (one of the poorest professions in regard to pay) should always, when possible, interest himself in a manufacturing proposition. The rope business being established, his ambition prompted him to greater efforts." [10] In 1848 Roebling moved his manufactory to Trenton; he designed all the buildings and machinery himself.

Roebling's career as a bridge engineer actually began in 1845, after the establishment of his wire rope business. He won an open competition for a small aqueduct over the Allegheny River at Pittsburgh. His design was a suspended structure. To carry the roadway he used his own wire rope, and devised a new method of stringing the cables in place, rather than the old procedure of assembling them on shore. He also invented a new anchorage system for the cables. The structure was a success, and attracted considerable attention. The same year an old timber bridge across the Monongahela in Pittsburgh had burned down, and Roebling immediately made a bid; he received the contract, and raised upon the old piers his first suspended highway bridge. On the basis of these two rapid

10. Washington A. Roebling, *Early History of Saxonburg* (Butler County Historical Society, 1924), 15.

achievements in 1845–46, he was commissioned in the next four years to build four more aqueducts for the Delaware and Hudson Canal Company. By 1850 he had six suspended structures to his credit, each using his own wire rope — and a successful industrial plant in Trenton.

Roebling's road to success was at least partially paved with the failures of Charles Ellet, Jr., his chief rival as an engineer. Ellet was also a pioneer of the wire suspension bridge, but, unlike Roebling, he was unable to achieve enough independence to pursue his experiments. Too often his work was restricted by his role as a functionary of construction companies.

Ellet's career reveals the pattern that had emerged in the engineering profession. He had left home at seventeen, escaping the unhappy prospects of a life on a Pennsylvania farm, worked for a year as a rodman on a survey, and then found a place as a "voluntary assistant" on the Chesapeake and Ohio Canal, without fixed pay. By 1830 he had saved enough money to travel to Paris, where he studied for one year at the Ecole Polytechnique. He returned in 1832, the first native American with European schooling in engineering. Young, ambitious, and brilliant, he presented a plan to Congress for a 1000-foot suspension bridge across the Potomac River. The plan failed to impress anyone, and Ellet returned to his earlier work with various canal and railroad companies. He wrote several essays on the economics of railroads and other internal improvements, proposed a design for a suspension bridge across the Mississippi at St. Louis, and finally managed to erect a bridge at Philadelphia. Of his many designs, only two were built; neither survived his life. He was killed in the Civil War in a naval skirmish in which steam battering rams he had designed were used successfully against a rebel fleet.[11]

Ellet was a professional; he could practice engineering only

11. Charles B. Stuart, "Colonel Charles Ellet, Jr.," *Lives and Works of Civil and Military Engineers of America* (New York, 1871), 257–85.

through his place within the construction company. He became a master of the "politics of internal improvements," but without economic independence he was unable nevertheless to win for himself the kind of control over projects a civil engineer required. Impetuous and restless, Ellet frequently quarrelled with superiors and lost commissions which might have meant fame. He dissipated his genius in the peripheral strategies of company politics.

Ellet was a lesson for Roebling. The relations between the two men had begun as early as 1840. Ellet had advocated a suspension bridge across the Schuylkill River at Philadelphia. The proposal was widely published, and the young engineer was confident he would get the job.[12] Roebling was still a surveyor on the Pennsylvania Canal, and his chances for building bridges seemed dim. When he heard of Ellet's plans, he offered his assistance. The proposal had "revived in me the old favorite ideas" he had entertained since his student days, of building suspension bridges:

> Let but a single bridge of the kind be put up in Philadelphia exhibiting all the beautiful forms of the system to the best advantage, and it needs no prophecy to foretell the effect, which the novel and useful features will produce upon the intelligent minds of the Americans. You will certainly occupy a very enviable position, in being the first engineer who, aided by nothing but the resources of his own mind and a close investigation, succeeds in introducing a new mode of construction, which here will find more useful application than in any other country.

In a swift series of events, the Philadelphia contract was offered not to Ellet but to an inexperienced contractor; Roebling immediately placed his bid to serve as chief engineer, and was accepted. But Ellet continued to promote his own interests, and offered to take real estate lots as payments for his work. The County Board reversed itself, awarded the contract to Ellet, and Roebling lost

12. "Plan of the Wire Suspension Bridge about to be constructed across the Schuylkill at Philadelphia," *American Railroad Journal*, Vol. X (March 1, 1840), 129–33.

what would have been his first chance to build a major bridge. He was baffled, but the lesson was clear.

The next encounter took place several years later. Both had responded to a circular in 1845 regarding the feasibility of a railroad bridge across the Niagara River just below the Falls. A suspension bridge, both argued, would best answer the need. The challenge was great; Robert Stephenson, the famous British engineer, had spoken against the suspension form in favor of a tubular bridge. Both Ellet and Roebling knew that the man to span the Niagara with a suspension bridge would become the world's leading practitioner of that form.

Ellet began a skillful program of promotion, arranging to have his name appear frequently in connection with the proposed bridge. A company was chartered in 1846, and Ellet quickly offered to serve as engineer-contractor, responsible for materials and labor as well as design. He also offered to subscribe to a substantial amount of the stock. Reluctantly, Roebling made a similar bid; he would have preferred not to concern himself with any aspect of the work except the engineering. Ellet won the contract in 1847. But less than a year later, after a small footbridge had been erected, he quarrelled with the company about the application of tolls. He was forced to resign — and lost the best opportunity of his career. Roebling was now able to negotiate for the sort of position he wanted: as a salaried engineer. He was given a free hand in the design and construction, and the result was, in 1855, his first great bridge: a two-level suspension span which supported moving railroad cars across one of the most dramatic gorges in the world.

The Niagara Bridge established Roebling's reputation as master-builder of the suspension bridge; it culminated a ten-year period of competition with Ellet for that title. The last encounter was in 1854. In that year a storm had damaged the cables of a bridge Ellet had built across the Ohio River at Wheeling in 1849. It had been an impressive structure — its 1000-foot span the longest in the

world. But Ellet had not allowed for the destructive vibrations caused by high winds, and during the storm the cables twisted into the treacherous oscillations which had destroyed many earlier suspension bridges (as late as 1940 a similar disaster wrecked "Galloping Gertie," the Tacoma Narrows Bridge). The disaster finished Ellet's career. John Roebling was appointed the task of reconstructing the bridge's superstructure; he used his system of inclined stays radiating from the towers to the roadway — the familiar diagonal lines that became his signature. The bridge is still in service. Roebling had succeeded where Ellet had failed.

The next phase of Roebling's career was marked by the emergence of his son as a collaborator. Washington Roebling had graduated from Rensselaer Polytechnic Institute in 1857 and immediately joined his father in Pittsburgh, where the two Roeblings replaced an old traffic bridge over the Allegheny River. At the same time they had begun work on the largest suspension bridge yet attempted — a span of close to 1100 feet across the Ohio River at Cincinnati.

John Roebling had been approached as early as 1846 by a Kentucky bridge company to draw plans for such a bridge. Approval of the project was blocked, however, in the Ohio legislature; shipping interests believed the bridge would interfere with passage on the river. The company asked Roebling to prepare a pamphlet to allay this fear. This was his first experience as a promoter. He took the occasion to argue for the suspension bridge as a perfectly feasible form for American waterways; it would not clutter rivers with piers, and its roadway could be arched to leave sufficient clearance for steamboats with high smokestacks or tall masted sailing vessels. The pamphlet failed to win the necessary votes, but was an accurate prediction of the future of the suspension bridge in America.

Ten years passed before a bridge company finally received a charter. Roebling negotiated slowly and carefully to win for himself

unhampered supervision and control over construction. The work required heroic patience; severe floods and the Civil War interfered. In 1864, after his retirement as a colonel from the Union Army, Washington Roebling took complete charge of the project; his father was already at work on plans for an even greater effort. The Cincinnati-Covington Bridge opened in 1867, and Washington joined his father in Brooklyn, to help him raise his final work: the East River Bridge.

### III

John Roebling's career in America discloses how well he succeeded in realizing his desires. Unlike John Etzler and Charles Ellet, he was able to dream his dream to actual fulfillment. Part of the explanation of his success was his flourishing wire-rope business; economic security provided the material conditions for his freedom. His success seemed to him to justify Hegel's idea of America as "the land of the future."

In 1847 Roebling read a paper before the Pittsburgh Board of Trade, proposing a "Great Central Railroad" between Philadelphia and St Louis.[13] The paper contains his idea of the *Zeitgeist* of pre–Civil War America. "Railroads and Telegraphs may be hailed as the latest offspring of the spirit of the present age," he wrote; "they have imparted a new and most powerful impulse to the social movement, from which will yet flow a vast train of beneficial results." A central railroad system would be a way to express and direct that movement — to realize its potentials.

Roebling expanded upon a theme with wide currency in the period: the virgin West beckoned the railroad to fulfill America's "manifest destiny." We have already seen that one of the rhetori-

13. "The Great Central Railroad from Philadelphia to St. Louis," *American Railroad Journal*, Special Edition, 1847. The essay also appeared as an article in Vol. XX (1847), 122–5, 134–5, 137, 138–41, 155–7.

cal uses of the land was to speed technological development. Roebling joined this chorus, as a spokesman for the eastern commercial classes. The aim of his paper was to provide Pennsylvania businessmen with a plan to win the western trade from their rivals in New York and Boston.

He used a two-pronged argument: historical necessity and moral duty. Of all the nations of the world, America was destined to benefit most from "modern improvements": "We abound in the elements of wealth, but want the means of moving, working and distributing them." Transportation, especially the railroads, held the key to the future: "Like a *magic wand,* they open the slumbering resources and long-hidden treasures of the earth; convert stone and iron into gold; draw into bonds of unity and amity isolated individuals, as well as communities and nations; unchain long-cherished prejudices and selfishness, and cause to be made more simultaneous, exertions in all that is useful and good." An instrument of progress, the railroad was also a revelation of providence; it was a spur to the awakening of mind. "The nobler feelings and sentiments of men are likewise partaking of the benefit of this general move; they will be roused to greater activity by the enlarged scope rendered accessible by the increased facilities of communication." In short: "We may entrust the future fate of our country to that great net of railways and telegraphs which soon will spread over the vast extent of its surface."

Roebling appealed to the businessman's desire for profit. Like Hegel and Marx he recognized the capitalist's self-interest as the foremost cause of progress at that moment in history. But in Roebling's mind profit was secondary to a larger purpose: "The grand object of railways" was "to facilitate commerce and intercourse." This entailed an obligation to the future. The obligation required that the present generation use all its capacities for planning. Businessmen must "act systematically throughout" — not solely for the sake of their pocketbooks but for the future. They required means

"fully adequate to the magnitude of the object." The means were at hand in modern science. Mathematics and technology were the causes not the products of wealth; therefore they could be deployed systematically to articulate the future. "We may project works with unerring certainty."

"The whole west," Roebling wrote, "is invoked to assist us in this vast work." And the "whole west" included both a national dream and a concrete set of figures. Population statistics, freight rates, lengths and grades of existing railroads, the anticipated rise in real estate values — and the costs of transporting hogs from west to east — bear the message of history. Roebling's central railroad would represent the orderly process of history: "The whole country should be divided into railroad systems, with main trunk lines forming direct communication between the most important commercial towns, and lateral branches extending thro' the adjacent country." Moreover, "No two roads shall be made where one can accommodate the business." There was no need for ruthless competition and selfishness: "We shall not allow our policy to be governed by feelings of envy. A generous, high-minded and honorable rivalry shall prompt us in the pursuit of our enterprise — we will remember that the Great West offers room for us all!" Such was John Roebling's optimistic creed, envisioning a world in which true self-interest was the common interest — a world whose rule was harmony.

## IV

"It is a want of my intellectual nature," wrote John Roebling, "to bring in harmony all that surrounds me. Every new harmony I discover is to me another messenger of peace, another pledge of my redemption." These words appear among the thousands of pages of philosophical manuscripts Roebling left behind at his death. The manuscripts, surviving among an equal number of technical papers, drawings, and meticulously kept double-entry account books, bring

to light an apparent contradiction in his nature. Thorough, exact, calculating on one hand, Roebling was also something of a spiritualist.[14]

In the 1850's and 1860's the language of Roebling's philosophic writings became more and more abstract. Without discrimination he had absorbed the transcendentalism and spiritualism of Swedenborg, Channing, Emerson, Henry James, Sr., and Andrew Jackson Davis, the "Poughkeepsie Seer" and "Clairvoyant." [15] Apparently caught up in the great outpouring of millennialist and reformist literature in this period, he came to believe firmly in immortality and the communication of spirits; he attended seances, and practiced the cold-water cure. He seemed to practice automatic writing as well. The American environment had released a vein of mysticism implicit in his early attachment to Hegel.

Roebling's mind dwelt among correspondences and analogies. The "great fact" he asserts over and again is that man's capacity to understand nature was "proof positive that our mind is one with the Great Universal Mind." The "operations of nature" he likened to "a great sylvan dance, all members moving in silent harmony." As a scientist, Roebling was concerned with the laws of matter, in particular with the changes in the physical world, the movements of the dance. The changing forms of matter also represented, however, "an evolution of the spiritual." Matter was an expression of spirit. As an epigraph for a comprehensive metaphysical system he was at work on in the 1860's, Roebling wrote:

14. Roebling Collection, Rutgers University Library. All of my citations from Roebling's philosophic and political writings are from this collection.
15. Inspired by Davis's book, *The Principles of Nature, Her Divine Revelations, and A Voice to Mankind* (New York, 1847), Roebling drafted a letter to the *New York Tribune*, entitled "An Appeal to the Philanthropist." In it he argued for an association of a thousand orphan children to be raised on the "principles of righteousness, truth, and brotherly love." The group would provide a core of "perfectly educated" people to lead "the emancipation of human nature." Davis, a proclaimed clairvoyant, was said to have written the book while in a trance. For an account of his life and his place among spiritualists in America, see Alice Felt Tyler, *Freedom's Ferment* (Minneapolis, 1944), 78–84.

> A self contradiction is matter,
> It is and is not;
> An ever-changing form,
> Whose truth is hid within;
> A form, that blooms today,
> Exhibits fruit tomorrow,
> And next death and decay.

The work, called "The Truth of Nature," was to prove that "spirit-ualising nature is the aim and end of creation." The hidden truth was that nature and history were processes in which "spirit" progressively unveiled its domination of "matter." And the path to the truth lay in the mind's discovery of correspondences between spirit and matter.

In Roebling's writings, harmony is often a blur; the sylvan dance is apt to dissolve into an orgy of words. Moving freely between the abstract and the concrete, the metaphysical and the physical, he seemed not to concede any essential separation between the two poles. Facts did not exist apart from ideas; ideas were frequently treated as facts. But the effect is not entirely vague. If the Hegelian tendency was a liability — a danger of losing oneself among abstractions — it was at the same time a distant asset: it saved Roebling from the alternative of losing himself among the sheer undigested facts of history.

Within the increasing verbiage of Roebling's later years, we can detect a thread of solid historical observation. It is best expressed in the dedication he wrote in 1863 for his projected work of synthesis, "The Truth of Nature" (or, "An Enquiry into the nature of the material and the immaterial"):

> When error, superstition and bigotry have assumed the garb of truth; when men have lost much of that intuitive perception of right and wrong; when the mercantile balance sheet and a false political aspiration threaten to become the sole arbiter of a na-

tion's fate; when even human slavery and human misery are sanctioned in the forum and in the pulpit; — then indeed is that nation's future history shrouded in darkness!

Roebling had become, it is clear, disturbed by events in American life. His confidence of the 1840's had been shaken by what he believed was a misdirection, a failure to exploit historical possibilities. His metaphysical writings, with their rhapsodic reiteration of harmony, can be taken as a highly abstruse form of his discontent.

This is not to say that Roebling's metaphysics were a covert lamentation. He never denied the supremacy of reason. But faced with the realities of slavery, which he hated (he ordered his son Washington to enlist in the Union Army), and of the profit motive, which he scorned when it was unaccompanied by a sense of mission, he needed to explain to himself the apparent failures of Reason.

"We cannot close our eyes to the appalling fact," he wrote in an essay called "A Few Truths for the Consideration of American Citizens," "that the prominent events of human history are made up of long series of individual and national crimes of all sorts, of enmity, cruelty, oppression, massacres, persecution, wars without end." Looking at these events as "isolated facts, and from a purely material standpoint," Reason seems helpless indeed. But, "with a philosophic eye," one can discern "the Great Spirit of Nature, always active, always at work." The channel may be crooked, but "the great stream of life is rolling along . . . towards the great Ocean of Universality." In that "living stream," rough edges are smoothed and "unruly passions" annihilated. In the end history will eliminate evil.

This is, of course, a stark theodicy. In an essay called "The Harmonies of Creation," Roebling drew analogies from geology to explain and justify violence and brute force in nature and in history: "What is mystery to us now will become plain in a higher state of existence. We are born to work and to study." Meanwhile we are

to find our clues in "that vast array of analogies which the phenomena of nature present all around us." Nature's abortions, "tormentors and devils" like mosquitoes, alligators, and vampires, serve useful functions, and eventually, with the spread of civilization, they will be eliminated. Likewise, he wrote in "A few truths for the consideration of the President of the United States, October, 1861," "Earthquakes and tornadoes are as necessary to the world's process as are sunshine and rain." Thus, "When a whole nation has been steeped for a whole century in the sins of iniquity, it may require a political tornado to purify its social atmosphere." Like Emerson, Roebling did not believe in the inherent reality of evil; if it existed it was for the sake of ultimate good.

More important is Roebling's implicit criticism of American life. He excoriated in the privacy of his journals all deviations from Reason. He attacked the willingness to compromise with slavery, siding with Jefferson's Declaration of Independence against the Constitution: "In that Constitution the corrupt seed was planted; the tree has been sedulously nourished in its growth, and we are reaping the fruit." This comment appears in "The Condition of the U.S. reviewed by the Higher Law." "The principle of free development does not harmonize with the principle of tyranny and oppression," he continued; "the one is light, the other darkness." As a result of compromise, "the claims of humanity have been lost sight of during the splendors of the reign of King Cotton."

Roebling's criticism touched the roots of American life. From the viewpoint of "the higher law," self-interest was "the great lever of action." But self-interest, "correctly understood," embraces all of mankind: "My own true self discovers my own interests indissolvably connected with those of my fellowmen." And it embraced the future. Let us consider the United States, he proposed, not as a business partnership but a family — "a parental estate." The estate is held in common, but held only in trust, "not for the few individuals who just now happen to occupy a state or territory, but

for all future generations." The earth is not assigned to us forever: "men live here only in the capacity of stewards, who have to account to future generations."

In light of such direct responses to American reality, the apparent contradiction between the engineer-businessman and the metaphysician seems more like a remarkable unity of character. Determined to "bring in harmony" all that surrounded him, Roebling employed Hegelian and spiritualist vocabulary — vague and vaporous as it was — to locate himself in the "material" world of society and history. His effort was an act of will:

> Whoever discovers disharmonies of nature, without being able to reconcile them, will discover that the idea of disharmony originated in his own mind, and was only reflected in that which surrounds him. Whatever you wish to perceive you can see. You can see everything in a beautiful light and rose color, if your own mind is at ease with itself and harmoniously lived. Here is your heaven and your hell, near enough and without any further search far off. Bring your own interior nature in union with the outer world, and harmony will be established.

The actual unity of Roebling's creations redeems whatever seems clouded in his metaphysics. In the end, the solidity of his bridges represents the true harmonies of his life.

John Augustus Roebling,
1806 - 1869

# II

# SHAPE

Tower design, Brooklyn
Bridge,
J. A. Roebling, 1869
(Rensselaer Polytechnic
Institute)

# 4

*True life is not only active, but also creative. Just in proportion, as the human mind creates within itself, does it partake of true spiritual life. . . . When I am, while in the natural state, at the same time endeavoring to carry out my conception practically and materially for the actual welfare of my fellowmen, then I am also living a useful natural life.*

JOHN AUGUSTUS ROEBLING, "Life and Creation" (1864)

# A Master Plan

One winter day in 1852, John Roebling found himself on a ferry-boat stranded in the East River; chunks of ice had clogged the channel, and all movement ceased. This chilly experience seems to have transformed itself into the spark that ignited Roebling's fervor for a bridge to Brooklyn. He was then at work on the Niagara Bridge, but the idea of an East River span continued to burn until it consumed his entire attention.

In 1856 Roebling drew rough plans for an immense multi-span bridge to arch over Blackwell Island in the East River, but changed the location in 1857 to a site near the city halls of Manhattan and Brooklyn. In that year, and again in 1860, he made his proposal in letters to the New York press. On the eve of the Civil War and in the midst of a minor economic crisis, the nation was in no mood for new constructions. In 1864 the situation was more favorable, and Roebling again published accounts of his plan. This time they attracted attention. A bridge company was formed in 1865 and chartered in 1867, and Roebling was appointed chief engineer.

The creator did not live to see his bridge; John Roebling died in 1869 as a result of an accident. Washington Roebling replaced his father as chief engineer and supervised the construction. But the final bridge remains in all essentials John Roebling's; his master plan gave the structure its shape and its reality.

For the elder Roebling the bridge's reality was multiple; it inter-sected theoretical, physical, economic, and historical considera-

tions. A fusion of these dimensions was necessary, in Roebling's mind, if the bridge was to possess the Hegelian trait of actuality or *Wirklichkeit.* "Actuality," Hegel had written, "is the unity of essence and existence, of the inner world of life and the outer world of its appearance." With the help of Roebling's manuscripts it is possible to reconstruct the steps whereby he meant to endow the bridge with this trait — to make it, in other words, a "world-historical" object.

### I

"Before the sculptor can embody his spiritual or ideal conception into marble, he must have spiritually created the statue in his mind," wrote John Roebling in "Life and Creation" (1864),[1] an essay inspired by Henry James, Sr.'s *Shadow and Substance.* The essay was to form a part of the engineer's metaphysical synthesis, "The Truth of Nature." In the same period Roebling worked on another synthesis, a study of the principles of the "parabolic truss" or suspension bridge. The work, *Long and Short Railway Spans* (1869), was to have comprised a general theory along with detailed analyses of his own major structures. Taken together, the metaphysical, the theoretical, and the practical provide the foundation for Roebling's "spiritual or ideal conception" of Brooklyn Bridge.

Roebling described, as he had earlier in arguing for the Cincinnati bridge, the suspension principle as a universal truth especially appropriate for America. Its chief feature was that it could produce long single spans, abolishing the supporting piers of the traditional stone arch bridge. A suspension bridge could cross a wide river without interfering with navigation. Hence it was "an American necessity": "No continent can boast of a more magnificent system of watercourses than ours, and on no other continent will there be a greater development of internal commerce, by land as well as by water." [2]

1. Roebling Collection, Rutgers University Library.
2. Preface, *Long and Short Railway Spans.* Roebling Collection, Rensselaer Polytechnic Institute.

If nature created the need for long-span bridges, it also supplied the means. "The nature of things" demonstrates the practicality of long-span suspension bridges. For the underlying principle of the form derives from one of the simplest unities of nature: the catenary curve, formed by a rope or cable hanging freely between two fixed points of support. The uses of this curve were "remarkable": "the problems of the greatest strength, greatest economy, greatest safety, of perfect equilibrium and consequently also of perfect stability, are all solved by the same curve." Because it was "a curve perfectly equilibrated in all its parts, and perfectly at rest, when not disturbed by outside forces," it would "support the greatest weight with the least tension at the point of suspension." Thus the catenary was the "true theory" for long spans.

The theory was simple: cables, anchored on shore, pass over towers and dip to form a catenary curve; the curve is also an inverted arch. Attached to the cables by suspenders is the roadway. The suspenders not only carry the roadway but form a truss with the cables, roadway, and towers. Hence the term: "parabolic truss." Because they are extended, the cables are in tension, while the towers, resting upon foundations on the river bed, are in compression. Viewed theoretically, the structure was a unity of opposite forces, harmonizing tension and compression.

Roebling had dealt with the subject of force in a section of "The Theory of Nature." It appeared as an essay in *The Scientific American* in 1865. The thesis of the essay was that "all forces in nature spring from one common source" — "Universal Causality." He presented a picture of a dynamic universe held in equilibrium by "a constant play of energies and movements communicated from one to the other." Force was matter-in-motion. It originated from a disturbance of "rest." In its effort to regain rest, matter generated force. Once set in motion, this force remained active in the universe, changing its form but remaining essentially "only a communication of a disturbed condition from one molecule to another." By balancing all its forces in a harmonious system, the universe ap-

peared to be in equilibrium. But in truth, all appearances of rest
were illusions: "A force at rest is at rest because it is balanced by
some other force or by its own reaction." A rock, pressing upon the
ground, was supported by "the reaction of the foundation"; the
pressure was "felt through the whole earth." [3]

The microcosmic unity of opposing forces in the suspension
bridge was therefore a reflection of the macrocosmic harmony of
"well-balanced motion." Just as one part of the structure commu-
nicated its force to another part, creating "the wonderful action and
harmony of the whole," all phenomena in nature were "interwoven
and interlocked." Furthermore, if in the macrocosm the whole
could be comprehended only by "an infinite mind," it was that
part of man connected with the infinite, his "spiritual eye," which
perceived unities in the microcosm. Mathematics represented this
spiritual perception; it was "the key which will unlock these mys-
terious movements." And because "all engineering questions are
governed by simple mathematical considerations," the suspension
bridge was truly "a spiritual or ideal conception."

Simple though the principle of the suspension bridge was, its
practical application required additional considerations. The cate-
nary curve by itself did not assure a bridge's stability. The chief
physical factors for stability were weight and stiffness. The heavier
the span the more secure: simple inertia would "prevent a dis-
turbance of its parts." Hence the longer the spans, the greater the
weight, the greater the stability. As for stiffness, it was necessary to
reinforce the truss formed by the cables and suspenders. Concerned
about vibrations caused by moving locomotives or "the violence of
a hurricane" — vibrations which could destroy the tension members
of the structure — Roebling devised a  trussing system that func-
tioned independently of the main cables. This was a system of
inclined stays which extended in diagonal lines from the summit of

3. "Remarks on the Subject of Force in General," *Scientific American*, Vol. XII,
New Series (1865), 114–15, 128, 144, 160.

the towers to various points on the roadway. He even provided that these stays be strong enough to support the roadway if the main cables should be removed or damaged. Each of the stays formed a hypotenuse of a right triangle; the towers and roadway were the other sides. Like the catenary curve, the triangle was a true principle of nature, "the only immovable figure in geometry." Triangle and catenary together could not help but hold the span in place.

To connect the bridge to the earth was the function of the towers and the anchorages. Both had to be massive: the anchorage to hold the anchor plate for the cables securely against the ground, and the towers to ensure stability against the downward pressure of the cables passing over their roofs. Thus the sheer mass of the towers and anchorage joined with the geometry of the cables to form a theoretical system rooted in the principles of nature.

## II

To pass from a conception in John Roebling's mind to an actuality over the East River, Brooklyn Bridge needed next to become an economic and political entity. Drawings and mathematical symbols were adequate to explain the idea to engineers, but words were necessary for businessmen and politicians. If his bridge was to be built at all, Roebling had to promote the idea.

New York in the 1860's was in the grip of the Tweed Ring, who were notorious for making public projects, like the Chambers Street Courthouse, a source of graft. In 1860 Roebling wrote: "As for the corporations of Brooklyn and New York undertaking the job, no such hope need be entertained in our time." Nor was it "desirable to add to the complication and corruption of the governmental machinery of these cities." He proposed that private interests undertake the project.[4]

4. Letter, *Architects' and Mechanics' Journal*, April 14, 1860.

Such an undertaking would require, however, far greater funds than could reasonably be raised privately. Any company, therefore, would need access to public monies. A pattern for the use of government revenue by construction companies already existed; indeed, such an alliance between the private and public sectors was a hallmark of the pre–Civil War internal improvements programs. Led by William Kingsley, a man with wide experience as a contractor, a group of Brooklyn and New York businessmen founded a company in 1867 for the purpose of constructing a bridge between the two cities.[5] Their first step was to acquire a charter from the state legislature.

Although his plans provided the impetus for the company, John Roebling himself had little to do with the legal procedures. The charter of 1867 is, however, a document of considerable importance to the nature of his bridge. The charter defined the status of the proposed bridge, and although that status changed a good deal before the bridge was opened in 1883, the initial definition reveals the underlying assumptions about city life which Roebling — in his capacity as promoter — had to take into account.

The most important fact about the 1867 charter is the absence of any significant concern with the bridge as a modification of an urban environment. It is simply an empowering document; it leaves the New York Bridge Company free of any controls in its decisions. The company was granted the right to build and main-

5. Kingsley's background had prepared him for his role as a founder of the Bridge Company. He had left home on a New York farm at the age of eighteen and joined a Pennsylvania railroad company as a clerk. After a few years as a bookkeeper, he rose to the position of supervisor on a canal project. Moving west, he became an independent contractor and railroad builder, returning to the East in 1857 (a depression year) to become a leading contractor in Brooklyn. City improvements became his speciality, and he found that his influence among bankers and insurance companies, as well as his interest in the Brooklyn *Eagle*, served him well. Although he never held office, he was thought of as a principal power in Brooklyn politics — perhaps, it was said, the leader of a Brooklyn Ring. See Harold Coffin Syrett, *The City of Brooklyn, 1865–1898* (New York, 1944), 75. Also, *Chronological Narrative of Brooklyn Bridge* (Department of Public Works, City of New York, 1933).

tain a public highway between two major cities, with the power "to purchase, acquire and hold as much real estate as may be necessary for the site of said bridge." It was allowed "to fix the rates of toll for persons, animals, carriages, and vehicles of every kind or description." Net profits were set at a limit of 15 per cent per annum, making the project a handsome investment. The cities were authorized to issue bonds in order to raise money for the company, but were not given a voice on the board of directors. Complete control rested with the board, to be elected annually by the stockholders; the cities were not required to approve the plans or the location. The only regulation to which the plans had to submit was national: an Act of Congress in 1869 established the bridge as a lawful post road, provided the height of the span was increased five feet, as recommended by a commission of army engineers. No other public scrutiny seemed necessary.[6]

### III

John Roebling prepared his master plan as a report to the New York Bridge Company. He delivered it in person at a meeting in September, 1867. Addressed to businessmen, the report is couched in a language of simple calculations; it begins and ends with the question: "Will the work pay as an investment?" [7]

To prove the bridge's practicality, Roebling explained the system of the suspension bridge. He pointed out that the length of the span — 1600 feet — and its weight — 5000 tons — would themselves assure stability. He explained the system of diagonal stays

6. *East River Bridge, Laws and Engineer's Reports, 1868–1884* (New York, 1885), 1–27. Roebling himself requested that the Company appoint a board of consulting engineers, consisting of seven professional engineers, to approve the plans — which they did. His motive was to overcome the skepticism of such figures as Horace Greeley and Mayor Kalbfleish of Brooklyn. See Steinman, 317.

7. *Report of John A. Roebling, C.E., to the President and Directors of the New York Bridge Company, on the proposed East River Bridge* (New York, 1867). All quotations are from this edition.

in great detail, emphasizing its role as a partner to the main cables. With their strength, the bridge was safe: "If the cables were removed, the Bridge would sink in the centre, but would not fall." And he explained that steel, never before used in suspension bridges, would increase the over-all strength of the structure.

Most of the technical discussion in the report was about the accommodations for traffic on the roadway. Roebling described his plan for five lanes, the two outer lanes designed for horse-drawn carriages, the inner lanes for a cable-train. The cable-cars would be a lucrative source of revenue; as rapid transit, they would appeal to the American businessman, for whom "time is money": "He will not hesitate to pay a charge of five cents for one mile of steam travel, when he can traverse this distance, from the centre of one city to the centre of the other, inside of five minutes." The fifth lane was a boardwalk, with an entirely different "principal use." Elevated 18 feet above the traffic it would "allow people of leisure, and old and young invalids, to promenade over the Bridge on fine days, in order to enjoy the beautiful views and the pure air." Roebling added: "I need not state that in a crowded commercial city, such a promenade will be of incalculable value."

His description of the elevated promenade was only one of several ways Roebling introduced to his audience the idea that the bridge served "the interests of the community as well as of the Bridge Company."

Explaining his choice of location of the New York terminus, opposite the Register's office in City Hall Park, Roebling argued that the bridge and its masonry approaches "will greatly beautify and improve this part of the city, which appears to need it more than any other." His desire for beauty expressed the engineer's sense of community; he pointed out that the approaches would require razing many of the buildings near the waterfront, and that the Bridge Company should take responsibility to construct new streets and improve the site. He hoped that the Company would

apply for the authority to do so, or that at least a separate improvement company be formed. It was "a most remarkable circumstance," he said, that so much valuable space should for so long be neglected by the cities; "every citizen who feels an interest in general improvement" will feel it "desirable that the construction of the Bridge and of the improvements underneath should be carried on simultaneously, and upon one and the same plan.'" He proposed that "a good market hall" be built to replace the old Fulton Market, "to better serve a vast and dense population all around within a radius of a half a mile. This hall would be most convenient for all the marketing which will come over the Bridge from the Brooklyn side."

Yet another service of the bridge appealed to businessmen who might grumble over "beauty." Describing the anchorages and their function, Roebling pointed out that two large spaces would be left open in each; these could be "improved and utilized to an excellent purpose, so as to bring a higher rate of rent." These spaces would house treasury vaults, the safest and most convenient on the continent. Properly managed, he declared, these vaults "would soon be filled with three-fourths of all investments now held in this country."

This plan, which never materialized, served as a transition to the next phase of Roebling's argument. The bridge embodied a historical reality — a shift of the center of civilization from Europe to America.

Roebling predicted that on the completion of the Union Pacific Railroad — which occurred in 1869 — "a great change" would take place in the world.

> This change will at first be very slow, but the breadth and depth of the new commercial channel will increase with every coming year, until at last the city of New York will have become the great commercial emporium, not of this continent only, but of the world. In another half-century, Liverpool and London, as com-

mercial centres, will rank second to New York. This is no futile speculation, but the natural and legitimate result of natural causes. As the great flow of civilization has ever been from East to West, with the same certainty will the greatest commercial emporium be located on this continent, which links the East to the West, and whose mission it is in the history of mankind to blend the most ancient civilization with the most modern. The old and new are to meet on this continent, and this will be effected through the means of commerce.

Moreover, the idea that America "links the East to the West" recalled the voyage of Columbus — the first phase of the "great flow of civilization." Although he did not make the idea explicit, it was apparent that after the Union Pacific Railroad, Brooklyn Bridge would be the final link, the virtual completion of Columbus's efforts to find a passage to India. Joining Long Island to the mainland, it would be the threshold of an east-west system of highways.

In Roebling's mind, a monumental bridge would acknowledge the movements of history, and also participate in them. For in ten years, a hundred million people will need to cross the East River yearly. The people "will make their appearance in due time, because they will simply form a portion of that natural and legitimate increase of population of the whole country, which will have centered about New York." In fact, the increase in population would be so great that additional bridges would be needed. And yet other avenues: "The time will arrive when substantial tunnels will be constructed, at an immense cost, *under* the bed of the river." The Bridge Company need not fear competition; the "natural and legitimate increase of population" would create enough wealth for all. Profits will be "so immense, that the Bridge Company in a few years after the completion of the work, will feel justified to put up great magnificent depots and portals at both terminii, which shall be a credit to the two cities."

Above all, Brooklyn Bridge was in its creator's mind a principle of order. Representing nature's laws and man's history, the bridge subdued, in mind if not in fact, the implied chaos of millions of people making their separate ways across the river. It would give their passage a form, and link them in consciousness to their national destinies as Americans. Its highest function was to salute history and provide a threshold to the future. And if it needed a tunnel to assist its labors, that too would share in the celebration of American society.

Drawings for East River Bridge towers, J. A. Roebling, 1857
(Rensselaer Polytechnic Institute)

# 5

*How does it come that we can appreciate the beauty and diversity of colors, the sound of music? Why does a flower attract us, when we are repelled by the sudden appearance of a snake, or a savage monster in the animal kingdom? Is it not because the same mind that composed the flower, composed us and instituted attractive relations between us and those beautiful objects? Here we see the beautiful harmony. The flower was made to correspond to our senses and call forth our promptings after the beautiful.*

<div style="text-align: right;">

JOHN AUGUSTUS ROEBLING, "The Harmonies of Creation"

</div>

# A Monument

In the preface to his Report to the New York Bridge Company in 1867, John Roebling wrote:

> The contemplated work, when constructed in accordance with my designs, will not only be the greatest Bridge in existence, but it will be the greatest engineering work of this continent, and of the age. Its most conspicuous features, the great towers, will serve as landmarks to the adjoining cities, and they will be entitled to be ranked as national monuments.

Roebling's claims were far from modest, but history has borne them out. There is no more famous bridge in all the world. And in 1964, almost a hundred years later, the American government proclaimed the structure an official national monument.

In Roebling's mind the monumentality of the bridge was assured by the massive stone towers. Carved as corniced walls and pierced with huge Gothic arches, they made the bridge "a great work of art" as well as "a successful specimen of advanced Bridge engineering." Roebling was apparently unaware of any anachronism in his selection of medieval forms to express America's new role in history. A "Gothic revival" had influenced American architecture since the 1840's, and the public was accustomed to broken arches in private homes, commercial buildings, and churches. It did not seem out of place to use the traditional motif along with the most advanced engineering techniques. The juxtaposition, in fact, gave rise to the popular observation that past and future meet in the

towers and superstructure (cables, stays, and roadway) of the bridge.

The conventionality of the tower design might appear to call into question Roebling's idea of what was art. By implying that the masonry was "art" and the rest "engineering," he seemed to accept without qualification the popular thinking of his age, which conceived of "architecture" as decoration. It is clear that he chose his tower design for symbolic rather than functional reasons.[1] On the other hand, his choice of allusive forms may have derived from a more sophisticated aesthetic. Hegel had written: "Art frees the true meaning of appearances from the show and deception of this bad and transient world, and invests it with a higher reality and a more genuine being than the things of ordinary life." Roebling echoed this idea in his statement that the perception of beauty is the perception of universal harmony. If this is the case, a work of art must represent the "Great Mind" — must function as a symbol of the harmony it embodies. By this reasoning Roebling may have

1. Functionalism — or the idea that an unadorned utilitarian structure can be beautiful in its own right — was discussed by engineers as well as architects. Carl Condit quotes a writer in an American engineering journal in 1869: "It may be stated, as a general view, that whatever in construction — in engineering construction, even — is true and suitable and proportional to strain and service, is also beautiful" (*American Building Art, The Nineteenth Century*, 271). A fuller statement, related directly to bridges, was made some years earlier by an Englishman, William Hosking: "The usual *materia architectureae* are entirely out of place, and out of character, in bridge composition. . . . If a work such as a bridge be well composed constructively, whatever may be the constituent material or materials employed, and whatever may be the kind of construction, it can hardly fail to be an agreeable object for it will certainly possess the essentials to beauty in architectural composition, simplicity and harmony. . . . It is impossible, therefore, to draw any line between the constructive and the decorative, or what is commonly termed the architectural composition of a bridge." *Theory, Practise and Architecture of Bridges* (London, 1842). Roebling was aware of these ideas, it is likely, and took them into account in the design of the strictly engineering aspects of his bridges. He always employed, however, a traditional motif in his masonry towers. See Edward Robert DeZurko, *Origins of Functionalist Theory* (New York, 1957), esp. chap. 10, "Early American Contributions to the Literature of Functionalism."

reached his decision to designate the monumentality of his bridge by one of the traditional emblems of man's aspiration toward the divine: the Gothic arch.

## I

How much of a choice did the designer of the towers actually have? The architectural problem Roebling faced was virtually without precedent: how to integrate masonry with steel. In Europe, suspension bridge builders had an apparently easier time solving this problem; existing architectural styles provided models, and engineers simply imitated neighboring buildings to harmonize the bridges with their surroundings. Early American towers, frequently of wood, are simpler and more original than their European counterparts. But regardless of solutions, all suspension bridge designers faced the same problem. Towers or tall piers were necessary to carry the cables, to bear their weight, to support the roadway, and to join the bridge to the earth. Beyond these structural necessities, builders had a free hand with materials and design. With the development of the steel tower in the twentieth century, the realm of the arbitrary narrowed considerably; design has become very largely a matter of creating a continuous structure consistently light and airy. Before this, the style chosen for wood or masonry, whether Egyptian pylon or Roman column, had nothing to do with the function of the towers as towers.[2]

In all, the problems of the suspension bridge designer were

2. For European examples, see Charles S. Whitney, *Bridges* (New York, 1829), Wilbur J. Watson, *Bridge Architecture* (New York, 1927), Karl Mohringer, *The Bridges of the Rhine* (Baden, 1931). Early American suspension bridges by James Finley and John Templeton are illustrated in Whitney, 195, and Watson, 176, and discussed in Condit, 163–6. Also, David B. Steinman and Sara Ruth Watson, *Bridges and Their Builders* (New York, 1957), and Elizabeth B. Mock, *The Architecture of Bridges* (New York, 1949).

symptoms of the discontinuities in building caused by nineteenth-century industrialism. Industrialism created both the techniques for such a bridge and the need: heavy trains requiring support and large expanding urban populations. But industrialism also cut the builder off from the rich tradition of functional architecture of the Middle Ages, throwing him upon a sea of architectural chaos. The public, especially in America, identified as architecture only certain familiar styles, the façade rather than the organic whole of a building. The architect Leopold Eidlitz had observed: "American architecture was the art of covering one thing with another to imitate a third thing, which if genuine would not be desirable." Banks paraded as Greek temples, department stores as Italian palaces. Sigfried Giedion, diagnosing the entire nineteenth century as a patient with "cultural schizophrenia," referred to the styles used in these masquerades as devalued symbols, icons once meaningful but debased by the status-seeking of the industrial age.[3]

It is possible to condemn Roebling's Gothic arches as merely fashionable disguises, an easy solution to a tough problem. But we should consider a recent reappraisal of nineteenth-century eclecticism by Carroll L. V. Meeks. Meeks claims that eclecticism, rather than a retreat from the problems of modern building, was actually a creative way of meeting those problems. The term Picturesque Eclecticism, Meeks argues, should be recognized as a legitimate style, as whole and valid as Classic or Baroque. This style, he writes, has five characteristics: variety, movement, irregularity, intricacy, and roughness. In its early phase, the style was used, it is true, mainly for associations aroused by certain historical motifs, like Gothic windows, or Byzantine minarets. But in later phases, it emerged as a synthetic and creative use of various architectural elements to express in design the major structural facts of a build-

3. Giedion's remarks are in *Space, Time and Architecture* (Cambridge, 1949), 13–17. See Winston Weisman, "Commercial Palaces of New York, 1845–1875," *The Art Bulletin*, Vol. XXXVI (December 1954), 285–302.

ing. Meeks demonstrates his thesis with a study of the changing styles of the railway station, which, like the suspension bridge, was a new and specifically industrial form.[4]

Meeks's argument can help us place Roebling's towers into his torical context. Throughout his career Roebling experimented on paper and in metal and stone with various tower styles. We see in his drawings a great variety of styles: Egyptian, Roman, Gothic, Byzantine, Baroque. Most important, we can follow the process whereby he finally chose a style; by and large his process suggests the development Meeks describes, from associational to synthetic and creative uses of the past.

The Niagara Bridge towers (1855), for example, are isolated rectangular columns, tapered to a truncated top and covered with plain ornamental blocks. At one stage of Roebling's plans, however, he drew twin piers projecting as columns from a wall which is pierced with a broken arch; above the spandrel is a small pediment. The effect is of a Georgian doorway, with a Gothic rather than Classical arch. The final solution is therefore a simplification of this design; the wall is removed between the piers; the piers tapered and truncated, assuming a somewhat Egyptian appearance. Early drawings for the Allegheny River Bridge at Pittsburgh (1858) are more elaborate. In the final version, the towers are cast-iron minarets. But an earlier design showed a masonry tower with a massive arch set into a corniced wall, complete with off-sets, spring course, inside piers with capitals, moldings, a decorative wrought-iron balcony, minaret-style adornments on the roof, and a gargoyle-corbel. His design for the tollhouse has an overhanging cornice, a minaret peak, and elaborate Baroque windows. Sketches for the Cincinnati-Covington Bridge (1867) are even more eclectic. One drawing shows a Tudor doorway, complete with battlements, turrets, and flying pennants; another shows an Egyptian doorway, with a tri-

4. Carroll L. V. Meeks, *The Railroad Station: An Architectural History* (New Haven, 1956), "The Nineteenth Century Style: Picturesque Eclecticism," 2–26.

glyph, corbel, and ornamental blocks. The final design is a buttressed wall similar to that of Brooklyn Bridge, with a large Roman arch opening; on the roof are a parapet and twin Byzantine spires.

Three very early drawings for Brooklyn Bridge towers, drawn within a period of two weeks in March 1857, again indicate Roebling's pattern of eclecticism. The first is the most elaborate; it is an Egyptian doorway with a fantastic triglyph of curling lines, a spread-eagle gargoyle for a corbel, and ornamental blocks. The second is much simpler; it recalls the early Niagara design, a plain wall, two piers, a small pediment, and a round arch opening. The third becomes even more monolithic; the piers project more forcefully, are truncated at the top, and are surmounted with a triangular form which accentuates the upward movement. The arch is still Roman, but in pencil, Roebling superimposed the shape of a Gothic arch. All of these designs are for much smaller towers than the final ones; they have only one opening, and about half the height of the completed version.[5]

The final version is another simplification. The ornament is minimal; it amounts to buttresses, a very mild corbel, off-sets, a plain cornice, and a rough texture. The arches, of course, are the most striking feature. They are quite high, surely much higher than they need be to serve simply as openings for traffic. One reason for the height may have been to lighten the wall within the limits of masonry, thus anticipating the openness of later steel towers. But much more significant is the fact that the arches unavoidably call attention to themselves as a form partly independent of the rest of the bridge. This may be, to a strict functionalist, a defect. But in Roebling's mind it must have been a virtue. For, in their outline against the sky, resembling the long lancet windows of English Gothic churches, the arches proclaim themselves not only as passageways, but monumental passageways. Literally, they are gate-

5. Although they are titled "Brooklyn Bridge," these drawings may have been for a route across Blackwell Island. Roebling Collection, Rensselaer Polytechnic Institute.

ways; but they are also icons, bearing the motif of a gateway. The theme they announce is that to pass through them is something more than to pass through an ordinary doorway. They add grandeur to the act of crossing the bridge.

This view of the towers is implicit in Roebling's report. The towers, he indicated there, would open upon the civic centers of both cities; they would supply what the cities lacked, an emblem to unite and identify them, like the wall, the fortress, and the cathedral in older European cities. They would formally establish New York — Manhattan and Brooklyn — as the new center of the world.

## II

Lewis Mumford has described Roebling's towers as "the highwater mark of American architecture in the period between the design of the Washington Monument and the last phase of Richardson." But an earlier critic, Montgomery Schuyler, had an another opinion. Schuyler, the first student of architecture to comment on the bridge, admired the engineering but deplored the art. He questioned Roebling's high claims.[6]

Schuyler did not deny the significance of the structure; he was the first critic to recognize its importance. In his essay, "Brooklyn Bridge as a Monument," written on the occasion of the Opening

6. Mumford does grant that the "heavy rustication of the granite" and the "character of the stone cornice" may be weaknesses. *Brown Decades* (New York, 1931), 104. See also, by the same author, "Function and Expression in Architecture," *Architectural Record*, Vol. X (Nov. 1951), 106–12, and "Monumentalism, Symbolism, and Style," *Magazine of Art*, Vol. XLII (Oct. and Nov. 1949), 202–7, 258–63, in which he argues on behalf of symbolism and monumentality in modern structures. Another architectural critic and scholar, Talbot Hamlin, shared Mumford's admiration of Roebling's towers, finding in them an "impression of immense power" — similar to that of the court of Thebes, the Roman Colosseum, and the cathedrals at Rheims and Westminster. *The Enjoyment of Architecture* (New York, 1929), 21. Elizabeth Mock more recently wrote: "In the Brooklyn Bridge, two materials of opposite nature are brought together in harmony; granite, strong in compression, piled majestically into the sky; steel wire, strong in tension, spun lightly through space." *The Architecture of Bridges*, 58.

Ceremonies in May 1883, Schuyler imagined a future archaeologist one day surveying the ruins of New York, "the mastless river and a dispeopled land." Only the towers of the Great Bridge are likely to survive; the cables and roadway would have already disintegrated. "What will his judgement of us be?" [7]

Through this fancy Schuyler made the point that the towers were meaningless forms without the superstructure of cables and roadway. Standing alone, they offer no clue to their function, or of what they are. This was a result of the designer's failure to incorporate the function of the towers in their design. Gothic arches, cornice, buttress, off-sets — these motifs plainly indicated that the engineer had relied on his conventional sense of beauty; the architectural details were decorations, not integrated aspects of the towers' function. In effect, the engineer had treated the masonry in a careless and insensitive manner.

Architecture should "expound, emphasize and refine" the structural elements of a building, not disguise them. In function the towers consisted of three standing piers each; each pier supported a cable (or two, in the case of the central post). The space between the piers was closed to form a solid wall, and the wall pierced with openings for traffic, the openings formed broken arches. So far so good; Schuyler had no objections. But to express this arrangement honestly, the designer should have given the piers more emphasis; they should "assert themselves starkly and unmistakably as the bones of the structure, and the wall above the arches should be subordinated to a mere filling." Instead, the piers are only shallow projections, hardly distinguishable from the wall. And the arches are "merely tunnelled through the mass," where they should have been carefully modeled. The entire wall needed more accents, more contrast, "higher lights and sharper shadows."

7. "Brooklyn Bridge as a Monument," *Harper's Weekly*, Vol. 27 (May 26, 1883), 326; most recently reprinted in Montgomery Schuyler, *American Architecture and Other Writings*, ed. William H. Jordy and Ralph Coe (Cambridge, 1961).

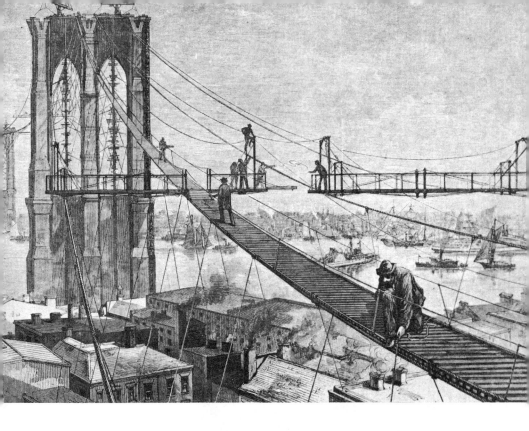

Stages of construction (*Harper's New Monthly Magazine*, May 1883;
Bettmann Archive)

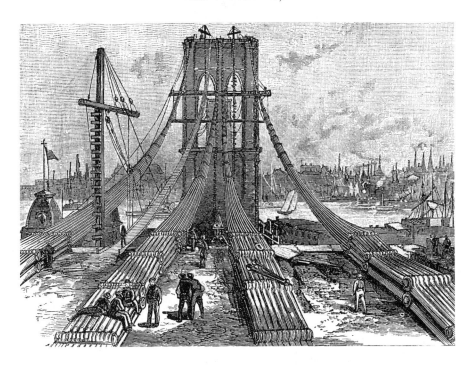

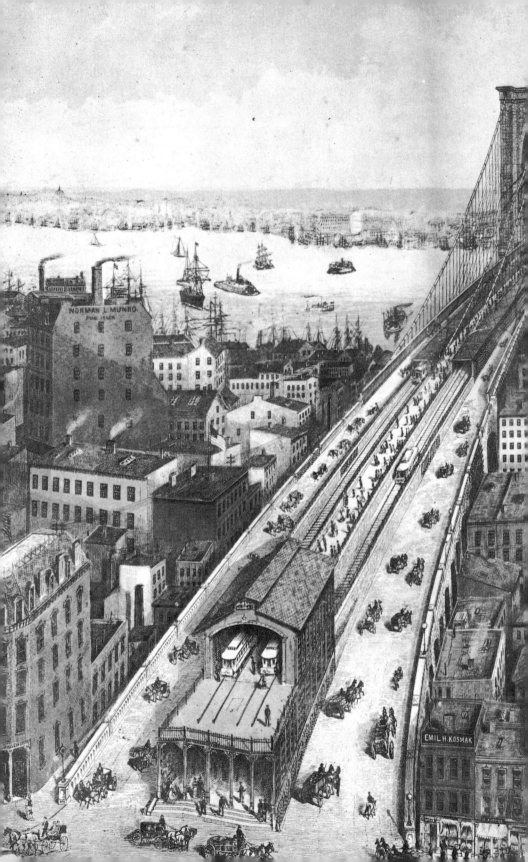

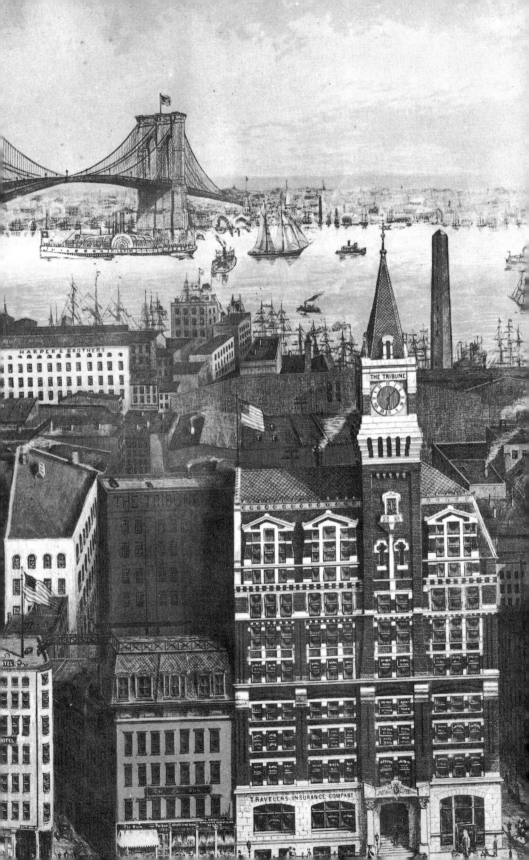

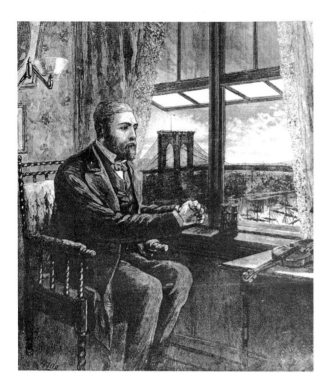

Washington Roebling, 1883
(*Frank Leslie's Illustrated
Newspaper*, May 26, 1883)

Brooklyn Bridge, 1883 (*Frank Leslie's Illustrated Newspaper*, May 26, 1883)

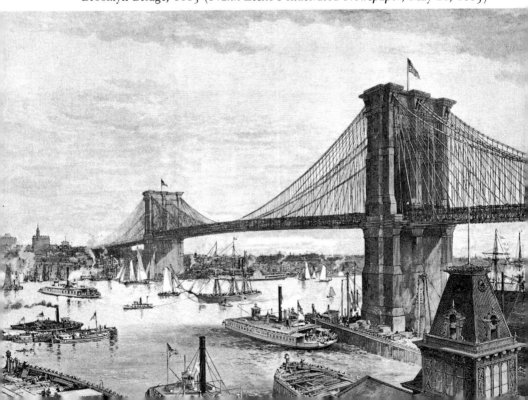

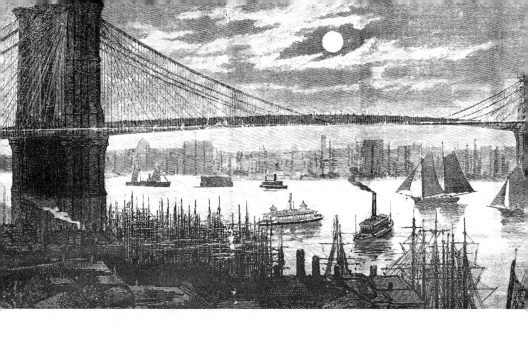

The Bridge at night. Above: Engraving by C. Bunnell (*Frank Leslie's Illustrated Newspaper*, May 26, 1883); below: Aquatint by Joseph Pennell, 1922 (Courtesy of the Brooklyn Museum)

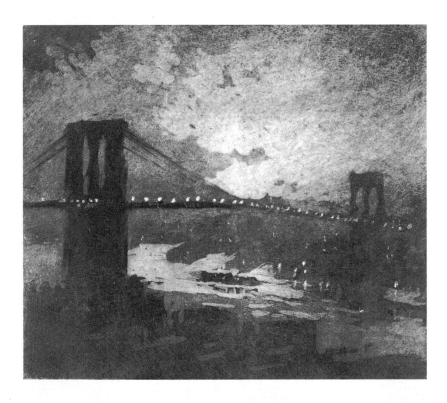

Beauty on the Bridge
(Museum of the City of New York)

Robert E. Odlum in a
dramatic—and fatal—leap.
May 19, 1885
(Bettmann Archive)

On Brooklyn Bridge. Oil by Albert Gleizes, 1917
(Courtesy of the Solomon R. Guggenheim Museum)

Two views by John Marin. Above: Related to Brooklyn Bridge. Oil, 1928 (Collection of Mrs. Edith Gregor Halpert, Courtesy of the Downtown Gallery); below: Brooklyn Bridge, 1917. Etching (Courtesy of the Brooklyn Museum)

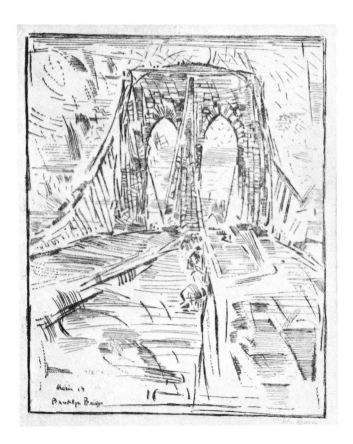

Schuyler admitted that the towers had a force and magnitude
commensurate with their function as the heavy parts of the bridge.
But to his eye they were dead and spiritless. He wanted more visual
evidence that the true work of the structures was to bear a heavy
load over their roofs.

Schuyler therefore directed most of his scorn toward the design
of the roof. The flatness of the top obscured the autonomy of each
pier. Moreover, the flatness concealed the "exquisite refinement"
of the arrangement whereby the cables passed over the piers. Each
cable rode upon an iron saddle embedded in the masonry at the
very peak of each pier, just below the cornice. "Is it not perfectly
evident," he wrote, "that an architectural expression of this me-
chanical arrangement would require that the line of the summit,
instead of this meaningless flat coping, should, to begin with, be a
crest of roof, its double slope following the line of the cable which
it shelters?" [8]

Roebling had in fact planned to place upon the roof sloped
ornamental blocks; lack of funds prevented their appearance. But
the flatness of the roof can be justified on its own grounds: the
main function of the towers, Roebling had explained, was not to
support the cables but the diagonal stays attached to the roadway.
Remove the cables, and the bridge would remain standing. Schuy-
ler neglected to consider the towers in their function as sides of
many right triangles; he apparently did not understand the func-
tion of the inclined stays.

Although Schuyler's criticisms are occasionally questionable,
they do point to something significant about the bridge. Unavoida-
bly it embodies two styles of building: the masonry, good or bad, is

8. Schuyler reports that Eidlitz admired Brooklyn Bridge but deplored the towers.
Eidlitz, according to Schuyler, had offered through a mutual friend to design the
towers for Roebling; the friend declined to pass on the offer, out of regard for Roeb-
ling's vanity. Schuyler remarks: "It was a great pity. . . . If he had done it, the
towers would not now stand as disgraces to the airy fabric that swings between
them" (*American Architecture*, 154).

traditional, while the steel is something new. To be recognized as architecture, structural stone must be carved into a familiar shape, while the steel, unburdened with precedents, could take whatever shape its function demanded.

Schuyler applauded the steel parts of the bridge for their honesty, their directness. The superstructure represented for him precisely what was lacking in the masonry parts: a marriage of form and function. "This is anatomy only, a skeletonized structure in which, as in a scientific diagram, we see — even the layman sees — the interplay of forces represented by an abstraction of lines." It was a "gossamer architecture," an "organism of nature."

More is the pity, then, that the superstructure would not survive the ravages of time and provide the archaeologist with a true sign of the age. For the engineer represented the genuine spirit of the times. It was significant to Schuyler that the leading monument of age — as he acknowledged the bridge to be — was a utilitarian structure, not a place of worship, but a highway. Moreover, when the engineer turned his hand to the traditional craft of masonry architecture, he blundered. He dealt with stone without the respect for workmanship that medieval builders felt. This was not his fault, Schuyler insisted, but the age's; the times demanded honesty and accuracy only on its utilitarian works, and conventionality in its art works. Roebling had built as best as he knew how, but the age's best was not good enough.

If the explorer of the future were to pass from New York harbor to the great Gothic cathedrals of the thirteenth century, how surprised he would be to learn they were six hundred years older than the unexplained towers in the New World! The old builders had understood the need of form to follow function. Every move was an elaboration of function; this was the height of building. And yet, Schuyler noted, the present age dares to look with contempt upon the past "as rude and barbarous and unreasoning."

In Schuyler's mind, Brooklyn Bridge, when considered with the

great cathedrals, seemed to indict the present age. Indeed, as engineering, it represented progress and foreshadowed a new era in building: the *engineer* had recaptured the spirit of the old masters. But as art, it was crude. The engineer as architect provided only what the age demanded and deserved, no more, no less — a monument embodying the ambiguities of its culture.

Fireworks and illumination in the evening (The J. Clarence Davies Collection, Courtesy of the Museum of the City of New York)

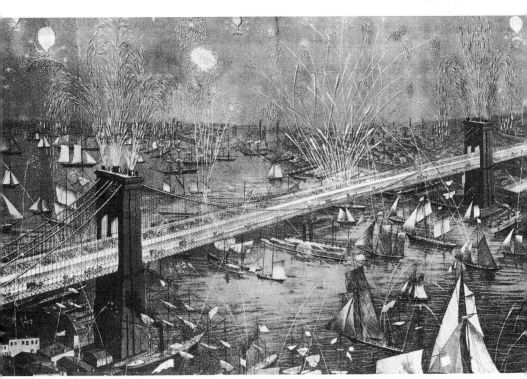

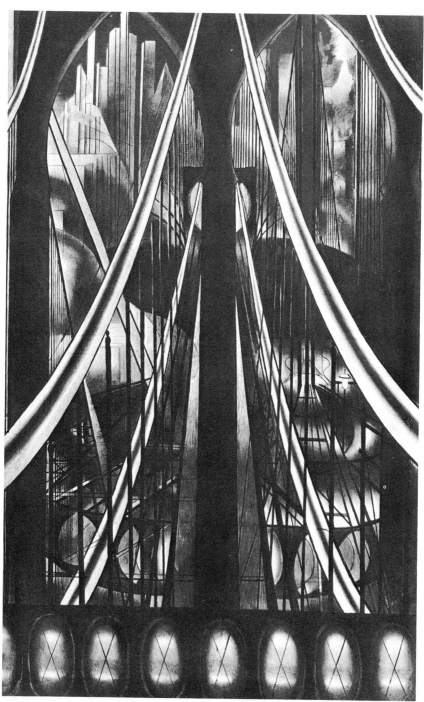

The Bridge. Oil. One of five panels by Joseph Stella entitled New York
Interpreted, 1922 (Courtesy of the Newark Museum)

# FACT and SYMBOL

President Chester A. Arthur at Opening Ceremonies
(*Harper's Weekly*, June 2, 1883)

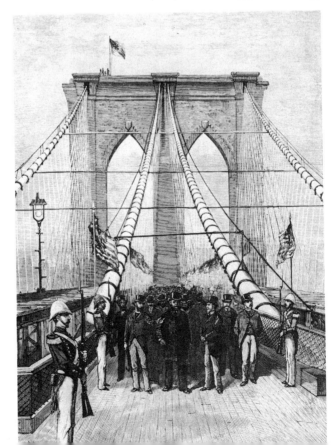

# 6

There can be no essential antagonism in creation. There can be no absolute opposition to the fulfillment of the Creator's design. . . . Yet the existence of evil in human life is a fact too patent to be ignored or to be denied. There is evil and plenty of it, the world over, but all this evil may be traced in its origin to man's transgression of the laws of his own being.

JOHN AUGUSTUS ROEBLING, "Life and Creation" (1864)

Is it the best of all possible worlds?

HENRY GEORGE, Social Problems (1883)

# History—and Secret History

In April 1883, a month before the long-awaited opening of the bridge, Henry George began a series of articles in *Frank Leslie's Illustrated Magazine*. In "Problems of the Times," George extended his argument of four years earlier, in *Progress and Poverty*, that as wealth increased in America, so did poverty and distress. He blamed the social system and, writing now as a journalist, reported accounts of human wretchedness, of emotional confusion, of corruption in government, of the rule of monopolies, and of latent violence in city streets. American society, he argued, was torn by the contradiction between wealth and poverty, between promise and distress—a confused and helpless giant. Social intelligence had not kept pace with technological intelligence.

And what better example to make this point in the first article than that of the Great Bridge about to open? He wrote:

> We have brought machinery to a pitch of perfection that, fifty years ago could not have been imagined; but in the presence of political corruption, we seem as helpless as idiots. The East River Bridge is a crowning triumph of mechanical skill; but to get it built a leading citizen of Brooklyn had to carry to New York sixty thousand dollars in a carpetbag to bribe a New York alderman. The human soul that thought out the great bridge is prisoned in a crazed and broken body that lies bed-fast, and could only watch it grow by peering through a telescope. Nevertheless, the weight of the immense mass is estimated and adjusted for every inch. But

93

the skill of the engineer could not prevent condemned wire from being smuggled into the cable.[1]

The image of defective wire woven into the bridge, the engineer and the public watching unsuspectingly, drops us, like the elevators in Hart Crane's "Proem" to *The Bridge*, from the heights of John Roebling's vision to the realities of American life (see p. 152).

## I

The construction of Brooklyn Bridge had been full of drama and excitement. The sinking of caissons, the raising of great towers, the spinning of cables — all of this had the suspense and uncertainty of any good story, and Americans followed it avidly. Up to six hundred men had worked on the project at once, and over twenty lost their lives. The job might very well have been taken as an initiation into a new era, and the deaths as heroic sacrifices, remembering the old superstition that all bridges demand a human life: a bridge being a transgression of a fundamental barrier of nature, the barrier of water.[2]

The story of the building of Brooklyn Bridge assumed a legendary aspect even while construction continued. Like every legend, this one had some shadowy elements. Who was the

1. The articles were collected and published as *Social Problems* (New York, 1883), 19.

2. The superstition has its root in an ancient ceremony in which once a year a human surrogate was thrown from a bridge into the flood. How close to the origin of religion this ceremony was is indicated by the common root of the Latin words for bridge and priest: *pons*. Standard sources for the details of construction are: A. C. Barnes, "The Brooklyn Bridge," *Harper's New Monthly Magazine* (May 1883), 925–46; W. C. Conant, "A History of the Bridge," *Harper's Franklin Square Library*, No. 331 (1883); E. F. Farrington, *Concise Description of the East River Bridge, with Full Details of the Construction* (New York, 1881); S. W. Green, *A Complete History of the New York and Brooklyn Bridge: From Its Conception in 1866 to Its Completion in 1883* (New York, 1883). See also articles and illustrations in *Frank Leslie's Weekly*, *Harper's Weekly*, *Engineering News*, *Scientific American*, and *The Iron Age*.

builder? It was believed that a character named Roebling, crippled and perhaps insane, controlled the work, like a wizard, from a room overlooking the harbor in Brooklyn Heights. He had a beard, and watched his magic work through a telescope. But if one were to ask, "Which Roebling?" the response would more than likely be bewilderment. Was there more than one? The fusion of the father John A. Roebling and the son Washington A. Roebling is itself one of the mythic elements of the story.

"Long ago I ceased my endeavor to clear up the respective identities of myself and my father," wrote Washington Roebling to a correspondent in 1924, when he was eighty-eight years old, two years before his death. "Many people," he continued, "think I died in 1869." But it was the father, John Roebling, who died that year at the age of sixty-three — victim of a cruel accident. D. B. Steinman described the event:

> The Chief Engineer was taking observations to determine the exact location of the Brooklyn tower. His assistant, Colonel William H. Paine, was stationed with a transit on the distant New York shore to help by giving the line across the river. Roebling was standing on a cluster of piles at the rack of the Fulton Ferry slip, receiving signals from Colonel Paine. Engrossed in the work, the bridge-builder was oblivious to a ferryboat just entering the slip. The boat, laden with passengers, crashed heavily into the fender. The fender rack was suddenly forced against the piles, and Roebling's foot was caught and crushed between the timbers.

The toes of his right foot were amputated immediately, but lockjaw set in. The philosopher-engineer refused, as he had always, conventional medical attention. He died after two weeks of great pain.[3]

Three years later, a second disaster almost took the life of the

3. Steinman, 319. The last two weeks of Roebling's life were lived in utter dependency. But his mind remained alert. Just before he died, on July 22, he had drawn plans for a mechanical device to lift and move himself in bed.

son, only thirty-three years old, who had succeeded to his father's position. Working alongside his men in a caisson below the bed of the river, Washington Roebling was stricken with the mysterious "caisson disease," or "bends," and was crippled for life. His nervous and muscular systems, though not his mind, were permanently damaged. He continued as Chief Engineer, however, directing the work from a window in his house in Brooklyn Heights, 110 Columbia Heights; his wife, Emily Warren Roebling, served as courier. Frequently he used binoculars or a telescope to watch the bridge rise in the harbor below him.

In a recent advertisement for United States Savings Bonds a bearded man sits tense and unsmiling by a heavily draped window. In the distance there is a glow of fireworks about the familiar shape of Brooklyn Bridge. The caption identifies the grim figure as "the man who wouldn't give up," and draws the lesson: "His were the courage, skill and vision that make America a nation of great builders."

Washington Roebling would have been amused by this implied analogy between his lonely fortitude as the crippled Chief Engineer of the bridge his father had designed, and the relative safety and ease for the buyer of government bonds. Not only did his disease result in permanent physical and nervous injury, but his emotional ordeal was profound. In his thirteen years as Chief Engineer, from 1869 to 1883, Washington Roebling endured meddling trustees, crookedness of contractors, animosity of the press, and attacks against his integrity. Two weeks before the bridge opened on May 24, 1883, he wrote in a letter: "For years I have been obliged to possess my soul with all the patience and philosophy that I could muster, and when I have had to yield to the inevitable I have consoled myself by thinking with Pope, 'Whatever is, is right, etc.'" After the opening of the bridge, he seems to have had enough of the besmirched values of the day, and retiring from public view, he collected rocks, stamps, wrote his memoirs, and

gave generous advice to fellow bridge builders. He died in 1926, almost ninety years old, without having broken his pledge never to step into an automobile.[4]

Death came to Washington Roebling while Hart Crane was in the midst of an outburst of work on *The Bridge*; when the creative spurt momentarily faltered in the fall of 1926, Crane thought seriously about writing what he called a "Spenglerian" biography of the engineer. Nothing came of the plan, unfortunately. But Crane perceived that under the retiring guise of Roebling (who once described himself as "unpretentious in manner") there was a fierce heroism. Crane was right; Roebling's exploits were considerable, both as a soldier and as an engineer.

After leaving Rensselaer Polytechnic Institute as a graduate civil engineer in 1857, Washington joined his father in the construction of the Allegheny Suspension Bridge at Pittsburgh. When what he always called "the War of Rebellion" broke out, he enlisted in the 6th New York Artillery, and soon was transferred to staff duty in the Army of the Potomac. He earned three brevets for "gallant conduct," which included, among other things, the construction of a 1200-foot-long suspension bridge across the Rappahannock, and a shorter bridge across the Shenandoah at Harper's Ferry. He took part in the pursuit of Stonewall Jackson; he was on duty at general headquarters during the Battle of Chancellorsville. Ascending in a balloon every morning to observe the enemy, he was the first to discover General Lee's forces moving toward Gettysburg. He saw action in dozens of battles, among them Bull Run, and left the army in 1865 as a colonel; he had entered as a private.

After his discharge, Colonel Roebling immediately joined his father at the site of the Cincinnati-Covington Bridge, and took complete charge of that project while his father worked on plans to link Brooklyn and Manhattan. He was now twenty-eight years old.

4. All quotations from the writings of Washington Roebling are from the Roebling Collection, Rensselaer Polytechnic Institute, unless otherwise indicated.

In 1867 he went to England, France, and Germany on a mission to investigate the latest developments in pneumatic foundations — a procedure of pumping air into underwater caissons. He also made a study of steel manufacture, visiting the Krupp works in Germany. Washington's letters to his father were extremely important to the planning of the bridge. In 1869 he returned, moved to Brooklyn Heights, and on his father's death was appointed Chief Engineer.

In an autobiographical note in 1883, Colonel Roebling wrote: "It has often pleased the average penny-a-line to remark that there is nothing new in the East River Bridge, and that Colonel Roebling only copied his father's plans." This mistaken notion contributed to the confusion about the builders' true roles. But the son was determined to distinguish himself from his father: "The fact is, there is scarcely a feature in the whole work that did not present new and untried problems." The form of the bridge, it is true, remained the father's; it was he alone who conceived the work as a monument and a symbol. Washington Roebling's mind did not think in those terms; his job was to get the bridge built, to see it stand first and foremost as a bridge. Because of his sudden death, the father left few specific plans for the actual construction; it was left to the son to figure out how the rainbow might materialize.

Among the technical operations that Washington Roebling contrived and supervised were: a method for removing the rock and dirt from the river bottom upward through the caissons; a method of lighting the caissons (the oxygen supply was extremely precious, making the task of lighting very delicate); machinery for raising the stone for the huge towers; the footpath slung over the roofs of the towers for the spinning of the cables; and a method for spinning the steel wire, never before used in cables. Some of his on-the-job decisions were equally impressive. When the New York caisson hit a bed of boiling quicksand before reaching solid bed-rock, Colonel Roebling decided not to risk loss of life, of time, and of money by taking the foundation any lower; he stopped within a few feet of

bed-rock, leaving a cushion of sand to distribute the pressure of the entire New York foundation and tower. Thus the New York tower rests on sand, but it has never settled unevenly. Anticipating that cable-trains would not be sufficient for bridge traffic and that elevated trains would probably get a franchise to run across the structure, Washington Roebling decided to widen and strengthen the roadway. In all, he wrote, "the changes that these improvements involved have made the bridge almost a different structure from the one originally designed."

From the time of his collapse in the New York caisson in 1872 to the end of the job, Washington Roebling lived in great pain; he was close to death more than once. In the winter of 1873, fearing he might die before his work was done, he spent all his energy writing out in detail minute directions for the remaining tasks, which included the making of the cables and the complicated assemblage of the superstructure. Too weak to talk, unable to visit the site, Washington Roebling doled out his energy with exacting care. His life, and his bridge, depended upon it.

## II

Brooklyn Bridge may have been conceived as a beautiful idea in the mind of John Roebling, but the midwives had horny hands. The full story of the origin of the bridge is probably sealed on many dead lips, but the discernible facts are these: In 1867, State Senator Henry C. Murphy, an associate of Kingsley and co-founder of the Bridge Company, approached Boss Tweed for his help in securing a charter from the legislature. The help cost $65,000, which Murphy handed over to Tweed. These facts were uncovered in 1878, the year of the defective wire scandal. Both events seemed to substantiate Henry George's charge: in the long run the bridge was surely a social good, a public service (only ferryboat operators continued to oppose it); but in the short run it seemed to serve the

pocketbooks of some notorious private citizens. During the entire period of its construction the bridge was shrouded in suspicion. One newspaper listed it among the "seven fraudulent wonders of the New World," along with the Chambers Street Courthouse, the Northern Pacific Railroad, and the Washington pavements. "Conceived in iniquity and begun in fraud," the paper exclaimed, "it has been continued in corruption."

Just how much corruption, and whose, has never been made perfectly clear. During the thirteen years of construction the Bridge Company was investigated more than once; except for the bribe to Tweed and a payment to Kingsley "beyond the amount to which he was entitled," nothing substantial was ever proved. But the charges continued right up to the Opening Ceremonies. This suspicion itself, aside from whatever chicanery was practised, is the clue to the state of urban culture in the Gilded Age. On most occasions Americans were predisposed to doubt the integrity of their leaders, especially when confronted with the apparently mysterious ways in which large construction projects came into being.

Much of the distrust in this case arose from the fact that no one seemed to know exactly who "owned" the unfinished bridge. The source of the shopworn ploy by which the city slicker "sells" the bridge to his hayseed cousin may very well be this same uncertainty. The original charter of 1867 was hardly vague on this matter: the bridge belonged to the New York Bridge Company. But from the public's point of view, there was a serious catch. The charter authorized the cities of New York and Brooklyn to subscribe to the capital stock of the company to the extent of 60 per cent. They were also given the dubious right to "guarantee the payment of the principal and interest" of all company bonds. It is true that the charter also gave the two cities a way of assuming control of the project if they desired — by paying the company the full value of "the said bridge and appurtenances" plus 33⅓ per cent. Nothing was said, however, about the representation of the cities on

the board of directors. This lapse was amended in 1869 by a provision that the mayor, comptroller, and president of alderman of each city be given seats on the board. The size of the board was to remain the same as originally designated, between 13 and 21, making the public representatives a distinct minority among the directors.[5]

In 1871, after Boss Tweed had been ousted and indicted, Abram S. Hewitt was invited by the Bridge Company to join a committee established to investigate the management of company affairs. Hewitt, one of the most prominent public figures in the post–Civil War period, was to become closely associated with the bridge in a number of ways, not all of them public. A member of an old New York family, Hewitt was a son-in-law and partner of Peter Cooper, and one of the founders of Cooper Union. He had a varied career as industrialist, politician, philanthropist, lecturer, and scholar. In all his capacities, Hewitt stood very close to the sources of economic and political power. He and Cooper operated an iron plant in Trenton, which pioneered in iron girders and beams, produced all the Union gun-barrels in the Civil War and, in the 1870's, produced the first steel of commercial value. He was a leading corporation figure, a director of numerous iron and railroad companies. In 1867 he served as the United States Commissioner to the Paris Exposition, and his report, "The Production of Iron and Steel in Its Economic and Social Relations," is still useful not only as a survey of the industry but as an analysis of the effect of industrialism on society.

Hewitt represented the most enlightened and responsible thinking of his class; in reputation he stood for liberalism and responsibility. He entered politics as a friend and supporter of Samuel Tilden, and served in Congress for a dozen years, from 1874 to 1886. As a politician, he was not a professional, but one of the

5. *East River Bridge, Laws and Engineer's Reports, 1868–1884* (New York, 1885), 1–27.

group of New Yorkers (including Tilden, John Hayes, and William Evarts) Henry Adams described as "men who played the game for ambition or amusement . . . whose aims were considerably larger than those of the usual player, and who felt no great love for the cheap drudgery of the work." Adams drew close to Hewitt, and described him as "the most useful public man in Washington." [6]

One of the uses of such a man in the Gilded Age was to demonstrate that integrity and intelligence still existed in America. Hewitt was respectable society's answer to Henry George, in a literal as well as a figurative sense: in 1886 Hewitt was chosen by Tammany to run for mayor against George, whose wide popularity posed a threat to the machine. Hewitt won in a very close election. He ran on his reputation as a liberal, a friend of labor, a reform Democrat, and most of all, as a man of honor. And it was precisely in this capacity, as a man of honor, that Hewitt was asked to join the Bridge Company and clear away some of the odor of Tweedism.

Henry Adams wrote that he found little in Washington from 1870 to 1895 but "damaged reputations." To Adams, Hewitt was an exception. Hewitt's reputation was his chief asset: he was the responsible capitalist, the honest politician, the trustee who could be trusted. His motives, according to reputation, were pure and selfless. This is a naïve point of view to take toward anyone at any time, but especially toward a man of power in post–Civil War America. An examination of hitherto unexamined documents in the Roebling Collection reveals that Hewitt too was a candidate for suspicion.

Except for the overpayment to Kingsley in the first years of the Company's existence, Hewitt reported that there were no essential irregularities. But he criticized the arrangement whereby a single man who happened to own most of the private stock (as did Kings-

6. *The Education of Henry Adams* (Modern Library Edition, 1931), 373. The standard source for the Hewitt biography is Allan Nevins, *Abram S. Hewitt* (New York, 1935).

ley) might assume "practical control" of the Company, and thereby of public funds. Such private control, he wrote, "is dangerous, impolitic, averse to all sound business principles, and alien to the spirit of our institutions." He proposed that New York and Brooklyn be allowed votes on the board in numbers proportionate to their investment, thus forming a more reasonable partnership between private and public interests.

This does in fact seem to have been a reasonable proposal. But Demas Barnes, the chairman of the investigating committee, felt that Hewitt's recommendation fell far short of the mark and issued a minority report. As a congressman in 1867 Barnes had helped secure federal legislation to make the bridge a legal post road. He had also been a leading advocate of the Union Pacific Railroad. As editor of the Brooklyn *Argus*, he was spokesman for municipal reform. In his minority report he spoke bluntly, charging the Company with "excluding the public from the deliberations of its agents when considering the expenditure of public money," and of "securing supplies without a thorough system of competition, and directly or indirectly allowing supplies to be furnished by those in administration." He identified the problem in this way: "Although the Bridge from every element of its use and from the source of its finances, is considered a public enterprise, yet it is entirely a private corporation in which the public has no voice, excepting by the courtesy of the owners of a one-twentieth or one-fortieth of the capital." The truth is, he wrote, that the Company violated no law in paying Kingsley 15 per cent of the total cost of materials: "Neither would it have done so had it paid 50 per cent, or 100 per cent. There are men in this city who will pay for all the private stock, and give one million dollars for the privilege of completing the Bridge under the existing charter." [7]

7. Source for Hewitt's and Barnes's reports, as well as all information regarding the meetings of the New York Bridge Company is *New York and Brooklyn Bridge, Proceedings, 1867–1884* (New York, 1884).

This was an accurate analysis. Hewitt seemed satisfied that once Kingsley reimbursed the Company (as he promised to do), the case was closed. Barnes, however, saw that something more fundamental was at stake — the charter itself. And he saw this even without the benefit of Tweed's confession six years later, in 1878, about the original bribe. At this time Tweed revealed that in addition to the bribe he had made a deal with Kingsley whereby Tweed could buy shares in the Company for himself at a reduction of 80 per cent in the going price, and Kingsley would get a 15 per cent cut on all purchases made for the construction of the bridge, apparently to reimburse him for the bribe. Where all this money came from is as unclear as the plots. But the case seems strong that nobody lost a penny — except the public. The charter Murphy and Kingsley bought from Tweed resembled a license to bleed the treasury.

The fault lay, Barnes explained, with the ambiguities of the original charter; he proposed a conference of public officials to suggest necessary revisions. The board rejected this proposal in 1871, but three years later, public pressure led to new legislation, increasing the representation of the cities among the directors. Moreover, the changes of 1874 made the interest on company bonds chargeable to the company itself, to be withheld from the annual appropriation of public funds. The next logical step, the dissolving of the company altogether, was taken in 1875. An act was passed, redefining the bridge as a "public work, to be constructed by the two cities for the accommodation, convenience and safe travel of the inhabitants." Directors became trustees, appointed by the mayors for two-year terms. The process of making the bridge "public" now seemed completed.

But the new arrangements did not quiet the opposition. Accusations continued. One reason may be that the change of status was not accompanied by a change in personnel; Henry Murphy, pres-

ident of the old board of directors, was elected president of the trustees, and William Kingsley was appointed to the executive committee, where most of the contract decisions were made. These decisions were still made behind closed doors, and aroused a good deal of concern in the press. How much jobbery actually took place is difficult to establish from the published records. But it is possible to reconstruct one troublesome situation — the case of the defective wire.

The specifications for the wire to be used for the bridge were ready in September 1876, and approved by the executive committee. Hewitt, however, offered an amendment to the approval, which denied the right of any company in which a trustee or engineer had an interest, to make a bid. The major wire-making company in the country, if not the world, was John A. Roebling's Sons, of Trenton, New Jersey, of which Washington Roebling was a member. Washington Roebling therefore sold out his interest in the family's business in order to allow the firm, about whose wire he could feel complete confidence, to make a bid. In December 1876 the executive committee unanimously recommended that the contract, for Bessemer steel wire, be awarded to J. A. Roebling's Sons. On January 11, 1877, the full board met to consider the recommendation. Then began a swift series of changes. The minutes record that "a letter of Hon. A. S. Hewitt to the President, dated Washington, January 8th, 1877, was read." Then the board apparently decided that wire made from Bessemer steel was less desirable than that made from crucible cast steel, and requested that the executive committee reopen the bids on this basis. The Roebling Company had made bids on both kinds; their Bessemer bid had been the lowest, but not their bid for crucible cast steel. The executive committee met immediately, that same day, and instead of reopening bids, awarded the contract to J. Lloyd Haigh, the lowest bidder for crucible steel in the first round of bidding.

In July 1878, after the spinning of the cables had begun, Roeb-

ling's assistants discovered that Haigh had been smuggling onto the delivery wagons wire which had not passed inspection; there was no way of telling, Roebling wrote to President Murphy, how much of the bad wire had already been woven forever into the cables. The responsibility for this fraud, he claimed, rested with the board of trustees, the awarders of the contract. Haigh, Roebling pointed out, was a known rascal, and his contract should be annulled. Murphy was obviously upset, but just as obviously cautious; he asked the engineer for a fuller report on the possible damage to the strength of the bridge. Roebling replied that even assuming the worst, a margin of safety "of at least five times" remained. The board, comforted by this report, asked that the president "continue the contract with Mr. Haigh for the wire required to complete the large cables, on such conditions and terms as he deems proper under the circumstances." Haigh, who claimed he was losing money, retained his contract.

So much for the public facts. What lies beneath them is a maze of plotting and accusations. The view of this situation one gets from Washington Roebling's day-journals is this: Haigh was an out-and-out scoundrel; half the wire he delivered was made of Bessemer steel anyway, but charged at crucible steel rate; on this alone he netted $60,000 which, together with $120,000 he cheated his supplier out of and the advances allowed him by the board, amounted to about $300,000 in illegitimate profits. Moreover, his cohort in rascality is none other than Abram S. Hewitt.

Hewitt's resolution of 1876, Roebling wrote, was solely for the sake of eliminating the Roebling Company from the bidding; Haigh, meanwhile, was a pawn of Hewitt; by agreeing not to foreclose a mortgage he held on Haigh's works, Hewitt got 10 per cent of the board's monthly payments to Haigh so long as Haigh retained the wire contract. Thus the motive of the resolution was clear: "When a demogogue wants to effect an object he always

raises the cry of public virtue, and under cover of the smoke he raises, slips in himself. It is on such low and crafty tricks that the honor of a Hewitt rests," wrote the engineer. A year later, when a similar contract fight resulted in an award to the Phoenix Iron Works, in which Hewitt again had some interest, Roebling wrote to another trustee, "I am apprehensive of Mr. Hewitt or any other man who depends on influence and not on integrity. His success will prove a source of endless trouble and vexation. He is unscrupulous and indulges in the sharpest practice by blowing the loudest about the honor of a Hewitt."

In October 1878, after the wire fraud, the Bridge treasury was exhausted, and New York City Comptroller John Kelly tried to get an injunction against the project, charging that it was "a scheme, through the instrumentality of a private corporation, to secure the expenditure and control of public funds." He lost his case, funds were raised, and work continued. But hardly in a peaceful manner. In May 1879 General Slocum, a trustee, reported to his fellows a comment made by one M. T. Davidson, not further identified, that the engineers were crooked, sold information on bids, and took graft as a matter of course. An investigating committee was established (with public funds), and the charges ruled ridiculous. But Washington Roebling was deeply wounded and exasperated, especially by an implication of favoritism toward the Roebling Company. He accused Slocum of inventing Davidson's "rumor," pointed out that his brothers acted independently of him, and even if he had wanted to, he could not prevent their bidding in public competitions. Further, is it not conceivable, he wrote, that his reputation as an engineer was as dear to his brothers as to himself, and that this alone would prevent their practicing fraud? His membership in the Roebling family was no secret, he added, and originally it was considered a qualification. "It was only when Mr. Abram Hewitt desired to get a contract for his friends that could not be

obtained by an honest competitive bid that the question was raised about my connection with the John A. Roebling & Sons Co."

The underlying tensions between the Chief Engineer and the Board came to the breaking point in 1882, when a move was begun to replace him. He was charged with being an invalid and unable to attend to his business, although it was well known that every step of construction was supervised by him in writing; the documents — notes, journals, letters, day-books — exist to prove this. In June he was asked to attend a board meeting, which he never before had been asked to do; vacationing in Newport, he sent his laconic regrets, and a storm broke on his head. The press charged him with insolence. In a letter to City Comptroller Campbell, Roebling pointed out that the trustees were not really interested in the problems of building the bridge anyway. "Most of their meetings in the thirteen long weary years of the work had been spent in quarrelling among themselves over petty trifles or in insulting the engineers." "I do not," he wrote, "propose to dance attendance on the Trustees. I never did it when I was well and I can only do my work by maintaining my independence." He had, he said, bitter enemies on the board, "for no reason except that I was in the way of any schemes for robbery." When they came to interview him, "they found themselves face to face with me and found me a live man and not the driveling idiot they had expected," and they "had very few questions to ask and scarcely anything to say about the bridge in any way." He concluded: "To build the bridge is quite enough for any one man but to carry the many Trustees on my back too is rather more than I can stand."

In notes for a letter to the New York *Sun* in reply to their editorial on June 28, 1882, charging the engineer with irresponsibility, Roebling commented that General Slocum, who had voted to request his appearance at the board meeting, is "the same Slocum who joined with the request that I absent myself from any meeting

of the Board because my presence may embarrass Mr. Kingsley's proposed operations of putting a couple of millions in his pocket, millions which have not yet reached their destination." His "patience at an end," Roebling revealed that the work of supplying materials for which Kingsley was "overpaid" in the early years of the project actually was done by himself, the Chief Engineer. He had had enough of the entire business.

"It took Cheops twenty years to build his pyramid, but if he had had a lot of Trustees, contractors and newspaper reporters to worry him, he might not have finished by this time," Colonel Roebling wrote in a reply to a letter from Abram Hewitt, requesting information for the Opening Ceremonies address the congressman had been invited to deliver. "The advantages of modern engineering are in many ways overbalanced by the disadvantages of modern civilization."

Washington Roebling's revelations and indictments are crowded in his journals in a scrawling hand among minute calculations, drawings, estimates, and instructions for his bridge. These journals reflect the world the bridge would serve, a world that seemed determined to make a prophet of Henry George. There is anger, there is rage and indignation, but in the end, as George had written, there is only helplessness and resignation: "Whatever is, is right."

### III

The confusion surrounding Brooklyn Bridge revealed a serious crisis in urban society. One of the causes was the subordination of the American city to state legislatures: not New York and Brooklyn, but Albany granted the authority to build the bridge.[8] More-

8. See Seth Low, "An American View of Municipal Government," in James Bryce, *The American Commonwealth*, 3 vols. (London, 1888), Vol. II. Low was mayor of Brooklyn in 1882, and led the movement to remove Roebling as Chief Engineer. See also Delos F. Wilcox, *Great Cities in America* (New York, 1906), 88ff.

over, by selling its vast municipal lands in the middle of the nineteenth century, New York had surrendered its power of self-determination, and turned its destiny over to real-estate operators, to "developers" who measure inches of land in thousands of dollars. Property values prevailed over community values, and "utility" was defined by standards of commerce.

The chief grounds of accusation against the Bridge Company in the press was the distinction between "honest" and "dishonest" profit. The *Tribune*, to cite one instance, evoked in an editorial on March 15, 1882, the dark image of conspiracy:

> It is understood that certain men expect to make large sums out of real estate operations in connection with the bridge. They believe that when completed it will increase the value of property on the line, and adjacent to it, to a degree which will make delay a source of profit. They are in no hurry to have their work finished. They wish to perfect all their plans and get hold of the property which they desire first.

Six years earlier, on September 30, 1876, the *Tribune* had editorialized in a different vein. Then it had complained that the people of Brooklyn were too dreamy about the bridge. "Most people look at the towers in a far-off way, as if the whole structure was intended as a work of art, and the towers were only to be considered monumental." These dreamy people fail to see that the bridge "is something in which they have a direct, personal interest." This interest is twofold: first "the course of travel of perhaps 50,000 people" will be changed, and second "great alterations in the value of property must result." The writer pleads with his readers to be hardheaded: "The whole question of the value of the bridge turns upon its capacity for shortening the delays of traffic." And in case the promenade might divert attention from "the whole question of the value of the bridge": "For foot passengers it will be of no great

importance; after its novelty is over people will think a walk over the bridge more wearisome than a ride on a ferry boat." [9]

An editorial in *The Railroad Gazette* a week after the bridge opened further explored the matter of value. What, asks the writer, is the nature of the work which the bridge will perform? This is indeed "an enormously expensive structure to provide for passages which individually are of infinitesimal value." Unlike a railroad bridge this span is a mere mile of highway for mere people to cross from one city to another. Certainly it can not be the individual value of each crossing which "caused the erection of this costly work." "On its face," he admits "it would appear that the expense could not possibly be justified by the service performed." But if we look at the bridge in another way, its greatness will become evident. The bridge is a way to increase the traffic between New York and Brooklyn — the increase measured in huge quantities rather than in single passages. But the bridge can serve this end only if rapid transit cars can run *through* one city to another without a change at the bridge terminals. "Only in this way can a considerable saving of time be effected by the bridge."

Running through-trains across the bridge rather than cable-cars would indeed bring Brooklyn much closer to New York. The writer now assumes an imperialistic tone toward Brooklyn, speaking of it almost as a territory to be exploited, and at the same time to be uplifted by the exploiters.

> Brooklyn would truly be made part of New York, and the bridge would be of enormous advantage to it. Its beautiful sites for dwellings, now accessible only by a wearisome journey of an hour and a

9. Perhaps the writer had in mind "far-off" descriptions like Whitman's in *Specimen Days*: ". . . the mast-hemm'd shores — the grand obelisk-like towers of the bridge, one on either side, in haze, yet plainly defined, giant brother towers, throwing free graceful interlinking loops high across the tumbled tumultuous current below . . ." This view had been recorded in 1878. *Complete Prose Works* (Boston, 1901), 109. Whitman's only other direct reference to the bridge seems to have been in "Song of the Exposition," 1881.

half, would be brought within half or ¾ of an hour of Union Square, and a very large part of the objections to living in Brooklyn, which have caused rents there to be half as great as in equally handsome parts, would be obviated.

The wealthy live in the city for the sake of privileges which only a center of civilization can offer. And "the particular centre in this country is above Union Square, in New York." Any place within three-quarters of an hour of this center can enjoy its virtues, and at the same time earn some virtues for landlords. Indeed, the writer assures us, "the whole difference is manifest in rents."

> A house near Prospect Park in Brooklyn, a location unexcelled for beauty of situation, orderliness and cleanliness, will not bring more than half the rent commanded by a similar house in a handsome and not especially fashionable location in New York. Bring it within half an hour of Madison Square and the values will certainly be much more nearly equal. The building lots in Brooklyn, now 30 minutes or more from Fulton Ferry, would probably double in price — much more, very likely — should rapid transit between the two cities be provided.

And then, in a sentence which runs the full gamut of values imaginable by *The Railroad Gazette*, the writer concludes:

> It is so certain that only a small part of the advantage of the bridge can be attained if there must be a transfer at each end of it, and the owners of real estate have so many millions and tens of millions to gain by the running of through cars, that we confidently expect that it will be done some time, that then first will *really great usefullness* result from the magnificent structure, which is one of the great monuments of the New World.

Usefulness to owners of real estate is the highest value to which the public voices of the times could ascend. Time-saving, land

values, and genteel uptown culture — these comprise the American *polis*. The bridge would introduce Brooklyn to the amenities of high culture, and high rents.[10]

10. *Railroad Gazette*, Vol. XV (June 1, 1883), 348.

Aftermath of the panic on the bridge, Memorial Day, 1883
(*Frank Leslie's Illustrated Newspaper*)

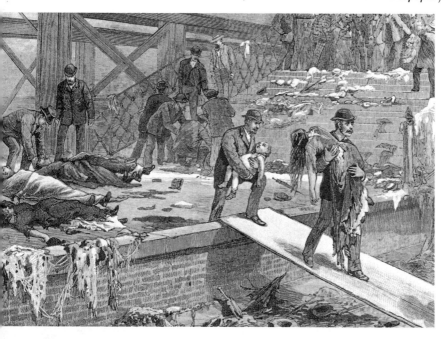

# 7

Babylon had her hanging gardens, Egypt her pyramid, Athens her
Acropolis, Rome her Athenaeum; so Brooklyn has her bridge.

Sign in Brooklyn shopwindows, 24 May 1883

# Opening Ceremonies

I

If one is disposed to look at life through the conventions of the theater, the story of Brooklyn Bridge makes a neat melodrama. It is staged in a world out of joint; good men vie with bad. Throughout, virtue seems a whore. The situation appears hopeless; nowhere in sight is a hero powerful enough to correct the world. Even the crippled Chief Engineer has been accused of venality. But when things look their worst, the sky suddenly clears, the leaders put on their noble robes, or disguises, and virtue, cleansed and regenerate, is restored. Every comedy has its last act, and Brooklyn Bridge its Opening Ceremonies.

The Opening Ceremonies were a public drama, a contrived pageant with a tone both festive and solemn. A civic occasion, it united the people to their leaders, and rededicated the community to the high values of honesty and accomplishment. The symbolic leader of the land, the President of the United States, sat on the platform while leaders from government, business, and religion wove a spell of rhetoric to rid the city of its evil visitations. The Great Bridge had survived its enemies, the breach was spanned, and the American world set right again.

But the appearance of a traditional civic ceremony, similar to rites of ancient and medieval cities, was deceptive. True, the event was accompanied by much fanfare; business establishments were shut down, streets were bedecked with banners and buntings, fire-

works and parades lasted late into the night. But what was the city celebrating? This was not an annual feastday, nor a day of traditional exercises, such as the fraternal members of medieval cities enjoyed. It was the celebration of a unique, and in some sense, problematical event in the life of the cities. They were celebrating their growth. The event would, everyone knew, change the character of the two cities in some crucial way — though exactly how, no one could say for sure.

It is inaccurate to call the Opening Ceremonies a civic ritual; it was, so to speak, a non-repeatable event. And yet, in the absence of long-standing traditions, the "opening" of some new facility was itself a tradition. Two similar occasions were brought to mind and referred to by the speakers, the opening of the Erie Canal in 1825, and of the Croton Aqueduct in 1842. These events brought out thousands of people in parades and ceremonies. They were remembered as milestones in the cities' histories. Furthermore, along with Brooklyn Bridge, all three events were technological achievements which widened the scope of the cities; instead of reinforcing a sense of urban autonomy and exclusiveness, each event increased the dependency of the cities upon the geographical region, and so had extra-municipal overtones. Not the mayor, but the state governor and the President of the nation were chief guests of honor.

The Brooklyn Bridge celebration surpassed the earlier ones in size and grandeur, but that was not the significant difference. In 1825 and 1842 citizens celebrated the events through their many civic and craft organizations. In 1825, firemen, carpenters, millwrights, merchants, militiamen, cabinetmakers, and so on, all subscribed as groups to the gala celebration; they built floats for the parade, and marched together. Civic identity was expressed through the participating voluntary organizations. In 1883, on the other hand, the only visible institutions were the militia and government; the only official parade was an escort for President Arthur from his hotel to the bridge. Merchants, of course, filled their windows and store

fronts with banners and replicas of the bridge. A minister and a millionaire were among the principal speakers. The fire department decorated the river with fire boats, and an army band supplied the music. The police department did its share by watching for pickpockets. The two leading emblems of the day, sold in large quantities by hawkers, were the American flag and a small replica of the bridge. Whether it was a national or a civic occasion, in short, was not perfectly clear.

The citizens attended the affair simply as "the people." Undifferentiated into craft or civic groups, they were the audience. At the same time, the common theme among the speakers was that the "people" themselves were the featured guests of the afternoon. The main "action" of the pageant was the presentation of the bridge to the "people." William Kingsley made the presentation on behalf of the trustees, and the mayors of New York and Brooklyn made the acceptance on behalf of the "people." It was called "The People's Day."

Aside from the action of presenting the bridge to the cities, the Opening Ceremonies performed another function. The implicit task of the speakers was to receive the bridge into the historical and moral experience of the cities, to establish its place in the mind. Much of the rhetoric, of course, has no more apparent significance than the familiar 4th of July oration. It was a public assembly, and the speakers rolled out their full regalia of public oratory. The speeches might be dismissed as highly conventional and insincere. Sincerity, however, is not a necessary qualification for cultural significance; surely the conventions of language themselves suggest predispositions among Americans to react in certain ways at certain times. And at this moment, when the people and their leaders together confronted something new in their common experience — the world's largest suspension bridge, equipped to carry mechanically drawn cable-cars as well as casual strollers — their language reveals a set of familiar ideas. On this day, in brief, Brooklyn Bridge

was assigned its place within the popular conception of American life.

Very little was said about the bridge's importance as a solution to the problems of urban transportation. Instead, it was considered an example of the American ability "to get things done." Three abstractions appeared over and over again during the speeches: Commerce, Science, and Courage. Commerce made "irresistible demands"; Science provided the means to overcome "the natural barriers to the union, growth and greatness of this great commercial centre"; and Courage added the moral fiber to keep Science at the task. "Science said, 'It is possible,' and Courage said, 'It shall be.'" The bridge was an American version of man's continuing victory over nature, "a trophy of triumph over an obstacle of Nature." The bridge embodied the virtues of a civilization which had begun its career on a virgin continent, and had raised itself steadily to this eminence. Said one speaker, "Courage, enterprise, skill, faith, endurance — these are the qualities which have made the Great Bridge, and these are the qualities which will make our city great and our people great." [1]

The image of the bridge as a "trophy" won against the odds of nature, was derived from the optimistic creed which prevailed in this period. It was based on a faith in universal moral values and in inevitable progress, with America in the vanguard.[2] Manifold rhetorical possibilities are suggested by this image, and Abram S. Hewitt and Reverend Richard S. Storrs, the two leading speakers of the day, exploited them with their finest eloquence.

## II

Unavoidably, Hewitt's role as the major orator will appear ironic in light of the hostility Washington Roebling felt toward him. But

1. *Opening Ceremonies of the New York and Brooklyn Bridge* (Brooklyn, 1883). All quotations from the speeches are from this source.
2. Henry F. May, *The End of American Innocence* (New York, 1959), 3–121.

it was not Roebling's bridge any longer; it was the world's, and to the world Hewitt's presence seemed perfectly appropriate. And in truth, it was. Hewitt was not frivolous; he was a student of his times, an honored man. Following his remarks we need to keep our secret knowledge in the background, but not out of sight; we should try to hear his words as his audience did.

Hewitt's Brooklyn Bridge address was his most famous (he published it as a pamphlet for his 1886 mayoralty campaign against Henry George) but not his only major public utterance. He spoke and wrote widely, and the dominant theme he brought to the public was, like George's, the theme of progress and poverty. Hewitt and George were more than political rivals, they were ideological opponents. Hewitt expressed the deep concern of his class over the rising discontent among workers; he was worried that radical ideas, like George's, or worse, Karl Marx's, would take hold in America. His message was that there is no fundamental antagonism between labor and capital, that class issues had no place in America (George replied to this idea that his was not a movement of class against class, but the masses against the classes). Labor and capital, Hewitt insisted, were natural allies. He argued for strong labor unions as a brake on radicalism; he liked the idea of workers forming their own large and respectable institutions that would deal with the corporations (and vice versa) on the level of power.

To prove his sincerity, Hewitt often criticized his fellow capitalists. In his report on the Paris Exposition, "The Production of Iron and Steel in Its Economic and Social Relations," he wrote that there must be "moral limits" placed on the production of wealth. Capitalists, he argued — especially British capitalists — often violated "fundamental laws of humanity . . . in the employment of women and children and the payment of a rate of wages to the common laborer inadequate for the proper support and culture of the family." Legislation could correct this situation without reduc-

ing the power of the capitalists. America, he argued, with its virgin soil, and "the largest and best supplies of the fundamental elements upon which industry, progress, and civilization are based," was an example of "how wealth may be created without the degradation of any class which labors for its production."

This was not to say that American capitalists were entirely enlightened. In a speech to a church group in 1878, Hewitt had made it clear that it was the capitalist's self-interest to share the wealth more equitably; otherwise, chaos and destruction awaited the country. It was a simple matter, Hewitt assured his audience; once the workers' wages go up, the chief problem of industrial society would be solved. And such a solution was a promise of unending human happiness. "Labor is thoroughly organized and marshalled on the one side," he said, "while capital is combined on the other; each powerful enough to destroy the other if they engage in conflict, but equally powerful to assist each other if they work together in harmony." This harmony it was America's mission to create, and in 1883, Hewitt declared that Brooklyn Bridge pointed the way.[3]

Hewitt's purpose at the Opening Ceremonies was to explicate the bridge as an emblem of the forces at work in modern America, an emblem of progress. To prepare for his speech he had written to Washington Roebling for help, saying that his comments would be "directed to the social and political considerations involved in the creation of new avenues of transportation." He asked the engineer for "comparative examples of great engineering works, which would show that by scientific appliances the cost of the bridge is very much below what would have been possible in any preceding age." He also asked for a table of wages, and other technical information. Roebling's reply was not very helpful. He wrote:

3. Allan Nevins, ed., *Selected Writings of Abram S. Hewitt* (New York, 1937), 76–85, 281.

To build his pyramid Cheops packed some pounds of rice into the stomachs of innumerable Egyptians and Israelites. We today would pack some pounds of coal inside steam boilers to do the same thing, and this might be cited as an instance of the superiority of modern civilization over ancient brute-force. But when referred to the sun, our true standard of reference, the comparison is naught, because to produce these few pounds of coal required a thousand times more solar energy than to produce the few pounds of rice. We are simply taking advantage of an accidental circumstance.[4]

Undeterred by Roebling's skepticism, or perhaps misunderstanding it, Hewitt proceeded with his task, which was to draw lessons from the bridge concerning "the destiny of men and the outcome of human progress."

Hewitt's version is this: If we compare the wages of the workers on the bridge with the wages of the workers (who were, he neglected to say, slaves) on the Pyramids, we will see most dramatically what progress we have made. The average daily wages on the bridge were $2.50, compared to the two cents per day in ancient Egypt. This, indeed, is irrefutable progress. "In other words, the effect of the discoveries of new methods, tools, and laws of force has been to raise the wages of labor more than a hundredfold in the interval which has elapsed since the Pyramids were built." Thus the bridge proves conclusively that "by a higher and immutable law," science tends "to the steady and certain amelioration of the conditions of society." It proves, moreover, that "notwithstanding the apparent growth of great fortunes . . . the distribution of the fruits of labor is approaching from age to age to more equitable conditions, and must, at last, reach the plane of absolute justice between man and man."

The bridge represented other "social tendencies" as well. It was built for peace, not war; for free commerce between cities, not for

4. Roebling Collection, Rensselaer Polytechnic Institute.

celebration of the dead. It broke down barriers, and thus stood for "the solidarity of the human race." And it was a lesson to those few in the nation who would obstruct free trade with the "artificial barriers" of high tariffs. If the obstructionists are right, said Hewitt, "then this bridge is a colossal blunder and the doctrine which bids us love our neighbors as ourselves is founded upon a misconception of the divine purpose."

The happy lessons Hewitt draws actually imply a rather dark world surrounding the bridge. For example, he felt "compelled" to devote part of his speech to "such vindication as it is in my power to make" of the board of trustees. He swore to the honesty of all concerned. The main point of his vindication, however, was to draw yet another lesson for Americans. That was the "miracle" of the cities themselves taking over a project initiated "exclusively by private capital for the sake of profit." Hewitt's version of this event shows his confidence that, at bottom, American life was sound. A "band of thieves" had captured the government of New York after the Civil War; they built "a series of great and beneficial public works, not for the good they might do, but for the opportunity which they would afford to rob the public treasury." Then, "the force of public indignation" drove the Tweed Ring into exile. With the "timely event" of their flight, "a new era commenced." The good men of the cities filled the offices of government, and their most important act was to take over the bridge as a public work, thus salvaging the age's monument from the touch of evil (actually, the transfer was made through the state government at Albany). Thenceforth, expenditure of funds was as honest and as economical as possible. Brooklyn Bridge thus stands as a "monument to the public spirit of the two cities." [5]

5. It should be noted that Hewitt seemed to take his own rhetoric seriously. In 1894 he vigorously opposed the use of public funds to finance a subway system to be built and run by private individuals, proposing instead that the city take complete charge of the project — apparently reversing his earlier notion of public-private co-operation. At this time he cited the example of Brooklyn Bridge: "The Brooklyn Bridge was

Therefore, the bridge was significant to the municipal government of the two cities as a model of applied intelligence, a model which modern America sorely needed. Political intelligence, according to Hewitt, had not kept pace with the rise of great cities; one saw corruption and failures throughout our urban centers. But the bridge represented the alternative of "organized intelligence." The structure

> looks like a motionless mass of masonry and metal; but as a matter of fact it is instinct with motion. There is not a particle of matter in it which is at rest even for the minutest portion of time. It is an aggregation of unstable elements, changing with every change in the temperature and every movement of the heavenly bodies. The problem was, out of these unstable elements, to produce absolute stability.

Thus: "If our political system were guided by organized intelligence, it would not seek to repress the free play of human interests and emotions, of human hopes and fears, but would make provision for their development and exercise, in accordance with the higher law of liberty and morality." Conflict, Hewitt said, is the law of the city, but intelligence, guided by Science, Commerce, and Courage, can transmute conflict into harmony.

The overthrow of the Tweed Ring had proved the existence of public virtue. That demonstration itself, Hewitt said, redeemed the twenty or thirty millions of dollars stolen by the Ring: virtue was here, intelligence was here, and national economic progress indicates that commercial health was also here. All that ob-

originally a private corporation, with private stockholders. The City of New York never loaned its credit to the Brooklyn Bridge — not a penny — but what it did was to subscribe for a portion of the stock. The City of Brooklyn did the same thing. The administration of the work was in the hands of private stockholders, and it culminated in a scandal of the worst kind; and the result was that the City of New York and the City of Brooklyn were compelled to do — what they ought to have done in the first place, or to have done nothing — they were compelled to buy out the private stockholders, and become the sole owners of the work." Nevins, *Abram S. Hewitt*, 57.

structed progress was the confusion of political life. Once that is eliminated, "who can venture to predict the limits of our future wealth and glory?" If we heed the message of the Bridge, Hewitt promised, the world will see Cathay come true: "Beyond all legends of oriental treasure, beyond all dreams of the Golden Age, will be the splendour, and majesty, and happiness of the free people dwelling upon this fair domain."

### III

It is reported that Hewitt read his speech so softly that it was not distinct to many of the thousands gathered at the site. But we can imagine that the final speaker of the afternoon, the Reverend Richard S. Storrs, spoke loud and clear.

The Reverend Mr. Storrs eschewed political messages, and filled the air with praise and rejoicing. At last, he said, the " 'silver streak' which has so long divided this city [Brooklyn] from the continent, is now conquered, henceforth, by the silver band stretching above it, careless alike of wind and tide, of ice and fog, of current and calm." He praised the principals, the engineers, the politicians, and "the real builders of the bridge" — the people. A "durable monument to Democracy itself," he proclaimed, the bridge "shows what multitudes, democratically organized, can do if they will." One wonders where the Reverend Mr. Storrs had been the previous thirteen years, but his job, after all, was to sanctify the bridge.

As a monument to democracy, the bridge was a promise, Storrs announced, and a prophecy. "One standing on it finds an outlook from it of larger circumference than that of these cities." The widened horizons proceed, first, from the fact that the bridge connects Brooklyn "with all that is delightful and all that is enriching in the metropolis" (Storrs's fellow clergymen in this period could be expected to raise eyebrows at this mention of New York's "de-

lights"). Moreover, that metropolis itself was the "natural centre of radiation" of the continental railroad system; hence the bridge connects Brooklyn with the heartlands of the continent. The bridge was a "surer certainty and a greater rapidity"; "the horizon widens around us as we touch with more immediate contact the lines of travel which open hence to the edge of the continent." As a technological achievement, the bridge would serve as an incentive to others; it would inaugurate a new age in America.

> Indeed, it is not extravagant to say that the future of the country opens before us, as we see what skill and will can do to overleap obstacles, and make nature subservient to human designs.

Fusing the traditional Christian creed with the American, Storrs celebrates the human will. And the chief cause for his celebration was the material of which the bridge is made, steel, "the chiefest of modern instruments." Steel is "the kingliest instrument of peoples for subduing the earth." In America the great supply of steel is based on the vast accumulation of gold; this "new supremacy of man" over the ancient metal illustrates "the bolder temper which is natural here, the readiness to attempt unparalleled works, the disdain of difficulties." Steel, in short, is America's spiritual medium.

It is also significant, Storrs pointed out, that steel in this case is used for peace, not war. A bridge unites, and thus it is the very "type of all that immeasurable communicating system which is more completed every year to interlink cities, to confederate States, to make one country of our distributed imperial domain, and to weave its history into a vast, harmonious contexture, as messengers fly instantaneously across it, and the rapid trains rush back and forth, like shuttles upon a mighty loom." The bridge is the "express palpable emblem" of peace. Contrast it with the warship, the *Monitor:*

No contrast could be greater among the works of human genius than between the compact and rigid solidity into which the iron had there been forged and wedged and rammed, and these waving and graceful curves, swinging downward and up, almost like blossoming festooned vines along the perfumed Italian lanes; this alluring roadway, resting on towers which rise like those of ancient cathedrals.

It is a Bridge of Peace, America's Arch of Triumph, dedicated to "the tranquil public order which it celebrates and prefigures." It is New York's Brandenburg Gate, "bearing on its summit no car of military victory," and standing within this "united city by the sea, in which all civilized nations of mankind have already their many representatives, and to which the world shall pay an increasing annual tribute." Built by a German, it stands next to the figure of Liberty, the work of a Frenchman; it "represents that fellowship of the Nations which is more and more prominently a fact of our times." This double crown in the harbor, is an auspicious omen: "the alliance of nations, the peace of the world, will seem to find illustrious prediction in such superb and novel regalia."

What more fitting image for such a work than an eternal harp:

> This structure will stand, we fondly trust, for generations to come, even for centuries, while metal and granite retain their coherence; not only emitting, when the wind surges through its network, that aerial music of which it is the mighty harp, but representing to every eye the manifold bonds of interest and affection, of sympathy and purpose, of common political faith and hope, over and from whose mightier chords shall rise the living and unmatched harmonies of continental gladness and praise.

Such was the Reverend Mr. Storrs's expectation of Brooklyn Bridge. He spoke of "mechanical invention ever advancing," of "beneficent peace," of "expansion and opulence." At the end he offered a solemn benediction:

Surely, we should not go from this hour, which marks a new era in the history of these cities, and which points to their future indefinite expansion, without the purpose in each of us, that, so far forth as in us lies, with their increase in numbers, wealth, and equipment, shall also proceed, with equal step, their progress in whatever is noblest and best in private and in public life; that all which sets humanity forward shall come in them linked together, and hereafter they must be, and seeing "the purple deepening in their robes of power," they may be always increasingly conscious of fulfilled obligation to the Nation and to God; may make the land at whose magnificent gateway they stand, their constant debtor; and may contribute their mighty part toward that ultimate perfect Human Society for which the seer could find no image so meet or so majestic as that of a City, coming down from above. . . .

From Brooklyn Bridge to "that ultimate perfect Human Society" must have seemed an inordinate leap that May afternoon in 1883. But the day was fair, and most shops were closed, and after dark, fireworks lit up the sky. The East River, according to reports, never looked so picturesque. And at such rare moments even the puny acts of men might seem divine. Washington Roebling greeted President Arthur and his company in his home at 110 Columbus Heights, and watched the proceedings from his window. One hopes that he was looking elsewhere a week later, when, on the afternoon of Memorial Day, the entire roadway was opened to pedestrians. Someone shouted, "The bridge is falling!" Twelve people were crushed or trampled to death in the rush. The baptism of rhetoric was followed by a baptism of blood.

8

The outline of the city became frantic in its
effort to explain something that defied meaning.
Power seemed to have outgrown its servitude
and to have asserted its freedom. The cylinder
had exploded, and thrown great masses of stone
and steam against the sky. The city had
the air and movement of hysteria, and the citizens
were crying, in every accent of anger and alarm,
that the new forces must at any cost be brought under control.

HENRY ADAMS, *The Education of Henry Adams* (1907)

# Two Kingdoms

In 1883 Brooklyn Bridge had dominated the New York skyline. Its towers rose high above the warehouses and shops of both shores, and ruled the East River. Prints from this period show the supremacy of the bridge. Only the Trinity Church steeple in lower Manhattan approached the height of Roebling's granite towers. Gothic steeple and Gothic arches together kept the peace in the sky above the city.

But the joint rule did not last. By the 1890's more imposing figures had appeared in the commercial streets of Manhattan. Trinity spire at the head of Wall Street was threatened with obscurity; in 1904, when Henry James visited the street, the church was already "cruelly overtopped" and "smothered" by "the mountain-wall" of surrounding skyscrapers. James himself had something of the same sensation on learning that the tall building leaning most threateningly over the church had been erected by the church-wardens themselves. Roebling's towers did not suffer as severely, but the same irony held true for the bridge as for the church: by increasing the volume of traffic into Manhattan and by helping to concentrate wealth in the business section of that city, the bridge indirectly promoted the skyscraper. Like the church, it conspired in its own decline as ruler of the sky.

The new physiognomy of New York expressed modern America with a clarity to be seen nowhere else. Here, in the jagged face of the city, the civilization of the New World displayed its most ex-

uberant forms. And here, interested observers — foreign visitors and native artists — searched for a clue to the meaning of a society which had turned its energies from pruning the wilderness to capturing the sky. Orderly gardens seemed to have given way to a landscape of grotesque shapes: the skyscraper, James wrote, was the new " 'American Beauty,' the rose of interminable stem." Writers and artists scanned the face of New York for images such as this, adequate to express the regime which now ruled America.

## I

The prominence of Brooklyn Bridge made it an obvious emblem for the new forces that had reshaped the city. Henry James found it to be the perfect physical equivalent of these forces, a naked demonstration of the power which created the skyscraper. He described the bridge in "New York Revisited," the best-known chapter of *The American Scene*, which is the record of his visit to America in 1904–1905 after twenty-five years of expatriation.[1]

James's responses to his native land were typically complex, but of one thing he was sure: New York City had become a place of "pitiless ferocity." "Chaos of confusion," he wrote, was everywhere. And nowhere with more arrogance than in the skyscrapers, those "giants of the mere market" which had "crushed" the familiar monuments of his youth "quite as violent children stomp on snails and caterpillars." Like Henry Adams, James felt violence in the very air of New York. Both men recognized that the turbulent city represented the dispossession of their class; new economic and political forces had arisen for whom Quincy, Massachusetts, and the New England tradition meant nothing. The most poignant moment in James's book is his discovery that a "high, square, impersonal structure" had replaced the site of his birth in Washington Square: "the effect for me . . . was of having been amputated of half my history."

1. *The American Scene* (New York, 1907). All quotations are from this edition.

Nonetheless, James admitted to an attraction for the furor of the city. The emotions produced by the unencumbered energies working upon the sky could be thrilling. In the opening scene of "New York Revisited," James views the city from the Bay, and writes:

> The extent, the ease, the energy, the quantity and number, all notes scattered about as if, in the whole business and in the splendid light, nature and science were joyously romping together, might have been taking on again, for their symbol, some collective presence of great circling and plunging, hovering and perching seabirds, white-winged images of the spirit, of the restless freedom of the Bay.

Here, at their best advantage, the new forces are displayed in a "splendid light"; their appeal is visual and highly engaging. The seabirds — "white-winged images" — are their symbol.

Probing the source of pleasure in the scene, James discovers that a sense of accomplishment, of "things lately and currently *done*," and done "on the basis of inordinate gain," was responsible for the "restless freedom" in the air. What lay behind the "great circling and plunging" of the sea-birds, he discovered, was vehemence and power, the true notes of the scene.

To describe the "dauntless power" in the harbor, James searched for an equivalent to the "diffused, wasted clamor" of the city. As his eye moved up the East River, the Great Bridge and the trains which cross it supplied the appropriate image:

> This appearance of the bold lacing-together, across the waters, of the scattered members of the monstrous organism — lacing as by the ceaseless play of an enormous system of steam-shuttles or electric bobbins (I scarce know what to call them), commensurate in form with their infinite work — does perhaps more than anything else to give the pitch of the vision of energy.

More than anything else, the bridge was a mechanical monster. As his language faltered ("I scarce know what to call them"), James

reached for technological images: a steam engine, a power loom, and in the passage that follows, a clock:

> One has the sense that the monster grows and grows, flinging aboard its loose limbs even as some unmannered young giant at his "larks," and that the binding stitches must forever fly further and faster and draw harder; the future complexity of the web, all under sky and over the sea, becoming thus that of some colossal set of clockworks, some steel-souled machine-room of brandished arms and hammering fists and opening and closing jaws.

The bridge was a mechanical spider in a "steel-souled machine-room"; a robot that "grows and grows," a piston, as he puts it in still another sentence, "working at high pressure, day and night." And the result of its work, James gloomily predicted, was "merciless multiplication" of itself.

James used this chilling portrait of the bridge to transport his reader from the joy of the Bay to the horror of the streets. He did not compromise his image: the bridge was monstrous. James did not even concede that the bridge, under certain atmospheric conditions, might have a visual appeal; the skyscraper, on the other hand, sometimes struck him as "justifying" itself, "looming through the weather," with a "cliff-like sublimity." Obsessed with the mechanical parts of the bridge, he seems not to have noticed the towers. This is curious because most other observers found in the towers the same sublimity James found occasionally in the skyscraper: Childe Hassam, John Twachtman, and Joseph Pennell painted the structure precisely this way, as a lofty presence. The popularity of this view of the bridge was such that James's own publisher inscribed a line drawing of the towers on the title page of the 1907 edition of his works!

James might have commented on these interpretations as he did upon his own sense of the skyscraper's sublimity: it came from the "intellectual extravagance of the given observer." He resisted that

extravagance in himself, and his image of the bridge, extravagant in another direction, represents his most powerful feelings toward the modern city.

## II

"I feel great forces at work," wrote John Marin in 1913, "great movements; the large buildings and the small buildings; the warring of the great and the small." Recently returned from a study of modern painting in Europe, Marin expressed his reactions in hundreds of water colors, drawings, and oils of lower Manhattan and Brooklyn Bridge.[2]

Many artists have painted and photographed Brooklyn Bridge, but none with the consistency and the fervor of John Marin, except perhaps Joseph Stella, who like his colleague seized upon the bridge after his return from Europe in 1911, as an expression of "great forces at work." The two painters recognized in the bridge and the skyscrapers fitting embodiments of the new. Stella wrote:

> Steel and electricity had created a new world. A new drama had surged from the unmerciful violations of darkness at night, by the violent blaze of electricity and a new polyphony was ringing all around with the scintillating, highly-colored lights. The steel had leaped to hyperbolic altitudes and expanded to vast latitudes with the skyscrapers and with bridges made for the conjunction of worlds.[3]

Although neither his language nor his paintings are as apocalyptic as Stella's, Marin felt excitement in the new forms of the city, an excitement that appears in his portraits of Brooklyn Bridge.

2. Herbert J. Seligman, ed., *Letters of John Marin* (New York, 1931), n.p. See also Milton W. Brown, *American Painting from the Armory Show to the Depression* (Princeton, 1955), 134.

3. Joseph Stella, "Autobiographical Notes," 1946, Whitney Museum. All quotations from Stella are from this source. See also John I. H. Bauer, *Joseph Stella* (Whitney Museum, 1963). For a catalogue of works depicting the bridge, see *Brooklyn Bridge, 75th Anniversary Exhibition* (Brooklyn Museum, 1958).

Marin's use of the image can be divided roughly into two phases: the sketches and drawings of the years before World War I, and the more elaborate compositions in the 1920's and early 1930's. In the first phase the painter saw mainly the structural parts of the bridge: towers, cables, and promenade. His early drawings and etchings are mainly views *of* the bridge from the river or the city. In many of these works, the bridge seems about to become an abstract form, a shape expressing energy and movement.

Later paintings reverse the point of view: the bridge provides a platform toward the city. In *Red Sun — Brooklyn Bridge* (1922), *Related to Brooklyn Bridge* (1928), and *Region of Brooklyn Bridge Fantasy* (1932), towers and streets are framed by heavy dark slashes, suggesting the bridge cables. Resembling the dark borders of his marine water colors, these lines intensify the light of the painting, and force the viewer's attention to the energetic movements within. The center regions of these paintings are usually very bright — flashing sun upon steel and glass. Diagonal cables pour across the surface of the paintings, locating the point of view on the promenade. Toward the bottom of some of these paintings, open forms within the overlapping buildings imply tunnels and subway entrances.

The simple visual relationship between bridge and city is Marin's subject in these works. His work as a whole conveys rapid, direct impressions, momentary glimpses cohered into permanent forms. The city is a vision of speed and frenzy — a sharp contrast to his relatively quiet sailboats and water. The bridge too is energy; it partakes of the frenzy. But, more important, it provides a perspective for a rapid succession of impressions. It is both of and apart from the city.

Stella's treatment of the structure is similar; he also uses it to view the city. But Stella's paintings invite fuller literary interpretations: their monumental forms appeal more overtly to the mind than the strictly visual images of Marin.

The first of Stella's many conceptions of Brooklyn Bridge is the famous 1917–18 version. The painting has two planes, distinguished by color as well as line. Below, deep reds and metallic blues predominate, while above, blue lightens into gray. In the middle area greens and yellows play among curving and angular forms. But the canvas is hardly flat in effect; it provides a complex spatial experience. The main features of the painting are the diagonal lines, which, like spotlights, cross, near the top; the twin arches of the towers; and a prism resting on a disc near the bottom. The movement is upward along the diagonal lines to the topmost image of the towers, bathed in light. But to get there, the eye must first encounter the hypnotic prism below and its glaring reds; it is the mouth of a tunnel, surrounded by receding caverns. The direction of the lower half of the painting is downward, under the bridge which rises above. The eye struggles to be released of this maze of underground forms, and finally breaks free. The viewer finds himself on a pathway which leads swiftly to the first tower, then upward to the higher towers, until, encouraged by diagonal and vertical lines, he reaches the topmost pinnacle surmounted by a narrow flat curve, a rainbow shape that runs the entire breadth of the canvas.

The painting conveys the physical sense of walking simultaneously under and over the bridge. Emotionally, however, it leads the viewer into demonic tunnels, and then out of them, into an empyrean of spires. Color and form separate bridge from tunnel. Moreover, the bridge does not emerge from the tunnels, but is imposed upon them. It is in a plane of its own. And except for the powerful diagonals which form a vortex at the top, the organization of the painting does not show the eye, or the emotions, precisely how to escape the tunnels and reach the bridge. There is no orderly procedure; the eye must be wrenched from one plane to another.

Stella's later paintings of Brooklyn Bridge do not possess this exacting tension between bridge and tunnel. The bridge rises firm

and solid, a triumphant form above chaos below. Of *New York Interpreted* (1920–23), Stella wrote:

> The bridge arises imperturbably with the dark inexorable frame among the delirious raging all around of the temerarious [sic] heights of the skyscrapers and emerges victorious with the majestic sovereignty sealed on his arches upon the subjugated fluvial abyss roaring below with the moanings of appeal of the tug-boats.

In this painting, the bridge has escaped the treacherous forms of the city, and become a principle of its own. The ambivalence of the first painting is resolved in the transcendence of the later.

### III

It is likely that Henry James would have recoiled from the "extravagance" of Stella's apocalyptic visions of Brooklyn Bridge. A mechanical horror for the novelist, the bridge was a spiritual presence for the painter. James had drawn his images from the roadway and its traffic; Stella, from the towers, cables, and promenade. In these two sets of images, the span occupied in the minds of the two artists entirely separate realms — as opposed to each other as the demonic and the divine.

The opposition is all the more interesting in that both artists envisioned the structure as fundamentally technological, yet animated with a spirit above and beyond what the casual eye can perceive. To both it was at once a bridge and something that transcended its concrete "bridge-ness." As such, it functioned for each artist in a realm of the imagination, a vehicle for emotions — rather powerful emotions — concerning the city and modern civilization. And in both cases, although the emphases are entirely different, the emotion is ambivalent: fascination coupled with horror or love. A clear graphic representation of the image would not express the emotion adequately; in each case, "extravagance" is necessary to suggest the wide range of conflicting feelings.

How can we explain this curious fact about Brooklyn Bridge — its ability to arouse such diverse and deep reactions? The answer

must be that for those individuals attuned to the tenor of the times, the bridge embodied physically the forces, emotional as well as mechanical, which were shaping a new civilization. The power of the image arose perhaps from the fact that it represented to certain minds alternate possibilities of those forces — in religious terms, salvation or damnation. Its power arose, in other words, from the fact that the bridge possessed either the capacity of healing, or the disease itself.

This ambiguity of the structure — and the ambivalence of its audience — was also expressed on the level of popular, or unsophisticated, culture. The power to heal and the power to destroy were portrayed in magazine engravings within one week of each other in May 1883: the presence of the symbolic leader of the land at Opening Ceremonies on May 24, and the crushed bodies and terror of May 31. In another mode, similar emotions were represented in the story told by Meyer Berger: A young reporter in the 1870's felt a profound longing for the still unfinished bridge, "unaccountably drawn to it, almost as to a woman warm and pulsing." One night, as though lured to it, he was overcome with the desire to possess the mysterious lady; he climbed one of the cables to the summit of the Manhattan tower. "The siren held him." But then the spell broke, and terrified, he cried for help. None came until morning. Shaken with fear, he was removed. But the fascination continued: "To him she was always a Circe made of steel and granite, but irresistible." [4]

Conflicting emotions such as these correspond significantly to

4. *Modernized Brooklyn Bridge: Souvenir Presentation: Official Opening,* May 2, 1954 (New York, 1954), 21. A similar ambivalence appears in a verse-drama, "The Bridge," by Dorothy Landers Beall, *The Bridge and Other Poems* (New York, 1913). To the heroine, a settlement-house worker, the bridge unites a divided society, linking "two cities, pride/ With anguish — luxury with agony,/ Beauty with squalor." At times, however, she fears the mechanical structure: "the horrible steel thing." Once a popular theme in newspaper verse and "amateur" poetry (e.g. "Brooklyn Bridge in Early Morning"), the span has been praised lavishly ("noble work," "this path among the stars"), and animated with soul and voice ("divine messages from above"). But also, in allusions to its builder's fate and to the multitude of jumpers, it has often been associated with death — especially with the lonely suicides of city-dwellers.

the opposition Henry Adams found at the heart of Western civilization, the opposition between what he called the Virgin and the dynamo. These images — drawn respectively from idolatry of Mary in the Middle Ages and the source of mechanical power in the Machine Age — represented for him two sets of opposing values. The Virgin represented a submissive feeling toward nature: toward its fecundity, its organic order, its mystery. Mary was the Christian version of Ceres and Venus, an earth mother, a goddess of love. Inspired by devotion toward her, medieval civilization had built its aspiring towers — the great cathedrals. These buildings, in all their complexity, their fusion of materials, their containment of "high" and "low" art, represent the unity of mind and heart resulting from love of a divine nature figure.

The dynamo, on the other hand, stood for the refinement of power, for the domination of nature, parallel to the dominance of ruthless, acquisitive, and repressive behavior in modern society. The feminine principle had been suppressed on behalf of the masculine, whereas earlier the masculine had felt itself realized in adoration of the feminine. The effect was a culture of disintegrating faith, of multiplicity. No one prayed to a dynamo. But the New York skyline, Adams observed in 1905, in its appearance of an exploded cylinder, expressed the dynamo's terrible sovereignty. In America, he wrote, "neither Venus nor Virgin ever had value as force — at most as sentiment. No American had ever been truly afraid of either." [5]

By designating these "two kingdoms of force," Henry Adams may have provided the key to unlock the meaning of the bridge. In the minds of many, it occupied both kingdoms — separately, of course, but unconsciously at once. As a highway it served the dynamo, as James recognized, and represented change and progress. But as a form against the sky, or a promenade for lovers, it seemed to serve the Virgin — particularly with its impressive Gothic arches,

5. *The Education of Henry Adams* (1907), Modern Library edition, 1931, 379–91.

like cathedral windows. It seemed to represent something permanent. There was also a mid-kingdom: the deranged discovered the fatal uses of its parapets, and obscure men, driven from the gloom of the streets, threw themselves from its towers to find glory. It is no wonder, then, that taken together in all its aspects, as highway and promenade, as engineering and art, it evoked responses as if it were a cardinal emblem of the age. For if it belonged to both kingdoms, might it not serve an even higher function as a reconciliation, a bridge between the opposite impulses of love and power? Might it not in the imagination heal the most serious breach in the age?

### IV

"Beyond any other aspect of New York," Lewis Mumford wrote in *Sticks and Stones* (1924), "the Brooklyn Bridge has been a source of joy and inspiration to the artist." Mumford himself initiated a new appreciation of the structure. It is notable that his was a backward look at an already fixed landmark, a vestige of an earlier age. To the public, the first of the East River spans was already touched with nostalgia; to Mumford it was a central monument in a "usable past." Writing as a young spokesman for a movement to revitalize American culture, he offered Brooklyn Bridge, along with the buildings of H. H. Richardson and Louis Sullivan, the parks of F. L. Olmsted, and the paintings of A. P. Ryder as a tradition to be built upon.[6]

Mumford's bridge is not a traffic highway; it is not a convenience for transportation. Instead it is a beautiful and prophetic form. The joy and inspiration it excites derives from its mastery over steel, its organic use of mechanical parts. The bridge transcends its materials; it is a "stunning act": "perhaps the most completely satisfying structure of any kind that had appeared in America." In a period

6. Lewis Mumford, *Sticks and Stones* (New York, 1924), 114–17, and *The Brown Decades* (1931), 96–106.

when industrialism was deforming the environment, the bridge, with its "strong lines" and "beautiful curve," proved that "the loss of form was an accident, not an inescapable result of the industrial processes." Roebling's work reproached the age, but also redeemed it: "All that the age had just cause for pride in — its advances in science, its skill in handling iron, its personal heroism in the face of dangerous industrial processes, its willingness to attempt the untried and the impossible — came to a head in Brooklyn Bridge."

In his quest for a "usable past," Mumford was guided by a desire to condemn mechanization without condemning the machine. It was possible, he felt, to assimilate modern technology to human ends. If only its true possibilities of service to humanity were acknowledged, the machine might reveal its inherent beauty of form. The bridge represented such beauty: its appeal was in its uniquely mechanical elegance, its undisguised expression of steel. "What was grotesque and barbarous in industrialism was sloughed off," Mumford wrote. "A fulfillment and a prophecy," Brooklyn Bridge embodied in its form and in the devotion of its creators — a devotion in the manner of those lovers of the Virgin who had raised Chartres in her honor — a victory over the aimless energy of the dynamo.

Mumford's treatment of Brooklyn Bridge was a direct response to what Van Wyck Brooks had named in 1912 the "culture of industrialism" — a culture which suffered from a deficiency of the humane, the organic, the aspiring. Along with many others, Mumford found in Brooklyn Bridge an image adequate to express his sense of the promise that lay buried within such a culture — a promise of reconciliation. The bridge seemed to stand between two kingdoms of force as a prophecy of a third.[7]

7. Implicit in Mumford's work of the 1920's was a nationalism based on an integrated culture of mechanical means and organic ends. In *Our America* (New York, 1919), Waldo Frank, a colleague in Mumford's quest for a "usable past," had spelled out the nationalistic implications. "America," wrote Frank, "is a mystic

Word." Without consciousness of itself, however, the land lies "dumb." Industrialism, feeding upon a moribund Puritanism and the exploitive pioneer spirit, had created a "shrieking" environment. The way out lay with a leap of consciousness in which the Machine would take its true place as a servant of man: man, the "parabolic force," the link between earth and heaven — in short, "the Bridge which all true artists seek."

Waldo Frank's mystical nationalism prepared yet another function for Brooklyn Bridge. Mumford had treated the bridge as a monument from the past; Frank, in a novel written several years before *Our America*, portrayed it as an immediate experience. In *The Unwelcome Man* (Boston, 1917), the bridge played an important role in the troubled life of Quincy Burt.

Seeking a "welcome" in American life for his deep but inarticulate yearnings, Quincy found himself one afternoon, "washed along like a splinter of wood on a rising wave," on the promenade of the bridge. "He felt that every cable of the web-like maze was vibrant with stress and strain. With these things he was alone. Yet he felt no insecurity, such as the crowds inspired." The bridge showed him the ugliness of the cities. But there was also a powerful sense of beauty. With these mixed emotions, Quincy suddenly realized: "from his perch of shivering steel the power should indeed come to poise and judge the swarm above which he rocked. The bridge that reeled beyond him seemed an arbiter. It bound the city. It must know the city's soul since it was so close to the city's breath. In its throbbing cables there must be a message."

But the message was too deep for him. Under the bridge, in its shadows in Brooklyn, it seemed to him "an unattainable pathway." He retraced his footsteps to Manhattan, descended, and saw the bridge again "a giant causeway." Underneath, "one arc-light . . . broke off a circlet of yellow-white from the surrounding gloom. Above shone a ragged strip of sky." In a panic, Quincy wandered through the streets near the bridge: "Under the Bridge itself he went — looming above him like a curse." He tried to "escape the omnipresent Bridge"! "Crowds jostled him; cars clashed; machines were braying, shuttling. The taste of New York was bitter on his lips." Finally he escaped. Unable to reconcile the beauty and the ugliness, to rise to the height of the bridge, Quincy Burt chose to die.

In his creator's mind, the hero of the novel was a victim of the "culture of industrialism." His truest impulses were not welcome precisely because they were "true," and organic; when he resorted to the less trying course of dying spiritually, he became a cog in the machine, a splinter in the "turbid stream" of the city. Van Wyck Brooks reviewed this novel as a substantiation of John Stuart Mill's prediction that industrialism would lead to "an appalling deficiency of human preferences." The bridge represented an alternative to the city streets, a way to absorb the entire urban reality into consciousness; but Quincy preferred to evade the struggle toward liberation. Deficient in courage and faith, he preferred the unthinking life of industrial culture.

Van Wyck Brooks's review is reprinted in Gorham B. Munson, *Waldo Frank: A Study* (New York, 1923), 75–6. See Mr. Munson's more recent study, "Herald of the Twenties: A Tribute to Waldo Frank," *Forum*, Vol. III (Fall 1961), 4–15.

# 9

Oh, grassy glades! oh, ever vernal endless
landscapes in the soul; in ye, — men yet may roll,
like young horses in new morning clover; and for some
few fleeting moments, feel the cool dew
of the life immortal on them. Would to God
these blessed calms would last.

HERMAN MELVILLE, *Moby-Dick* (1851)

The time is barren, and therefore its poet overrich.

MARTIN HEIDEGGER, "Hölderlin and the Nature of Poetry" (1937)

# The Shadow of a Myth

In the winter of 1923, Hart Crane, a twenty-four-year-old poet living in Cleveland, announced plans to write a long poem called *The Bridge*. It was to be an epic, a "mystical synthesis of America." [1] Crane had just completed *For the Marriage of Faustus and Helen*, a poem which sought to infuse modern Faustian culture (the term was Spengler's, designating science and restless searching) with love of beauty and religious devotion. Now, confirmed in his commitment to visionary poetry and feeling "directly connected with Whitman," Crane prepared for an even greater effort: to compose the myth of America. The poem would answer "the complete renunciation symbolized in *The Waste Land*," published the year before. Eliot had used London Bridge as a passageway for the dead, on which "each man fixed his eyes before his feet." Crane replied by projecting his myth of affirmation upon Brooklyn Bridge.

1. *The Bridge* was first published by The Black Sun Press, Paris, 1930; this edition included three photographs by Walker Evans. The lines quoted throughout this chapter are from *The Complete Poems of Hart Crane* (New York, 1933), ed., Waldo Frank; references in the chapter are to *The Letters of Hart Crane* (New York, 1952), ed., Brom Weber. The critical works I have profited from most in my reading of *The Bridge* are, Allen Tate, "Hart Crane," *Reactionary Essays* (New York, 1936); Yvor Winters, "The Significance of *The Bridge*," *In Defense of Reason* (New York, 1947), 575–605; R. P. Blackmur, "New Thresholds, New Anatomies: Notes on a Text of Hart Crane," *Language as Gesture* (New York, 1952); Brom Weber, *Hart Crane: A Biographical and Critical Study* (New York, 1948); L. S. Dembo, *Hart Crane's Sanskrit Charge: A Study of The Bridge* (Ithaca, 1960); Sister M. Bernetta Quinn, *The Metamorphic Tradition in Modern Poetry* (New Brunswick, 1955),

In the spring of 1923, Hart Crane left his father's home in Cleveland, and from then until his suicide in 1932, lived frequently in Brooklyn Heights, close to "the most beautiful Bridge of the world." He crossed the bridge often, alone and with friends, sometimes with lovers: "the cables enclosing us and pulling us upward in such a dance as I have never walked and never can walk with another." Part III of *Faustus and Helen* had been set in the shadow of the bridge, "where," Crane wrote, "the edge of the bridge leaps over the edge of the street." In the poem the bridge is the "Capped arbiter of beauty in this street," "the ominous lifted arm / That lowers down the arc of Helen's brow." Its "curve" of "memory" transcends "all stubble streets."

Crane tried to keep Brooklyn Bridge always before him, in eye as well as in mind. In April 1924 he wrote: "I am now living in the shadow of the bridge." He had moved to 110 Columbia Heights, into the very house, and later, the very room occupied fifty years earlier by Roebling. Like the crippled engineer, the poet was to devote his most creative years to the vision across the harbor. In his imagination the shadow of the bridge deepened into the shadow of a myth.

## I

*The Bridge*, Crane wrote, "carries further the tendencies manifest in 'F and H.'" These tendencies included a neo-Platonic conception of a "reality" beyond the evidence of the senses. The blind chaos of sensation in the modern city apparently denies this transcendent reality, but a glimpse of it is available, through ecstasy, to the properly devout poet. Helen represents the eternal, the unchanging; Faustus, the poet's aspiration; and the "religious gunman" of Part III, spirit of the Dionysian surrender (sexual as well as aes-

---

130–68; Stanley K. Coffman, "Symbolism in *The Bridge*," PMLA, Vol. LXVI (March 1951), 65–77; John Unterecker, "The Architecture of The Bridge," *Wisconsin Studies in Contemporary Literature*, Vol. III (Spring–Summer 1962), 5–20.

thetic) necessary for a vision of the eternal. The threefold image constitutes what Kenneth Burke has called an "aesthetic myth" — a modern substitute for "religious myth." [2] The poet's impulse toward beauty is a mark of divinity. A part of the myth, and another "tendency" of the poem, is what Crane called its "fusion of our time with the past." The past is represented by the names Faustus and Helen; the present by the data of the poem: the "memoranda," the "baseball scores," and "stock quotations" of Part I; the jazz dance of Part II; the warplanes of Part III. The present fails to live up to the past. But the poet, a "bent axle of devotion," keeps his "lone eye" riveted upon Helen; he offers her "one inconspicuous, glowing orb of praise." At the end, in communion with the "religious gunman," he accepts and affirms past and present, the "years" whose "hands" are bloody; he has attained "the height/ The imagination spans beyond despair."

The idea of a bridge is explicit in the closing image; earlier, as I have indicated, it had appeared in fact, leaping over the street. In the projected poem, it will leap far beyond the street, but its function will be similar: an emblem of the eternal, providing a passage between the Ideal and the transitory sensations of history, a way to unify them.

In the earliest lines written for the new poem, the bridge was the location of an experience like that which ends *Faustus and Helen:* the imagination spanning beyond despair.

> And midway on that structure I would stand
> One moment, not as diver, but with arms
> That open to project a disk's resilience
> Winding the sun and planets in its face.
>
> \*     \*     \*     \*
>
> Expansive center, pure moment and electron
> That guards like eyes that must look always down

2. *A Rhetoric of Motives* (New York, 1950), 203.

> In reconcilement of our chains and ecstasy
> Crashing manifoldly on us as we hear
> The looms, the wheels, the whistles in concord
> Tethered and welded as the hills of dawn  . . .[3]

Somewhat like Wordsworth on Westminster Bridge, here the poet experiences harmony, his troubled self annihilated in a moment of worship. Subsequently Crane developed a narrative to precede this experience. In the narrative, or myth, the poet, like Faustus, was to be the hero, and his task a quest — not for Helen but her modern equivalent: Brooklyn Bridge.

Although the bridge lay at the end of quest, it was not, like the grail in *The Waste Land*, simply a magical object occupying a given location. It does not wait to be found, but to be created. That is, it represents not an external "thing," but an internal process, an act of consciousness. The bridge is not "found" in "Atlantis," the final section of the poem, but "made" throughout the poem. In "Atlantis" what has been "made" is at last recognized and named: "O Thou steeled Cognizance." Its properties are not magical but conceptual: it is a "Paradigm" of love and beauty, the eternal ideas which lie behind and inform human experience.

If we follow the poet's Platonic idea, to "think" the bridge is to perceive the unity and wholeness of history. In the poem, history is not chronological nor economic nor political. Crane wrote: "History and fact, location, etc., all have to be transfigured into abstract form that would almost function independently of its subject matter." Crane intended to re-create American history according to a pattern he derived from its facts. His version of American history has nothing in common with the ceremonial parade of Founding Fathers and bearded generals of popular culture. The poet's idea, and especially his distinction between history and "abstract form,"

3.  The first four lines are from "Lines sent to Wilbur Underwood, February, 1923," and the remainder from "Worksheets, Spring, 1923," in Brom Weber, *Hart Crane,* 425–6.

is closer to what the anthropologist Mircea Eliade describes as the predominant ontology of archaic man — the myth of "eternal return." According to Eliade, the mind of archaic man sought to resist history — the line of "irreversible events" — by re-creating, in his rituals, the pre-temporal events of his mythology, such as the creation of the world. Unable to abide a feeling of uniqueness, early men identified, in their rituals, the present with the mythic past, thus abolishing the present as an autonomous moment of time. All events and actions "acquire a value," writes Eliade, "and in so doing become real, because they participate, after one fashion or another, in a reality that transcends them." The only "real" events are those recorded in mythology, which in turn become models for imitation, "paradigmatic gestures." All precious stones are precious because of thunder from heaven; all sacred buildings are sacred because they are built over the divine Center of the world; all sexual acts repeat the primordial act of creation. A non-precious stone, a non-sacred building, a non-sanctified act of sex — these are not real. History, as distinct from myth, consists of such random acts and events, underived from an archetype; therefore history is not real and must be periodically "annulled." By imitating the "paradigmatic gesture" in ritual, archaic men transported themselves out of the realm of the random, of "irreversible events," and "re-actualized" the mythic epoch in which the original archetypal act occurred. Hence for the primitive as for the mystic, time has no lasting influence: "events repeat themselves because they imitate an archetype." Like the mystic, the primitive lives in a "continual present." [4]

*The Bridge* is a sophisticated and well-wrought version of the archaic myth of return. The subject matter of the poem is drawn from legends about American history: Columbus, Pocahontas, Cortez, De Soto, Rip Van Winkle, the gold-rush, the whalers; and

4. *Cosmos and History: The Myth of the Eternal Return* (Harper Torchbooks, 1959), 4, 90.

from contemporary reality: railroads, subways, warplanes, office buildings, cinemas, burlesque queens. Woven among these strands are allusions to world literature: the Bible, Plato, Marlowe, Shakespeare, Blake; and most important, to American artists: Whitman, Melville, Poe, Dickinson, Isadora Duncan. The action of the poem comprises through its fifteen sections, one waking day, from dawn in "Harbor Dawn," to midnight in "Atlantis." Through the device of dream, that single day includes vast stretches of time and space: a subway ride in the morning extends to a railroad journey to the Mississippi, then back in time, beyond De Soto, to the primeval world of the Indians,[5] then forward to the West of the pioneers. In a sense, the entire day is a dream; the poet journeys through his own consciousness toward an awakening. He seeks to learn the meaning of American history which, in so far as that history is inseparable from his own memories, is the meaning of himself: Cathay, which designates the end of the journey, or the discovery of a new world, Crane wrote, is "an attitude of spirit," a self-discovery.

Thus in no sense of the word is *The Bridge* a historical poem. Its mode is myth. Its aim is to overcome history, to abolish time and the autonomy of events, and to show that all meaningful events partake of an archetype: the quest for a new world. In this regard the importance of Walt Whitman requires special notice. For among the many influences that worked upon Crane, few were as persuasive as Whitman's.[6]

5. Crane's conception of the Indian in "The Dance"— in the "Powhatan's Daughter" section of *The Bridge* — seems to owe something to Waldo Frank's *Our America* (1919). In his personal copy, Crane had underlined the following passage: "His [the Indian's] magic is not, as in most religions, the tricky power of men over their gods. It lies in the power of Nature herself to yield corn from irrigation, to yield meat in game. The Indian therefore does not pray to his God for direct favors. He prays for harmony between himself and the mysterious forces that surround him: of which he is one. For he has learned that from this harmony comes health." Hart Crane Collection, Columbia University Library.

6. A word should be said about the powerful influence upon Crane's sensibility — and his plans for *The Bridge* — of the Russian mystic, P. D. Ouspensky, and his

In "Passage to India," we have seen, Whitman identified the quest for wholeness — the "rondure" — as the chief theme and motive of American life. In Whitman's version of history, man was expelled from Eden into time: "Wandering, yearning, curious, with restless explorations,/ With questions, baffled, formless, feverish." Divided into separate and warring nations, at odds with nature, historical man was a sufferer. Now, however, in modern America, the end of suffering was in sight. The connecting works of engineers — the Suez Canal, the Atlantic Cable, the Union Pacific Railroad — had introduced a new stage; the separate geographical parts of the world were now linked into one system. The physical

work, *Tertium Organum: The Third Canon of Thought, A Key to the Enigmas of the World,* tr. Nicholas Bessaraboff and Claude Bragdon (New York, 1922). Crane read this book early in his creative life — possibly in 1920 (an earlier edition had been published that year). It seems very likely that he derived most of his philosophical idealism, and a good deal of his language and imagery, from Ouspensky. A case could be made for the fact that he interpreted Whitman in Ouspenskian terms — as a mystic who saw through the world to a higher reality. "Higher consciousness" was a typical Ouspenskian term. So was "vision," in its literal and metaphoric senses. Plato's parable of the cave, in which most men sit in darkness, hidden from the truth, is the unstated assumption of Ouspensky's book. The book attempts to place the mystical experience of light and oneness on accountable grounds; its method is to prove by analogies that the true or noumenal world lies beyond space and time, beyond the capacity of the normal mind to perceive. Limited to a three-dimensional view of the world (a consequence of education and bad science), the mind normally interprets what are really flashes from the true world as things moving in time. In truth, however, the "whole" is motionless and self-contained; time itself is man's illusion: "The idea of time recedes with the expansion of consciousness." The true world being "invisible" to normal sight, it is necessary to cultivate the inner eye. This can be accomplished only by exercising the outer eye to its fullest capacities — to strain vision until familiar things seem unfamiliar, new, and exciting. Then we might penetrate the "hidden meaning in everything." Then we will see the "invisible threads" which bind all things together — "with the entire world, with all the past and all the future." It should be noted that an idea of a bridge is implicit here — a metaphoric bridge which represents the true unity of all things. Moreover, Ouspensky held that art, especially poetry, was a means to attain this metaphoric bridge. To do so, however, poetry must develop a new language: "New parts of speech are necessary, an infinite number of new words." The function of poetry is to reveal the "invisible threads," to translate them into language which will "bind" the reader to to the new perceptions. It is quite easy to see how attractive these ideas were to Hart Crane's poetic program. See Weber, 150–63.

labors of engineers, moreover, were spiritual food for the poet; the "true son of God" recognized that by uniting East and West such works completed Columbus's voyage. Now it was clear: The "hidden" purpose of history was the brotherhood of races that would follow the bridges and canals of modern technology.

Crane was not interested principally in Whitman's social vision, but in his conception of poetry as the final step in the restoration of man's wholeness. Not the engineer nor the statesman nor the captain of industry, but the poet was the true civilizer. Translating engineering accomplishments into ideas, the poet completed the work of history, and prepared for the ultimate journey to "more than India," the journey to the Soul: "thou actual Me." Thus the poet recognized that all of history culminated in self-discovery; and he would lead the race out of its bondage in time and space to that moment of consciousness in which all would seem one. That moment of "return" would redeem history by abolishing it. In short, Crane inherited from Whitman the belief in the poet's function to judge history from the point of view of myth.

Whitman himself appears in "Cape Hatteras," which represents a critical phase of the action of *The Bridge*. In the preceding sections, the poet had set out to find Pocahontas, the spirit of the land. With Rip Van Winkle his Muse of Memory, and the Twentieth Century Limited his vehicle, he moved westward out of the city to the Mississippi, the river of time. Borne backward on the stream, he found the goddess, joined her dance of union with nature, and thus entered the archetype. Now he must return to the present, to bridge the personal vision of the goddess and the actuality of modern America. An old sailor (possibly Melville) in a South Street bar and an apparition of old clipper ships from Brooklyn Bridge in "Cutty Sark," are reminders of the quest. But the old has lost its direction; the age requires a renewal.

"Cape Hatteras" is the center of the span that leaps from Columbus to Brooklyn Bridge. The sea voyages are now done, the

rondure accomplished. Now, a complacent age of stocks, traffic, and radios has lost sight of its goal; instead of a bridge, the age has created "a labyrinth submersed/ Where each sees only his dim past reversed." War, not peace and brotherhood, has succeeded the engineers, and flights into space are undertaken, not by poets but by war planes. "Cape Hatteras" poses the key questions of the poem: "What are the grounds for hope that modern history will not destroy itself?" "Where lies redemption?" "Is there an alternative to the chaos of the City?"

The answers are in Whitman's "sea eyes," "bright with myth." He alone has kept sight of the abstract form, the vision of ultimate integration. His perspective is geological; he stands apart, with "something green,/ Beyond all sesames of science." Whitman envisioned the highest human possibilities within the facts of chaos. It was he who "stood up and flung the span on even wing/ Of that great Bridge, our Myth, whereof I sing." He is a presence: "Familiar, thou, as mendicants in public places." He has kept faith, even among the most disastrous circumstances of betrayal. With his help, the flight into space might yet become "that span of consciousness thou'st named/ The Open Road."

"Cape Hatteras" introduces the violence and the promise, the despair and the hope, of modern life. It argues for the effectiveness of ideals, for the power of Utopia over history. The poet places his hand in Whitman's, and proceeds upon his quest. Returning from the sea in "Southern Cross," he searches for love in "National Winter Garden" and "Virginia," for community and friendship in "Quaker Hill," and for art in "The Tunnel." He finds nothing but betrayal: the strip tease dancer burlesques Pocahontas, the office girl is a pallid Mary, the New Avalon Hotel and golf course mock the New England tradition, and the tunnel crucifies Poe. But throughout, the poet's hand is in Whitman's, and at last, having survived the terrors of "The Tunnel," he arrives at the bridge.

II

Brooklyn Bridge lay at the end of the poet's journey, the pledge of a "cognizance" that would explain and redeem history. To reach the bridge, to attain its understanding, the poet suffered the travail of hell. But he emerges unscathed, and ascends the span. In "Atlantis" he reaches Cathay, the symbol of sublime consciousness. The entire action implies a steady optimism that no matter how bad history may be, the bridge will reward the struggle richly. Such is its promise in the opening section of the poem, "Proem: To Brooklyn Bridge."

> How many dawns, chill from his rippling rest
> The seagull's wings shall dip and pivot him,
> Shedding white rings of tumult, building high
> Over the chained bay waters Liberty —
>
> Then, with inviolate curve, forsake our eyes
> As apparitional as sails that cross
> Some page of figures to be filed away;
> — Till elevators drop us from our day . . .
>
> I think of cinemas, panoramic sleights
> With multitudes bent toward some flashing scene
> Never disclosed, but hastened to again,
> Foretold to other eyes on the same screen;
>
> And Thee, across the harbor, silver-paced
> As though the sun took step of thee, yet left
> Some motion ever unspent in thy stride, —
> Implicitly thy freedom staying thee!
>
> Out of some subway scuttle, cell or loft
> A bedlamite speeds to thy parapets,
> Titling there momently, shrill shirt ballooning,
> A jest falls from the speechless caravan.

Down Wall, from girder into street noon leaks,
A rip-tooth of the sky's acetylene;
All afternoon the cloud-flown derricks turn . . .
Thy cables breathe the North Atlantic still.

And obscure as that heaven of the Jews,
Thy guerdon . . . Accolade thou dost bestow
Of anonymity time cannot raise:
Vibrant reprieve and pardon thou dost show.

O harp and altar, of the fury fused,
(How could mere toil align thy choiring strings!)
Terrific threshold of the prophet's pledge,
Prayer of pariah, and the lover's cry, —

Again the traffic lights skim thy swift
Unfractioned idiom, immaculate sigh of stars,
Beading thy path — condense eternity:
And we have seen night lifted in thine arms.

Under thy shadow by the piers I waited;
Only in darkness is thy shadow clear.
The City's fiery parcels all undone,
Already snow submerges an iron year . . .

O Sleepless as the river under thee,
Vaulting the sea, the prairies' dreaming sod,
Unto us lowliest sometime sweep, descend
And of the curveship lend a myth to God.

The setting of "Proem" in the harbor and lower Manhattan area is distinct, though the point of view shifts a good deal within this area, from a long view of the Bay and the Statue of Liberty, to an office in a skyscraper, down an elevator into the street, into a dark movie house, and then to the sun-bathed bridge. The view of the

bridge also changes, from "across the harbor," in which the sun appears to be walking up the diagonal stays, to the promenade and towers as the bedlamite "speeds to thy parapets." Later the point of view is under the bridge, in its shadow. The shifting perspectives secure the object in space; there is no question that it is a bridge across a river between two concretely realized cities.

At the same time, the bridge stands apart from its setting, a world of its own. A series of transformations in the opening stanzas bring us to it. We begin with a seagull at dawn — a specific occurrence, yet eternal ("How many dawns"). The bird's wings leave our eyes as an "inviolate curve" (meaning unprofaned as well as unbroken) to become "apparitional as sails" (apparitional implies "epiphanal" as well as spectral and subjective). Then, in a further transmutation, they become a "page of figures." As the wings leave our eyes, so does the page: "filed away." Then, elevators "drop us" from the bird to the street. In the shift from bird to page to elevator, we have witnessed the transformation of a curve into a perpendicular, of an organism into a mechanism — wings into a list of numbers. "Filed away," the vision of the curve, identified with "sails" and voyages, has been forgotten ("How many" times?), like a page of reckonings. The quest for a vision of bird and sails resumes in the cinema, but, as in Plato's cave, the "flashing scene" is "never disclosed." Then, the eye finds a permanent vision of the curve in the "silver-paced" bridge.

The bridge has emerged from a counterpoint of motions (bird vs. elevator; sails vs. "multitudes bent") as an image of self-containment. Surrounded by a frantic energy ("some flashing scene . . . hastened to again"; "A bedlamite speeds . . .") the bridge is aloof; its motions express the sun. Verbs like drop, tilt, leak, submerge describe the city; the bridge is rendered by verbs like turn, breathe, lift, sweep. Established in its own visual plane, with a motion of its own, the bridge is prepared, by stanza seven, to receive the epithets of divinity addressed to it. Like Mary, it em-

braces, reprieves, and pardons. Its cables and towers are "harp and altar." The lights of traffic along its roadway, its "unfractioned idiom," seem to "condense eternity." Finally, as night has extinguished the cities and thereby clarified the shadow of the bridge, its true meaning becomes clear: its "curveship" represents an epiphany, a myth to manifest the divine. Such at least is what the poet implores the bridge to be.

In "Proem," Brooklyn Bridge achieves its status in direct opposition to the way of life embodied in the cities. Bridge and city are opposing and apparently irreconcilable forms of energy. This opposition, which is equivalent to that between myth and history, continues through the remainder of the poem; it creates the local tensions of each section, and the major tension of the entire work.

This tension is best illustrated in "The Tunnel," the penultimate section of the poem. After a fruitless search for reality in a Times Square theater, the protagonist boards a subway as "the quickest promise home." The short ride to Brooklyn Bridge is a nightmare of banal conversations and advertisements: "To brush some new presentiment of pain." The images are bizarre: "and love/ A burnt match skating in a urinal." Poe appears, his head "swinging from the swollen strap," his eyes "Below the toothpaste and the dandruff ads." The crucified poet, dragged to his death through the streets of Baltimore, "That last night on the ballot rounds," represents how society uses its visionary devotees of beauty.[7]

7. It is wrong to assume that Poe and Whitman oppose each other in this work — one gloomy, the other cheerful. Poe in the tunnel does indeed represent the actuality of art in modern life, but the image is not meant to contradict Whitman's vision — perhaps to countervail it, and by so doing, to reinforce its strength. According to his friends — especially Samuel Loveman — Crane loved both poets, although he derived more substance for his art from Whitman (and Melville). To make this point may also be a good occasion to recall that Whitman himself was powerfully drawn to Poe. There is some evidence they knew each other as newspaper men in New York in the 1840's. Whitman was the only major American writer to attend the dedication of a Poe memorial in Baltimore in 1875, and sat on the platform as Mallarmé's famous poem was being read. In Specimen Days, Whitman wrote that Poe's verse

If the "Proem" promised deliverance, "The Tunnel" seems to deliver damnation; its chief character is a Daemon, whose "hideous laughter" is "the muffled slaughter of a day in birth." The Daemon's joke is that he has inverted the highest hopes and brightest prophecies: "O cruelly to inoculate the brinking dawn/ With antennae toward worlds that glow and sink." The presiding spirit in the tunnel, he represents the transvaluation of ideals in modern America.

At the end of "The Tunnel," the protagonist leaves the subway and prepares, at the water's edge, to ascend the bridge. His faith, like Job's, is unimpaired. Job endured the assault of Satan, uttered no complaints, and in the end profited by an enlightened understanding, albeit an irrational one, of the power of his God. It is revealing — although it has been largely unnoticed — that Crane's epigraph to *The Bridge* is taken from Satan's reply to God in Job, 1.7: "From going to and fro in the earth, and from walking up and down in it." The words might be read to indicate the theme of voyage, but their source suggests a richer interpretation: the omnipresence of evil, of the Daemon of "The Tunnel." Job's only defense is unremitting faith in his own righteousness and God's justice. And the same holds for the poet: faith in Whitman, his own powers, and in his bridge.

---

expressed the "sub-currents" of the age; his poems were "lurid dreams." Thus, Poe presented an "entire contrast and contradiction" to the image of "perfect and noble life" which Whitman himself had tried to realize. But it is significant that Whitman concedes morbidity to be as true of the times as health. He tells of a dream he once had of a "superb little schooner" yacht, with "torn sails and broken spars," tossed in a stormy sea at midnight. "On the deck was a slender, slight, beautiful figure, a dim man, apparently enjoying all the terror, the murk, and the dislocation of which he was the center and the victim. That figure of my lurid dream might stand for Edgar Poe" (*Complete Prose Works*, 150). Whitman's "lurid dream" may very well be a source for Crane's nightmare in "The Tunnel" — where once more Poe is "the center and the victim." Much of the power of both images comes from the fact that, as Jack McManis has said to me, "Whitman's head [or Crane's] also could be swinging from that subway strap."

III

To keep the faith but not close his eyes to reality was Hart Crane's chief struggle in composing *The Bridge*. Reality in the 1920's — the age of jazz, inflated money, and Prohibition — did not seem to support any faith let alone one like Crane's. It was a period of frantic construction, of competition for the title of "Tallest Building in the World," won in 1930 by the Empire State Building. That tower had climbed the sky at the rate of a story a day to the height of a hundred and two floors. Elsewhere, Florida experienced a hysterical real-estate boom. In 1927 the first cross-country highway announced the age of the automobile. The same year, Lindbergh crossed the Atlantic. And in the same decade, the movie palace spread into neighborhoods.

In certain moods, Crane was possessed by the fever of the period: "Time and space is the myth of the modern world," he wrote about Lindbergh, "and it is interesting to see how any victory in the field is heralded by the mass of humanity. In a way my Bridge is a manifestation of the same general subject. Maybe I'm just a little jealous of Lindy!" [8] But the over-all effect of the direction of American life did not accord with his myth. From 1926 to 1929, years during which his own physical and emotional life deteriorated noticeably,[9] Crane searched for a way to acknowledge the unhappy reality of America without surrendering his faith. The changes he made in the final poem of the sequence — the poem he had begun in 1923 and altered time and again — disclose the accommodation he reached.

At first, as I have indicated, the finale projected an intense experience of harmony. As his conception of the bridge took shape, he changed the ending accordingly, weaving into it the major images developed earlier, which are mainly nautical and musical. He reor-

8. Hart Crane to his father, June 21, 1927. Yale American Literature Collection.
9. See Philip Horton, *Hart Crane: The Life of an American Poet* (New York, 1937).

ganized the section into a walk across the bridge, and incorporated many structural details of the cables and towers. "I have attempted to induce the same feelings of elation, etc. — like being carried forward and upward simultaneously — both in imagery, rhythm and repetition, that one experiences in walking across my beloved Brooklyn Bridge."

> Through the bound cable strands, the arching path
> Upward, veering with light, the flight of strings, —
> Taut miles of shuttling moonlight syncopate
> The whispered rush, telepathy of wires.
> Up the index of night, granite and steel —
> Transparent meshes — fleckless the gleaming staves —
> Sibylline voices flicker, waveringly stream
> As though a god were issue of the strings. . . .
>
>             *    *    *    *
>
> Sheerly the eyes, like seagulls stung with rime —
> Slit and propelled by glistening fins of light —
> Pick biting way up towering looms that press
> Sidelong with flight of blade on tendon blade
> — Tomorrows into yesteryear — and link
> What cipher-script of time no traveller reads

Rhythm and imagery convey a real bridge as well as an "arc synoptic": the walk across the span recapitulates the experience of the concluding day.

In stanza six, at the center of the roadway, the poet attains his vision. It is midnight; night is lifted "to cycloramic crest/ Of deepest day." Now, as "Tall Vision-of-the-Voyage," the bridge becomes a "Choir, translating time/ Into what multitudinous Verb": it is "Psalm of Cathay!/ O Love, thy white pervasive Paradigm. . . !" This moment is the climax of the poem. In the six stanzas which follow, Crane interprets the "multitudinous Verb" as the explicit action of reaching Cathay. He achieves this through

predominant images of voyage; the bridge becomes a ship which, in stanza seven, "left the haven hanging in the night." The past tense modulates the tone of the entire section, for we are now "Pacific here at time's end, bearing corn." We have left the physical bridge, and are transported to another realm, a realm which fuses land ("corn") and water ("Pacific") — or Pocahontas and Columbus. The implied image is clearly that of an island, much like the "insular Tahiti" of the soul which Ishmael discovers to his salvation in Melville's *Moby-Dick*. The *Pequod* too had rushed ahead "from all havens astern." In stanza eleven, the poet like the lone survivor of Ahab's madness, finds himself "floating" on the waters, his visionary Belle Isle (Atlantis) sustaining him. In the last stanza, still addressing the bridge, he floats onward toward Cathay. The passage has been made "from time's realm" to "time's end" to "thine Everpresence, beyond time." Like Melville, Crane began his spiritual voyage in the North Atlantic, plunged into older waters, and nearing Cathay, recovered the even older shores of Atlantis. East and West have merged in a single chrysalis.

The language of the closing six stanzas of the section has the resonance of a hymn; it includes some of Crane's most quoted epithets: "Unspeakable Thou Bridge to Thee, O Love." But the oracular tone is bought at an expense. The opening six stanzas were dominated by the physical presence of the bridge and the kinetic sense of moving across it; the last six, having left the "sheened harbor lanterns" behind, remove to a watery element. And as the bridge becomes a symbolic ship, we sense an underlying relaxation. It is true that the language remains rich, even rugged ("Of thy white seizure springs the prophecy"). But the hyperbolic imagery itself seems an effort to substitute verbal energy for genuine tension. The original tension, between the poet-hero and history, seems to be replaced by an unformulated struggle *within* the poet, a struggle to maintain a pitch of language unsupported by a concrete action. For the climactic action of the entire poem had already occurred,

when, at the center of the span, the poet names the bridge as "Paradigm." The rest is an effort, bound to prove inadequate in the nature of the case, to say what it is a paradigm of. Thus the poet, full of ponderous (and, we sense, conflicting) emotions, sails away from the harbor, detaching the myth from its concreteness. And the bridge achieves its final transmutation, into a floating and lonely abstraction.

### IV

The dissolution of the bridge as fact — and the subsequent drop in the poem's intensity — was perhaps an inevitable outcome of the poet's conflict between his faith and reality. In the summer of 1926, suffering an attack of skepticism about his "myth of America," Crane stated the problem in his own terms. "Intellectually judged," he wrote to Waldo Frank, "the whole theme and project seems more and more absurd." He felt his materials were not authentic, that "these forms, materials, dynamics are simply non-existent in the world." As for Brooklyn Bridge: "The bridge today has no significance beyond an economical approach to shorter hours, quicker lunches, behaviorism and toothpicks." A month later he had recovered his faith. "I feel an absolute music in the air again," he wrote to Frank, "and some tremendous rondure floating somewhere." He had composed the "Proem," in which the bridge stands firmly opposed to the cities. He had beaten back the nightmarish view of the bridge, and could now proceed with his aim of translating a mechanical structure into a threshold of life.[10]

10. In light of Crane's efforts to sustain belief in his cultural symbol, Henry Miller's treatment of the bridge is significant. For Miller, Brooklyn Bridge was an intensely private experience — a means of release from his culture. It served him as it did John Marin, as a perspective upon the city. Only Miller found nothing in modern New York to celebrate. "Way up there," he wrote in *Tropic of Capricorn* (Paris, 1939), he seemed to be "hanging over a void": "up there everything that had ever happened to me seemed unreal . . . *unnecessary.*" (p. 72) The bridge, he felt, disconnected him from the "howling chaos" of the shores. See also "The 14th Ward," *Black Spring* (Paris, 1936). In "The Brooklyn Bridge," the concluding essay in *The Cos-*

But Crane could not dismiss the nightmare. He had to account for it, and he did so in a subtle fashion. Later in 1926 he arrived at the title for his last section: "Atlantis." Until then, it had been "Bridge Finale." The destination of the protagonist's journey, like Columbus's, had been called Cathay, the traditional symbol of the East. Atlantis was the sunken island of the West — older even than the Orient. What does Crane intend by his new title? Does he mean to identify East and West? Or to introduce the idea of the decline of greatness at the very moment his hero's journey is accomplished? What precisely does Atlantis add to our "cognizance" of the bridge? [11]

The fable of Atlantis had been as important as Cathay to the discovery of the New World. Originally, it was a somewhat mystical legend told by Plato in *Timaeus* and *Critias*, concerning a

---

mological *Eye* (New York, 1939), he writes that the bridge had appeared to him with "splendour and illumination" in "violent dreams and visions." He recalled that he took to the bridge "only in moments of extreme anguish," and that he "dreamt very violently" at its center. In these dreams "the whole past would click"; he felt himself annihilated as an ego in space and time, but reborn in a "new realm of consciousness." Thus, he now realizes, the bridge was no longer "a thing of stone and steel" but "incorporated in my consciousness as a symbol." And as a symbol it was a "harp of death," "a means of reinstating myself in the universal stream." Through it he felt "securely situated in my time, yet above it and beyond it." Crane's conception is similar, with this crucial difference: Miller stripped the bridge altogether of its ties with American life, but Crane wished to restore a meaningful relation between bridge and city, and to fuse the personal and the cultural. Moreover, Crane wished to incorporate the stone and steel into the symbol — to join meaning to fact.

Other treatments of the bridge versus the city theme appear in John Dos Passos, *Manhattan Transfer* (New York, 1925); Thomas Wolfe, *The Web and the Rock* (New York, 1938); Vladimir Mayakovsky, "Brooklyn Bridge" (1925), reprinted in *Atlantic* (June 1960); Federico Garcia Lorca, "Unsleeping City (Brooklyn Bridge Nocturne)" (1932), *Poet in New York* (New York, 1955). On May 26, 1923, the Sunday Brooklyn *Eagle* celebrated the fortieth birthday of the bridge with a poem by Martin H. Weyrauch, "The Bridge Speaks," in which the structure argues against modernization of itself in these words: "I think we ought to have/ At least one personality/ In this City of Wild Motion/ That stands for the solid,/ The poised,/ The quiet/ Things of Life." It is likely that Hart Crane, already at work on his poem and living in Brooklyn Heights, read these lines.

11. In May 1926 Crane recorded in a letter that he had been reading *Atlantis in America* by Lewis Spence. Spence, a leading student of mythology (he died in 1955),

land in the western ocean (the Atlantic), founded by Poseidon, god of the sea. Once all-powerful, the nation had grown lustful, and was punished for its pride with earthquakes and floods; in a single day it sunk forever. But the legend remained, and during the fifteenth century, was popular among sailors. The island was believed to be the place where seven Portuguese bishops, fleeing the Moors, had founded seven golden cities. Sailors hoped to rediscover this land, where Christians still lived in piety and wealth. To discover Atlantis, or to reach Cathay — these were the leading motifs among the navigators who sailed westward in the fifteenth century. No one, not even Columbus, dreamed that an entirely new world lay between the sunken world and the legendary riches of the Orient.[12]

Crane thus had historical grounds for identifying Atlantis and Cathay. As it turned out, the discovery of America proved both

---

devoted much of his time and numerous books to "the Atlantean question." Crane found convincing his argument that there are traces of Atlantean civilization in American Indian culture: "it's easy to believe that a continent existed in mid-Atlantic waters and that the Antilles and West Indies are but salient peaks of its surface" (*Letters*, 255–6). It is, unfortunately, impossible to learn whether Crane knew *Atlantis: The Antediluvian World* (1882) — a remarkable work by Ignatius Donnelly, the fascinating Minnesotan, who tried to found a city in the 1850's, served many years in Congress, was an out-spoken Populist, a Baconian in the controversy over the identity of Shakespeare (he produced a massive argument in 1885, *The Great Cryptogram*), and something of an embittered prophet (*Caesar's Column*, 1890). His book on Atlantis was widely influential among students of the problem; Lewis Spence linked his name with Plato as the most prominent in "Atlantean science." Among the propositions Donnelly tried to prove were that Atlantis was "the true Antediluvian world; the Garden of Eden," and therefore, "the region where man first rose from a state of barbarism to civilization." To establish these — and other — "facts," would, he wrote, "aid us to rehabilitate the fathers of our civilization, our blood, and our fundamental ideas — the men who lived, loved, and labored ages before the Aryans descended upon India, or the Phoenicians had settled in Syria, or the Goths had reached the shores of the Baltic." Atlantis, in other words, provided mankind — and Americans in particular — with a historical tradition far older than any yet imagined. Donnelly's book was reissued, with revisions by Egerton Sykes, in 1949.

12. See Boies Penrose, *Travel and Discovery in the Renaissance, 1420–1620* (Cambridge, 1952), 5, 19, 25; also, J. H. Parry, *The Age of Reconnaissance* (New York, 1964), 165.

legends to be illusions: neither had the geographical position attributed to it by Renaissance navigators. Both, however, remained active myths — Cathay inspiring the revived theme of the Northwest Passage in the nineteenth century, and Atlantis even yet arousing speculation. Crane had indicated early in the composition of his poem that Cathay would stand for "consciousness, knowledge, spiritual unity" — material conquest transmuted into "an attitude of spirit." What does Atlantis stand for?

The answer is complex. When we learn from Plato that the Atlanteans possessed a land with a great central plain, "said to have been the fairest of all plains, and very fertile," the resemblance to America is striking. Further, we learn that they were a race of highly inventive builders, who intersected the island with a vast system of inland canals. They had invented basic tools, farming, and the alphabet. Their proudest creations, however, were bridges — a series of bridges, in fact, which led over the canals toward the exact center of the island. There, a monumental bridge opened upon the gate to a temple, the shrine of Poseidon.

This was Atlantis in its glory. But, Plato revealed, the glory did not last. The "divine portion" faded away, and human nature "got the upper hand." The people grew prideful, avaricious, imperialistic. And most of all, they grew blind to their own failings — blind to the loss of their true powers.

Crane wove references to the sunken island throughout the fabric of the poem. They appear in "Cutty Sark" as the old sailor's memory of "the skeletons of cities." They recur forcefully in "The Tunnel" in two echoes of Poe's "The City in the Sea": "And Death, aloft, — gigantically down," and "worlds that glow and sink." And they emerge explicitly in stanza eleven of the finale:

> Now while thy petals spend the suns about us, hold —
> (O Thou whose radiance doth inherit me)
> Atlantis, — hold thy floating singer late!

In the preceding line, the bridge was addressed as a sea creature — "Anemone." Here, the poet invokes the floating form, now

called Atlantis, to sustain his faith. In the following stanza, the last of the poem, the poet passes "to thine Everpresence, beyond time," as the "orphic strings . . . leap and converge." Then:

> — One Song, one Bridge of Fire! Is it Cathay,
> Now pity steeps the grass and rainbows ring
> The serpent with the eagle in the leaves . . . ?
> Whispers antiphonal in the azure swing.

The question *may* indicate doubt that the bridge does in fact represent the "mystic consummation" of Cathay; more likely, it indicates wonder. The antiphonal whispers through the cables of the disembodied bridge could hardly be negative. Atlantis, the bridge-anemone, had answered the prayer and held the "floating singer late."

How did the sunken island earn such a high function? Where did it get the "radiance" to bestow upon the poet? The answer lies once more in Plato's account. The people of Atlantis had indeed become blind in their pride and materialism — but not all of them. "To those who had no eye to see the true happiness, they still appeared glorious and blessed at the very time when they were filled with unrighteous avarice and power." Some, however, retained "an eye to see," and these few recognized baseness as baseness. The still radiant ones kept their "precious gift" of the "divine portion." [13]

It is now clear what Crane meant. His Cathay, his moment of supreme awareness, was a moment of Atlantean "radiance." With

---

13. It should be noted that Crane's epigraph to "Atlantis" is from *The Symposium*: "Music is then the knowledge of that which relates to love in harmony and system." This reinforces my view of his reliance upon the Platonic version of Atlantis — and the Platonism of *The Bridge*. Harmony and system were central features of the island civilization — as they are of the Platonic cosmology. Love and music, moreover, had been identified with the poet's quest throughout, and with the bridge in "Proem." The image of Atlantis, then, helps Crane draw these threads together in the finale.

an "eye to see," he perceived the bridge as more than stone and steel, as a "mystic consummation." He perceived the gift embodied in the bridge. The inhabitants of the Daemon's dark tunnels could no longer see — no longer make out the shape of the future within the chaos of the present. These are the people for whom the bridge was nothing but "an economical approach." They represented the loss of radiance, the sinking of Atlantis.

Crane used the Atlantis legend, like the epigraph from Job, to maintain a double insight: the promise of redemption and the actuality of evil. As long as he held the double view, as long as he was able to affirm the myth while condemning the actuality of his culture, he would not sink. To this end he required a bridge to rise above the wreckage of history — to rise above itself — and be a pure curveship. The purity was essential; the bridge could harbor no ambiguities. Hence its symbolic radiance became the only enduring fact of Hart Crane's Brooklyn Bridge.

Their understanding

Begins to swell; and the approaching tide

Will shortly fill the reasonable shore,

That now lies foul and muddy.

---

*The Tempest*, V, 1

# Epilogue

Hart Crane completed the passage of Brooklyn Bridge from fact to symbol. Such a passage was implicit in the earliest ideas of an East River bridge, in Thomas Pope's conception as well as John Roebling's. In the transformation, Crane eliminated the bridge's function as "an economical approach to shorter hours, quicker lunches, behaviorism and toothpicks." He imagined an ideal function: a leap into a new consciousness. He refused to — or could not — acknowledge the social reality of his symbol, its concrete relations to its culture.

The basic motive of Crane's poem was to redeem a bad history for the sake of a good myth: to abolish time and its struggles for a timeless Utopia. An undertaking of this sort is essential for the well-being of any civilization; societies need Utopia to provide directives for action. Crane wanted, in Kenneth Burke's expression, to state his "culture's essence in narrative terms," and thereby provide a myth that might serve as an ideology to guide America in history.[1] He chose materials that were not only authentically American but accurately mythological: Philip Young has shown how well the poet exploited the mythopoeic possibilities of Pocahontas and Rip Van Winkle.[2] Equally important, Crane understood the idealistic strain in American life, a strain which he accurately identified with

1. "Ideology and Myth," *Accent*, VII (Summer 1947), 195–205.
2. "Fallen from Time: The Mythic Rip Van Winkle," *Kenyon Review*, XXII (Autumn 1960), 547–73, and "The Mother of Us All: Pocahontas Reconsidered," *Kenyon Review*, XXIV (Summer 1962), 391–415.

167

the imaginative construct of land and nature: Pocahontas embodying the Virgin Land.

For Jefferson, history lay far beyond the sea, in the courts and on the battlefields of Europe. He felt secure in the timeless bosom of the American landscape. But for Crane, history was the condition of daily life. What had begun for Jefferson as a road in the wilderness had become for Crane on one hand, an ideal bridge, but on the other, a mad tunnel under a city. Hence his resentment against history was deeper than Jefferson's, more abrasive than Whitman's. Hence his myth in the end finds no accommodation with history. It was not political, like Jefferson's, or social, like Whitman's. It was aesthetic and private. The very language in which it is realized forbids the access of a large audience. With no common ground between myth and history, he found no common ground between himself and his culture.

And yet, the symbol of his myth, Brooklyn Bridge, is a concrete historical object; it was created in travail amidst corruption; it serves as a highway between two cities; it connects tunnels. This is a paradox no amount of rhetoric can deny: to secure its link with eternity, Crane had to abolish the bridge's link with the opposite shores — to abolish exactly that which made it a bridge! To serve as America's symbol it could no longer serve as Brooklyn's bridge. Crane could not have it both ways.

"Hart Crane saw the structure only as an idea," writes Alfred Kazin; "to the Roeblings the idea was only in the structure." [3]

3. "Brooklyn Bridge," *Harper's Bazaar* (September 1946). Kazin's treatment of the bridge in his autobiography, *A Walker in the City* (New York, 1951), is closely tied to the pattern which has emerged in this study. "Whenever I humbly retired into the subway for the long ride home," he wrote, "something would automatically pull me out at Brooklyn Bridge for one last good walk across the promenade before I fell into the subway again." All his walks across the bridge, he continued, "were efforts to understand one single half-hour at dusk, on a dark winter day, the year I was fourteen." Alone on the bridge that day, he suddenly "felt lost and happy" as he "passed under the arches of the tower." With a "riot" in his heart, he saw "the cables lead up to the tower, saw those great meshed triangles leap up and up, higher and still

The difference Kazin expresses is significant. By reducing it to "idea," did not Crane strip the bridge of possible social values, values which might have provided an alternative to the blind life of the cities? Might not the bridge have served as a moral as well as mystical symbol — indicating a state of society as well as a state of consciousness?

Crane's predicament represents a conflict within an entire civilization. The paradox of his symbol resembles the paradox of those early proposals to build roads into the wilderness as a way to return to nature, to escape history. America seems to have learned very late, if at all, that roads create history, not abolish it; they inevitably lead to cities, not to the land. And in reaction against the city, Americans have tended to conceive of the land, like Crane's bridge, as an escape rather than as a source of values by which history might be directed, or the growth of cities controlled.

Although his Hegelian confidence, often bordering on naïveté, can no longer be ours, John Augustus Roebling seemed to grasp what eluded many of his countrymen: the idea that history was the realm of the possible. Guided by ideals, Roebling transformed stone and steel into a shape that was both practical and symbolic; he found for his Utopia a tangible form. His materials mediated between the ideas his mind wandered among and the ground he stood on. By and large his countrymen have alternated between the two extremes: a high-flown idealism, scornful of social goals, and an abject historicism, in which a bridge is "nothing but" an "economical approach." Unable to incorporate the "nothing but" into his myth, Hart Crane himself swung from exaltation to jeremiad. His Word could not redeem, and so it lamented. Above the conflicting emotions arose a symbolic bridge, shorn of its history and its actuality: it was a reconciliation detached from space and time.

---

higher — Lord my Lord, when will they cease to drive me up with them in their flight? — and then, each line singing out alone the higher it came and nearer, fly flaming into the topmost eyelets of the tower." (105–7)

A detached symbol, whatever its roots in the psyche of the poet, is helpless against the facts of tunnels, cinemas, and elevators. If it is to redeem its culture — if it is to project a meaningful Utopia — it must be grounded in actuality. To bring the symbol back to earth requires a simultaneous grasp of the desirable and the possible. John Roebling possessed such a grasp. In his mind the bridge was both fact and ideal: a roadway for traffic below and a structure for poets above. Each required the other; each was incomplete without the other. Thus acknowledged as a fact in all its dimensions, Brooklyn Bridge might still incite dreams of possibility, might yet become a new symbol of what ought to be.

# A Walker Evans Portfolio

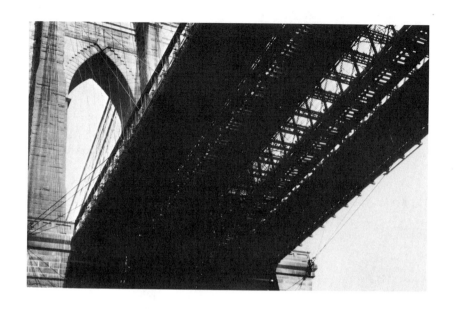

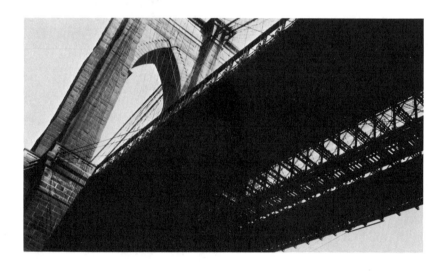

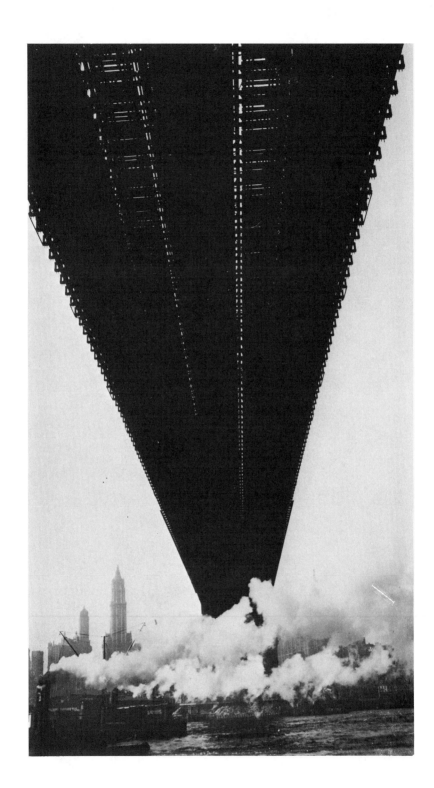

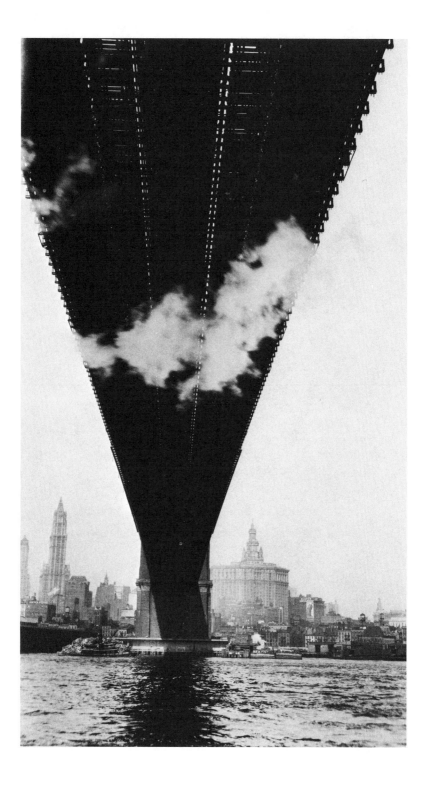

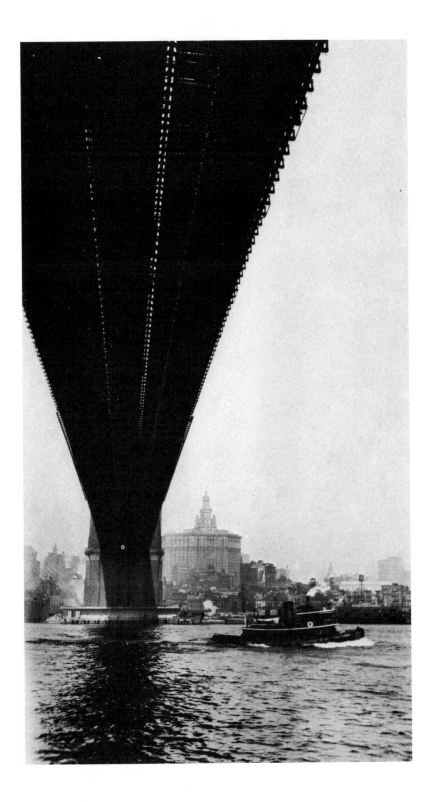

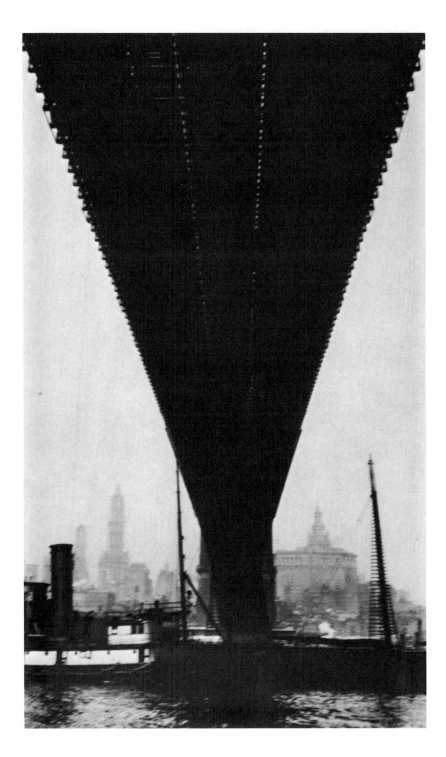

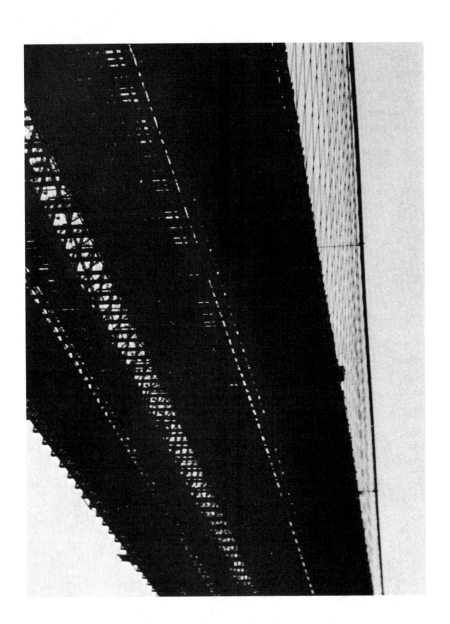

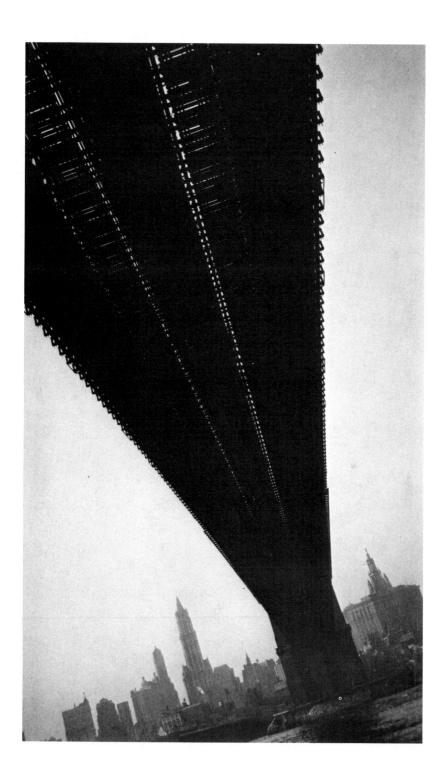

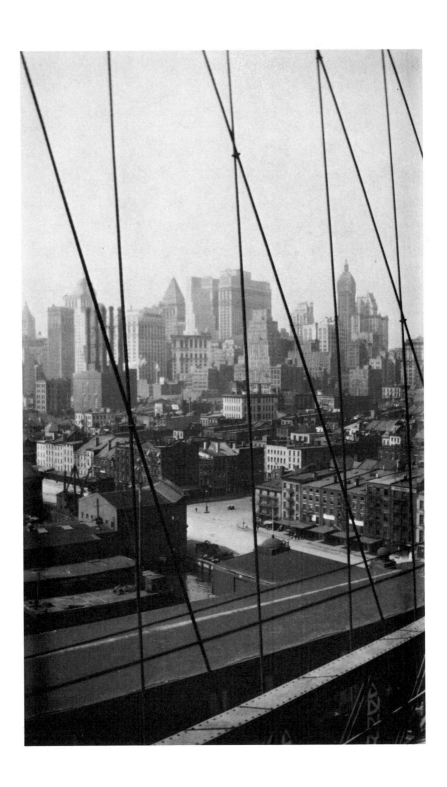

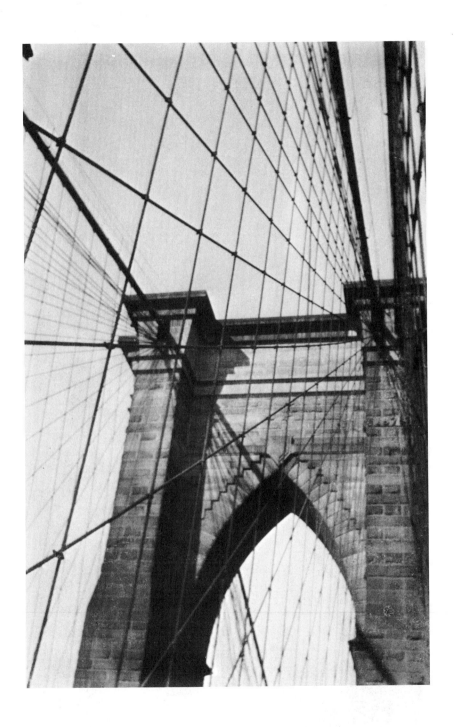

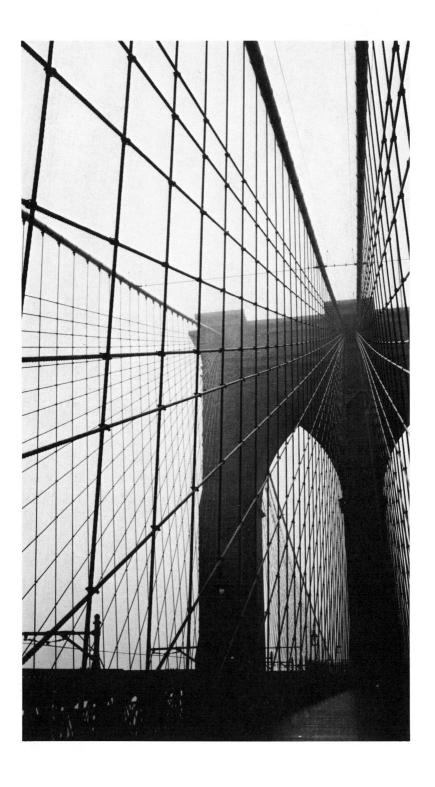

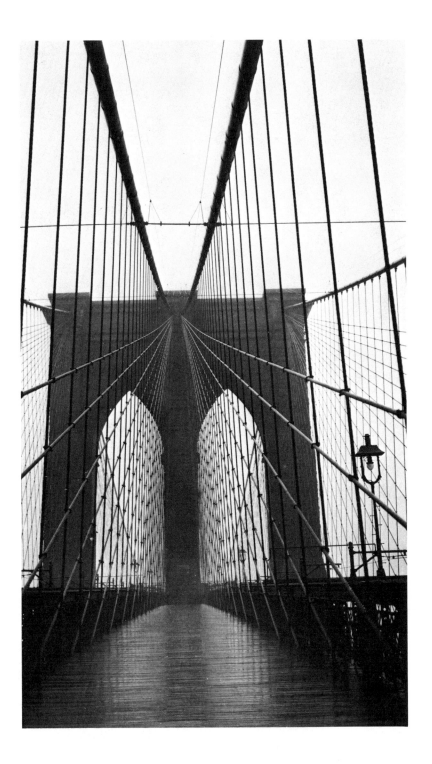

# Afterword

*Did one look at what one saw*
*Or did one see what one looked at?*

HART CRANE, *Ten Unpublished Poems*

# Walker Evans's Brooklyn Bridge

The first appearance of *The Bridge*, in February 1930, proved to be a singular artistic event, for it also marked the first appearance of the work of Walker Evans. Hand-set in Paris under the elegant imprint of the Black Sun Press, the book included three small photographs by Evans, each treated as an artwork in itself, printed in gravure and given the full space of a page interleaved with protective tissue. A thoughtful collaboration between poet and photographer, the edition inaugurated the distinguished career of Walker Evans, an inauguration prophetic of future literary collaboration (with James Agee in *Let Us Now Praise Famous Men*, 1941) and of a characteristic American subject-matter. At the same time the photographs work subtle effects upon the poem itself. They call attention to the bridge itself as a physical object, as a palpable presence in the poem. The association continued in the first American edition of *The Bridge*, issued in March 1930 with yet another image by Evans as frontispiece. Four months later, in a second printing, still another view replaced the earlier frontis-

piece, which now appeared on the cover of the dust jacket. In sum, five photographs by Walker Evans accompanied *The Bridge* in its three distinct printings in 1930, the only publications of the poem during Crane's lifetime.[1]

None of these photographs has reappeared in any of the later editions. The excision of Evans's contribution to the poem is more than unfortunate; the poem is seriously misrepresented when read without at once seeing the bridge, and seeing it especially in the strong, distinct, and original way of Evans's pictures. They are integral to the text, and should be restored. At the same time they are significant works in their own right and deserve to be seen and studied, especially in ensemble, as a majestic interpretation of Brooklyn Bridge, and as early masterpieces of a premier American photographer.

In 1929 Evans and Crane lived near each other in Brooklyn Heights. They had known each other about a year. In the fall of 1928 Evans had helped Crane find a job as a file clerk in a Wall Street brokerage office where he himself worked as a stock clerk. Younger by about three years, and just recently returned from an important year in Paris where he had decided to put literary aspirations aside and take up the camera, the more reticent Evans was no doubt attracted by Crane's energy, his prowling intimacy with the city, his Bohemian freedom, and the verve and visual excitement of his poetry. They came from similar bourgeois Middle West families, from what Crane called a "sundered parentage" (the poet suffered deeply his parents' divorce, while Evans was outwardly unaffected by his parents' long separation), and may have suspected a family relation (Evans's mother's family name was Crane; it turned

---

1. Hart Crane, *The Bridge* (Paris: The Black Sun Press, 1930); *The Bridge* (New York: Horace Liveright, 1930), two printings. For a suggestive, pioneering discussion of the photographs in the Black Sun edition, see Gordon K. Grigsby, "The Photographs in the First Edition of *The Bridge*," *Texas Studies in Literature and Language* Vol. IV (Spring 1962), 5–11.

out instead that their fathers were acquainted through social con-
nections). Evans had taken up photography in earnest in 1928,
and Crane, whose interest in the medium had been awakened and
nurtured by his friendship with Alfred Stieglitz, occasionally joined
the younger artist in his explorations of Brooklyn, the waterfront,
and Lower Manhattan.[2]

Crane mentioned Evans in a letter to Yvor Winters in January
1930, in connection with the Black Sun edition: "You ought espe-
cially to appreciate the three photographs therein, taken by Walker
Evans, a young fellow here in Brooklyn who is doing amazing
things."[3] Several years earlier Crane had expressed amazement about
the photographs of Alfred Stieglitz. He spoke of the "eerie speed
of the shutter," of "the moment made eternal," as the essence of
photography: "It even seems to get at the motion and emotion of
so-called inanimate life."[4] Evans himself held Stieglitz in some
youthful disdain; he found him (in an unsatisfactory visit) pomp-
ous, self-absorbed, and "arty." Solving for himself the mysteries of
the medium, Evans struck out in his own direction. It happened
to lie in these years along an axis remarkably close to Crane's own
vision of contemporary life and of art. The remarkable meshing

---

2. I have drawn the information about the friendship of Evans and Crane from
a variety of sources, including conversations with Walker Evans and Jay Leyda. See
Philip Horton, *Hart Crane* (New York, 1937), 246, 288–89; John Unterecker,
*Voyager; A Life of Hart Crane* (New York, 1969), *passim*; Susan Jenkins Brown,
*Robber Rocks: Letter and Memories of Hart Crane*, 1923–1932 (Middletown,
Conn., 1969), 101. See also Leslie Katz, "Interview with Walker Evans," *Art in
America* (March 1971). For general discussions of Evans's work in photography, see
John Szarkowski, *Walker Evans* (New York, 1971), 9–20; also Alan Trachtenberg,
"The Artist of the Real," in *The Presence of Walker Evans* (Boston, 1978), 17–26;
reprinted in *Afterimage* (December 1978).

3. Thomas Parkinson, *Hart Crane and Yvor Winters: Their Literary Correspondence*
(Berkeley, 1978), 140.

4. *The Letters of Hart Crane*, ed., Brom Weber (New York, 1952), 132. Crane's
interest in the art of photography and its appearance in his poetry are intelligently
discussed by F. Richard Thomas, "Hart Crane, Alfred Stieglitz, and Camera Pho-
tography," *Centennial Review* (Fall 1977), 294–309.

of vision in the first edition of *The Bridge* is proof enough. But the coincidence shows as strikingly in a sequence of four photographs that appeared later in 1930, titled "Mr. Walker Evans records a City's scene." After a heading in the form of a typographical array of such contemporary words as "machine," "ultra," "speed," "profit," "wonder," and "camera" (recalling the opening lines of "The River"), the sequence begins with a picture of an electric sign being removed from a truck. The sign reads "DAMAGED." The second image is a "Broadway composition" that appears to be a nocturnal montage of neon lights and signs. Facing this picture is a bold, sharp-angled view from below of the prow of a steamer; the caption (undoubtedly by Evans) reads: "S.S. Leviathan. An unexpected monument of calm in extreme contrast to the agitated stridency typified in the composition opposite." The caption echoes precisely the contrast between bridge and city Crane makes throughout *The Bridge*, and especially in "Proem." The final image is a view of three standing diners through the glass-plate window of a downtown eating establishment. " 'Hurry up please, it's time,' " reads the caption; "New York City's quick lunch. The foundations of dyspepsia for the million." A brief, unsigned text accompanying the sequence identifies Evans as "a Commercial Photographer, working in New York. He has been in Europe where he studied modern continental methods, and has since spent some time in experimenting. He now records in a vivid and peculiarly appropriate manner the scene of which he is a product. The present four examples are chosen as representative 'records' of this order. The Heading . . . is intended to convey in symbolism—as it were, to typify—the blended babel of such a modern city's life."[5]

Evans's role in *The Bridge* must have developed very rapidly. As late as September 1929, Crane had intended as a frontispiece a color reproduction of one of Joseph Stella's paintings of Brooklyn

5. *Creative Art*, Vol. VII (December 1930), 453–456.

Bridge. He had not yet met Stella, but in February of that year had seen a privately issued monograph including the "New York Interpreted" panels and an essay on Brooklyn Bridge. From Paris Crane wrote to Stella asking permission on behalf of the journal *transition* to publish the material, and added his own request to reproduce the Brooklyn Bridge panel as "a private favor." "It is a remarkable coincidence," he wrote, "that I should, years later, have discovered that another person, by whom I mean you, should have had the same sentiments regarding Brooklyn Bridge which inspired the main theme and patterns of my poem."[6] Stella presumably consented, but that fall the plan collapsed, apparently for technical reasons. It is not certain exactly when Crane decided to use the Evans photographs (or to ask Evans to make them), but by December 26 they were a definite feature of the book. On that date Crane sent off the final revisions of the text and added: "By the way, will you see that the middle photograph (the one of the barges and tug) goes between the 'Cutty Sark' Section and the 'Hatteras' Section. That is the 'center' of the book, physically and symbolically." He added: "Evans is very anxious, as am I, that no ruling or printing appear on the pages devoted to the reproductions."[7] By now the photographs had an integral role, and the poet granted to the photographer control over their presentation.

The change from painting to photographs raises fascinating but

6. *Letters*, 334. As Weber explains in *Hart Crane* (New York, 1948), 317–320, it is hardly likely that Crane was unacquainted with Stella's paintings before 1929. Reproductions of the first (1918) canvas had appeared since 1921 in periodicals Crane regularly read and even contributed to, and Weber raises the possibility that Crane "derived the symbol of the bridge from Stella's painting." The suggestion is carried further and parallels are examined in thorough detail by Irma B. Jaffe in "Joseph Stella and Hart Crane: The Brooklyn Bridge," *The American Art Journal*, Vol. I (Fall 1969), 98–107, and in *Joseph Stella* (Cambridge, Massachusetts, 1970), 245–248. Another valuable discussion, especially of Crane's sensitivity to the visual arts, can be found in George Knox, "Crane and Stella: Conjunction of Painterly and Poetic Worlds," *Texas Studies in Literature and Language*, Vol. XII (1970–71), 689–707.

7. *Letters*, 347.

probably unanswerable conjectures regarding Crane's view of his poem. It is evident that Crane did not reject the painting on behalf of the photographs; if color reproduction had been feasible, he would no doubt have continued with the painting. Certainly it is not surprising that Stella's essay struck a responsive chord; the language, like the painting, is rhapsodic, hyperbolic, and like the poem, evocative of clashing forces. Stella, too, appeals to Poe and Whitman in a manner bound to impress Crane by its resemblance to his own fervor: "Meanwhile the verse of Walt Whitman—soaring above as a white aeroplane of Help—was leading the sails of my Art through the blue vastity of Phantasy, while the fluid telegraph wires, trembling around, as if expecting to propogate a new musical message, like aerial guides—leading to Immensity, were keeping me awake with an insatiable thirst for new adventures."[8] In the energy of their colors and their forms Stella's paintings of the bridge partake of the flamboyance of his prose—and indeed of some of Crane's verse.

Would the painting have competed with the poem as a statement of a similar order? The question is, of course, entirely academic. But in asking about the effect of the photographs, we cannot entirely forget that the painting had been an alternative. At issue, though admittedly a very conjectural issue, is what might be termed the status of Brooklyn Bridge within the poem—the real, factual bridge within the symbolic structure of imagined bridging, of crossing from one state of consciousness to another. Is the poet's bridge a symbol in the sense of an icon, a physical "shrine," as Stella had described his first canvas, "the eloquent meeting point of all forces arising in a superb assertion of their powers, in APOTHEOSIS"?[9]

Perhaps noteworthy is a comment made by John Marin, to the effect that Stella's bridge compositions were excessively formalistic; they have no more relation with the actual bridge, he remarked, "than if he had put up some street cables and things in his studio—

8. Quoted in Weber, *Hart Crane*, 319.
9. *Idem.*

painting a rather beautiful thing and called it the 'Bridge.' "[10] Marin apparently misses what he himself tried to convey in "The Red Sun, Brooklyn Bridge" (1922): the *experience* of the bridge in space. His stricture deserves some thought. Do not Stella's paintings, in their very power, their stylization, project more an *idea* of the bridge than the felt experience of a crossing (though, to be sure, the sense of being swept up by the cables and towers is present)? As dynamic as his compositions may be, do they not freeze the bridge into an icon, a static, familiar image of towers, arches and cables? Is not the response elicited from the viewer less a crossing into a new awareness than a recognizing of a familiar object transfigured into an image of heroic energies?

Crane also spoke of the bridge as a "climax," a "symbol of our constructive future, our unique identity." But it is relevant to note that nowhere in the poem does the bridge appear exactly in this light, as an unambiguous symbol, a sign standing for the abstraction "America." Its status as a symbol is far more complex, entailing in part an exquisite texture of physical details transfigured through Crane's "logic of metaphor" (the curve becomes a "curveship," the span of steel a "cognizance") into the governing "abstract form" of the epic. When it is mentioned as such, the bridge always appears in its aspect as Brooklyn Bridge: a shuttle for traffic, a parapet for bedlamites, a pier under which the poet waits in shadow, a walkway from which he sees a vision of old clipper ships, and on which he makes his final walk and crossing into a glimpse of Oneness that take their force from his kinetic and visual experience of the actual bridge.

By contrast with the Stella painting the Evans photographs are supremely simple and austere, their predominance of soft blacks muting their emotional tonality. They represent the bridge as stone and steel, as precise textures, and they site it just as precisely. Each

10. Quoted in Sheldon Reich, *John Marin* (University of Arizona Press, 1970), 54–5.

of the three images in the Black Sun edition has an unambiguous point of view: the first looks up at the steel underside of the bridge floor, and across the river toward Manhattan; the second looks down from the bridge, at coal barges and a tug boat; the third looks ahead from the promenade, toward the towers and the Gothic arches. The photographs take their lead from the poem, and yet they also stand as an independent visual conception, especially when viewed in sequence: a composite work of art in their own right. They are not merely recognitions of the bridge, but constructive visions, unexpected organizations of objects in space: not simply representations of Brooklyn Bridge, but also of the act of seeing, of the photographic discovery that form follows point of view. Their originality lies in part in their decisive break with the conventional distant and lateral views in standard commercial and "serious" photographs of this most famous of New York landmarks. Here the bridge is seen freshly, not merely looked at; it emerges, as it does in the poem, as the vision of a specific eye, as *someone's* palpable experience. Crane may have been present when Evans took the photographs—using a simple folding tourist camera with bellows, a fixed focus lens, and a 2½ x 4¼ inch format—and like Henry James accompanying Alvin L. Coburn during the composition of the frontispieces for James's New York Edition, an active participant in the making of the pictures.[11] In any case the poet's intimacy with the bridge informs the

11. See Henry James's "Preface" to *The Golden Bowl* for an account of his collaboration with Coburn and his appraisal of the photographs, in *The Art of the Novel*, ed., R. P. Blackmur (New York, 1934), 327–348. Coburn himself included two photographs of Brooklyn Bridge in his *New York* (London, 1910), a book of original photogravures. Other pictorialist treatments of the bridge can be found in *Camera Work* (July 1903), 43 and (October 1908), 35. The style, manner and feeling which Evans pointedly repudiates in his photographs is rendered with devastating precision by F. Scott Fitzgerald at the end of Chapter Two of *The Great Gatsby* (New York, 1925), where Nick Carroway describes Mr. McKee, a photographer "in the 'artistic game,' " "sitting up between the sheets, clad in his underwear, with a great portfolio in his hands.

" 'Beauty and the Beast . . . Loneliness . . . Old Grocery Horse . . . Brook'n Bridge . . .' " (38).

pictures. Surely Crane found in Evans's eye a sympathetic comple-
ment to his own.

By their clarity, the dominance they allow the bridge, and their
uncompromising originality, the pictures convey at once the integ-
rity of Evans's eye and of Crane's poetry. The coincidence which
gave them birth remains their heritage. Facing the opening lines of
"Proem," where Brooklyn Bridge dominates the poet's vision as it
does the harbor, the first photograph brings the bridge into the focus
of both literal and symbolic attention. The second image, midway in
the poem, frames the coal barges and tug boat in a diagonal, cutting
composition that counterpoints the poet's elevated fantasy of clipper
ships with a subtle irony that registers throughout the poem. The
final image faces the concluding lines of "Atlantis," where the poet
crosses and asks of the transfigured towers and cables and meshwork,
"Is it Cathay?" The swinging antiphonal whispers of the last line
awaken the lines of the photograph, and words and image together
ground the major question in the living experience of crossing the
bridge. The poem is framed by two images of the bridge, and punctu-
ated at midpoint by an image from the bridge. Starting low, under
its piers, and concluding high, our eyes caught amidst the vibrant
pattern of cables, tower and stays, we begin and end with Brooklyn
Bridge—the bridge of both Hart Crane and Walker Evans.

# Index